Calligraphy

First published
in Great Britain 1991 by
Anaya Publishers Limited
3rd Floor, Strode House
44-50 Osnaburgh Street
London NW1 3ND

ISBN: 1 85470 037 5

British Library Cataloguing
Harris, David
 Calligraphy.
 1. Calligraphy
 I. Title
 745.61

Conceived, designed
and edited by
Playne Books
New Inn Lane
Avening Tetbury
Gloucestershire GL8 8NB
United Kingdom

Editor
Gill Davies

Designers
David Playne
Ged Lennox
Claire Pelta
Clare Playne

Typeset in Gentleman
on Scantext by Playne Books

Reproduction by
Chroma Graphics Singapore

Printed and bound by
Singapore National Printers

For Nancy

*Endpapers: calligraphy by
Julian Waters (see page 38).*

*Illustration facing title page:
Geometry Werner Schneider
(see page 16).*

*Illustration on the right: **Alfred
Fairbanks** quotation 'Writing
considered as an art' John
Stevens (see page 68).*

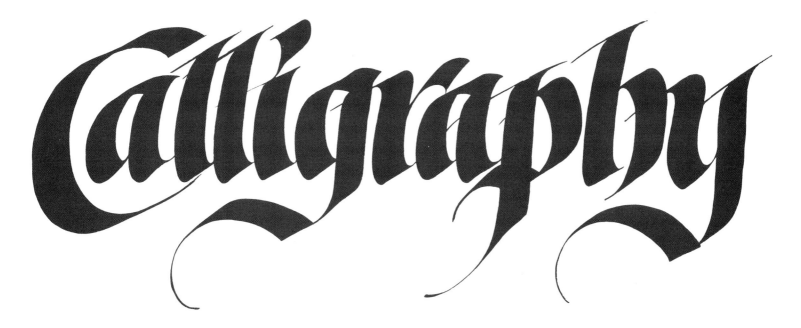

Calligraphy

Inspiration · Innovation · Communication

David Harris

ANAYA PUBLISHERS LIMITED
LONDON

GEOMETRY
CAN PRODUCE
LEGIBLE LETTERS,
BUT ART
ALONE MAKES
THEM BEAUTIFUL.
ART BEGINS
WHERE GEOMETRY
ENDS,
IMPARTS TO LETTERS
A CHARACTER,
TRANSCENDING
PAUL STANDARD MERE
MEASUREMENT

Contents

JUST AS ONE WOULD WISH TO SPEAK NOT ONLY CLEARLY BUT WITH SOME CIVIL-IZED AND MUSICAL QUALITY OF GRACE, SO ONE MAY WRITE

WRITING CONSIDERED AS AN ART.

AND THE WRITING BE WORTHY OF THE NAME OF CALLIGRAPHY. BY WHICH IS MEANT. HANDWRITING CONSIDERED AS AN ART.

Introduction

'The gates are opened now for new ideas to flourish — not a recreation of the past but a harnessing of the knowledge of the past to create a new future.'

The making of marks to convey specific information, which is the original purpose of writing, can be a very boring occupation. For proof of this, look no further than that which we do each day — write with a ballpoint pen. The tedium of this can sometimes be relieved by the content of what we are writing but often by the time this stage is reached, we will be using a typewriter or word-processor instead.

It is arguable whether the wide range of writing hands which have come down to us from the past sprang from a reaction to this tedium experienced by the scribe who sat writing hour after hour.

From the realization that a slight variation of pressure on the quill could produce a subtle thickening or thinning of a letterstroke, or that a slight change of angle consistently applied could give a letter its distinctive characteristics, or that skating over the wet ink with the corner of a quill could produce a hairline of exquisite sensitivity, the understanding grew that an ability to repeat this with consistency word after word, line after line did not, paradoxically, increase tedium, but relieved it, and through achievement gave pleasure. Perhaps at the end of the day it was a worthwhile reward for stiff and aching limbs. And as with any creative art, the joy we now have in seeing these manuscripts from the past is in direct proportion to the pleasure and a little of the suffering of the scribe who created it.

This book is about calligraphy — literally the art of beautiful writing — and the modern scribes of world stature who

have not only lifted writing to levels of technical perfection, but have used words and word rhythms to create images which transcend craft and have elevated it to a noble art form. Thus, as all art must, it gives us new perceptions of ourselves and our very being.

In the following pages we shall be seeing the techniques and methods of twenty calligraphers from across the world: calligraphers who have been largely instrumental in shaping the modern calligraphic scene and, at a deeper level, have helped us to understand their individual philosophies.

What are the mainsprings of modern calligraphy and by which route has calligraphy travelled to reach its present position? Why, indeed, has the scope of this book been restricted to the work of the last twenty years?

Superficially, the last question can be answered simply: one of the purposes of this book has been to show where calligraphy 'is at' today. However, at a more profound level, I believe the last twenty years have witnessed a discernible change of emphasis from the sixty years that preceded, almost amounting to a second calligraphic revival. Jean Larcher says: 'When I look at English and American books on calligraphy from the 1960s, they seem to belong to the last century.'

The invention of printing by movable type had an effect on society that we can now recognize as one of the great watersheds of human history and the humble scribe was one of the first casualties of this invention. Not that the effect of this revolution was total — although books were now printed, letters still had to be handwritten, documents compiled and, at the most prestigious end of the scribe's spectrum, charters prepared.

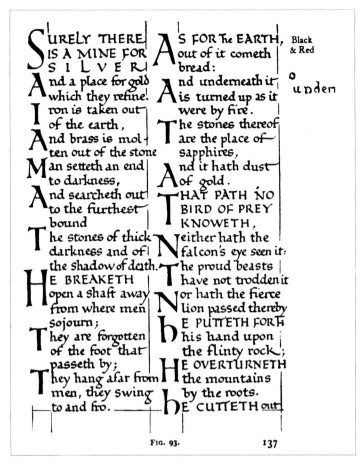

Edward Johnston: an early script
From Writing & illuminating, & lettering

Indeed, it took another four hundred years before the activities of the scribe became effectively obsolete with the invention of the typewriter at the end of the nineteenth century. With regard to calligraph, the end of the nineteenth century can be seen as its lowest point. It is also the period when the first awakenings of what had been lost were beginning to resurface.

In England, as the industrial revolution gained its pinnacle towards the end of the nineteenth century, so a nostalgic and intellectual reaction developed, looking back to what it perceived as a golden age. Spearheaded by the writing of John Ruskin and later William Morris of the Arts and Crafts movement, the products of modern capitalism were called increasingly into question. Redemption would come about only when the everyday artefacts of living were produced by craftsmen and an honesty of

design could be achieved only when craftsmen, tools and material were in communion one with one another.

It is against this background that we first meet the man who, whatever opinions we have of him (and in this respect all calligraphers have some definite view), is regarded as the father of the English calligraphic revival.

Edward Johnston (1872-1944) was training to become a doctor when, owing to his health, he abandoned his chosen career in 1897 and from then on until his death, decided to devote himself to the study and craft of calligraphy. He was fortunate in having the support and encouragement of two influential members of the Arts and Crafts movement, firstly W R Lethaby, the principal of the Central School for Arts and Crafts in London, who introduced him to S C (later Sir Sydney) Cockerell in 1897.

Sydney Cockerell had been the librarian and secretary to William Morris until Morris's death in 1896 and was at that time winding up his affairs. Like Morris, he had considerable interest in calligraphy but whereas the Arts and Crafts movement had pursued calligraphy as one of a number of interests, it fell to Johnston to make it his life's work.

One must admire the courage and foresight of Lethaby when in 1899, he invited Johnston to teach a class in calligraphy and illumination — courage in the sense that at the time Johnston was very much the student teaching himself by research and experiment. As such, he adopted the approach of co-opting his students to share in his work. One can imagine the excitement as they made their pioneering discoveries together.

It is important to understand why the work of Johnston was so significant at this stage. Throughout the 19th century calligraphers had been drawing Gothic letters with a pointed steel nib and carefully filling in the letters; masons cut Gothic letters and signwriters painted them. Many of these craftsman knew the external shape of the letters. The importance was not that Johnston could create them for his students; it was (and this is our debt to the Arts and Crafts movement) his understanding that fundamentally the shape and form of a thing must spring directly from the tools and material used to make it. This he taught. When such practice and knowledge are combined with scholarship, the gates are opened for new ideas to flourish; not a recreation of the past, but a harnessing of the knowledge of the past to create a new future.

The culmination of Johnston's early work was the publication of *Writing and Illuminating and Lettering* in 1906 and (with Eric Gill) a portfolio *Manuscript and Inscriptional Letters* in 1909. Through their publication his ideas were disseminated

Edward Johnston's Winchester Formal Writing Sheet.

Edward Johnston 1919 A part of his Winchester Formal Writing Sheet.

beyond his immediate students to the rest of the country and thence to the world at large.

Johnston's vision of relating all lettering-based design to the central understanding of form through writing, tools and materials, backed by scholarship, was largely a failure. His concept simply did not fit into the structure of the British Art School system. Until the early 1960s, calligraphy (in this context, writing with a broad-edged tool) was to be a rather refined activity, unrelated to other aspects of applied lettering. It was practised mainly by young ladies required to produce a manuscript book as part of their assessment and whose teachers were likely to be students of Johnston or his proté-gées. So, printing apprentices worked behind locked doors in the composing room and letter cutters and signwriters were still tradesmen taught at evening classes by other tradesmen, generally unable or unwilling to cross the bridge constructed so painstakingly by Johnston.

Although perhaps Johnston's broader vision of the role of lettering failed, in a narrower sense the achievements of the calligraphic movement he had fathered were considerable, as witnessed by the work of the scribes since the turn of the century. This work was first brought together in the early years of this century by the Calligraphic Society of which Johnston was President. After its stormy demise the Society of Scribes and Illuminators was founded in 1921, mostly by the students associated with the Central School of Arts and Crafts; and in Britain, it is still regarded as the premier calligraphic society.

In Germany and Austria a parrallel and not wholly unconnected revival was occurring at the same time. The chief exponents were Edward Johnston in England, Rudolph von Larisch in Vienna and, later, Rudolph

Koch in Germany — who was not only a great teacher but one of the world's great calligraphers. The aims of these men were to raise the status of both writing and the scribe from the debased level at which they had found them.

Rudolph von Larisch (1856-1934) was an official in the Chancery of Emperor Franz Joseph. Looking at the personal calligraphy of von Larisch today, one would not find this remarkable. His importance in the calligraphic revival lies in the fact that he recognized and identified the low levels to which calligraphy had fallen when he compared them to the manuscripts in his charge. In his attempt to rectify this he published in 1899 *Zierschriften in Dienstder Kunst* (Decorative Writing and Lettering in the Service of Art). This publication led to his appointment in 1902 as lecturer on lettering at the Vienna School of Art and Crafts.

In 1906, the year that Johnston published *Writing and Illumination and Lettering*, von Larisch published *Unterricht in Ornamentaler Schift* which was concerned with the application of lettering on different materials. Unlike Johnston, he saw calligraphy not as an end in itself but as a natural basis for self-expression with a variety of tools and materials serving this end. As a result of this publication, Larisch obtained the eminence in German-speaking countries that was held by Johnston in England.

Rudulf von Larisch 1856-1934 An example from the Klingspor Museum, Offenbach am Main, in Germany.

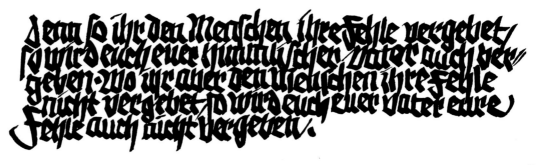

One of Johnston's students from 1901, when he moved to the Royal College, was Anna Simons (1871-1951) who had been denied an Art School education in her native Germany because of her sex.

Johnston found her one of his most able students. When she returned to Germany, Anna Simons began to teach Edward Johnston's methods and in 1905 was asked by the Prussian Ministry of Commerce to organize a lettering course for teachers in Dusseldorf which was enthusiastically received by teachers eager in their desire to revive the art of calligraphy. The course became a yearly event and, spread by Anna Simons, the influence of Johnston was considerable, strengthened by her translation of *Writing and Illuminating and Lettering* in 1910.

Looking at the work of Anna Simons from today's viewpoint, the influence of Johnston and the English calligraphic school is unmistakable. We should perhaps be grateful that her students, accepting Johnston's ideas, were not overly influenced stylistically and generally remained true to their own cultural traditions.

Rudolf Koch (1873-1934) of Offenbach was a type designer, calligrapher and craftsman as well as a teacher. He studied at the most important printing centres in Germany. Although his influence occurred later in Germany than did Johnston's in England, it was still considerable. He worked as a type designer for the Kingspor type foundries in Offenbach and taught lettering in the School of Arts and Crafts there. In 1918 he brought together a group of calligraphers, letterers and craftsmen; known first as the Offenbach Penmen, the group grew into a workshop community. Koch's great contribution was that he saw lettering in its broadest sense as the central discipline: all members of the workshop had to be practised in it whether they were silver-

24. ½ der Originalgröße. Vereinfachung einer bestimmten Buchstabenform. Stahlfeder.

25. ¾ der Originalgröße. Gewöhnliche Schreibschrift eines Kursteilnehmers. „Grenzen" der gewöhnlichen Schreibschrift.

wöhnliche Schreibschriften sehr dekorativ wirken können. ■
■ Bei solchen Schriften kann am ehesten eine Anlehnung an Vorbilder Platz greifen. Je mehr sich der ornamentale Schriftcharakter der gewöhnlichen Schreibschrift nähert, umso geringer ist die Gefahr, daß durch Kopiatur das Handschriftliche verloren geht. Selbst in den

Rudolf von Larisch 1905 From Unterricht in Ornamentaler Schrift, *the German equivalent to Johnston's publication in England.*

smiths, weavers or practitioners in any other craft.

Johnston saw writing as a central discipline and, accomplished as he was, he remained essentially a penman throughout his life. By contrast, Koch had a multi-faceted talent and was personally involved in the range of the craft activities around him. Johnston wrote about other lettering-related crafts while Koch and his assistants actually practised them.

The workshop in Offenbach was all-embracing whereas in England the Society was elitist and the education fragmented in various lettering activities, none of which saw writing as a central discipline.

Many of Koch's students became distinguished teachers

and practitioners working in Britain and America as well as in Germany and Austria. The calligraphic revival sprang essentially from the insight and work of these dedicated teachers and of the students whom they influenced.

What is the position of calligraphy today? We have seen the calligraphic revival as having taken place mainly in England and Germany, but what of America and the rest of Europe or, indeed, any other part of the world using the Latin alphabet? And what influences do the early pioneers wield today?

Although many links still remain with our calligraphic past it is now nearly one hundred years since Johnston made his first experiments with a broad-edged nib. If one were

to look at the time-span it takes for any great creative, innovative artistic movement to be born, flourish and finally wither, we would, in most cases, find the span surprisingly short; and calligraphy would be no exception. But, as so often happens, a new rebirth takes place from the dying embers of the old.

I believe that the excitement and discovery of the early years of the century had, by the late 1960s onwards, run its course. For the most part calligraphers were producing simply more of the same. It is discernible that from the late 1960s onwards a new generation of calligraphers was arising, challenging and, indeed, revitalizing the concepts of calligraphy.

In Britain at this time, the work of Donald Jackson and David Howells was beginning to break new bounds. This work is looked at in more detail in the sections on Donald Jackson (pages 52-59) and on David Howells (pages 12-15.)

Donald Jackson is, perhaps, Britain's greatest calligraphic export since Edward Johnston for, through a series of workshops and lectures, Jackson's enthusiasm exploded on to the American scene at a time of growing interest there in the calligraphic arts.

Indeed, it is in America that the torch of calligraphic art is now burning most strongly. In America the cultural divide between artists, calligraphers and designers has never been wide and the organization of calligraphic activity is locally based and generally open to all, providing stimulus to the professional and encouragement to the amateur.

The rewards of this liberal approach can be seen in the work of practitioners such as Thomas Ingmire (see pages 94-97). Also inspirational is the pioneering work of the signwriter priest, the late Father E M Catich, who has produced the definitive work on

the Roman alphabet and has demonstrated, in the way that Johnston and Koch would have approved, that the uniquely beautiful but highly improbable form of the classic Roman letter has come directly from the tools which created them.

In France, we have the pioneering work of Claude Mediavilla and Jean Larcher;

in Germany, the calligraphy and type design of Friedrich Poppl and Karlgeorg Hoefer and the great type designer Hermann Zapf. It is perhaps through them that the great German tradition of the all-round letterer is most apparent — where the boundaries are crossed and recrossed, resulting in a complete and unified whole. They can in many ways be seen as the true successors to the attitudes of Rudolph Koch.

The last twenty years have also seen a dramatic increase in the media coverage of calligraphy, particularly noticeable in the number of books and (mostly American) periodicals on the

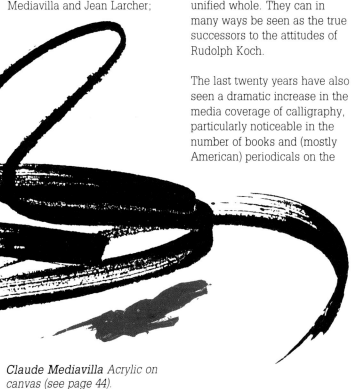

Claude Mediavilla Acrylic on canvas (see page 44).

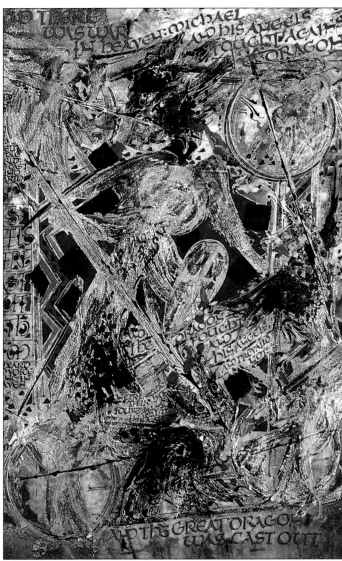

Donald Jackson 1988 'And there was war in heaven' (see page 52).

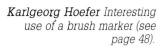

WRITING IT IS THIS BOON TO MANKIND THAT ABRAHAM LINCOLN PRAISED IN THE HIGHEST OF TERMS WHEN HE SPOKE OF WRITING AS THE GREATEST INVENTION OF MAN·

E·A·LOWE

Hermann Zapf A quotation by E A Lowe (see page 98).

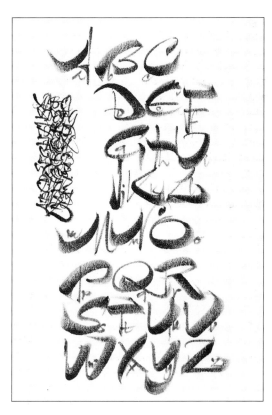

Karlgeorg Hoefer Interesting use of a brush marker (see page 48).

Top right **Jean Larcher** (*see page 86*).

subject. The result of this has been to spread interest into many countries where previously calligraphy had little impact. For this, one must be profoundly thankful because only with a greater love of letters by many more people can pressure be brought upon our educational establishments to teach lettering — and teach it properly to all those involved in graphic and letterbased studies. In Britain, although taught devisively, it was still taught until the 1960s. After then it was effectively not taught at all.

When I began compiling this book, I had hoped to identify a particular watershed — to be able to say 'look — at this point of time something significant happened', to show precisely why the last twenty years is so different from the previous period. That it *is* different I am convinced, but to find a specific turning-point has eluded me, so what *has* happened?

I suggest it is this: About twenty years ago calligraphers realized that calligraphy had the potential to be so much more than a craft, and this knowledge opened up new horizons. This is not to say that all calligraphy is necessarily art. Far from it, but the potential for an art forms exists within it. I believe that the calligraphers in this book have appreciated, explored and realized this potential in many different ways. The results are enormously exciting.

It is thanks to such people — the contributors to this book, and the many calligraphers and calligraphic societies they inspire — that calligraphy is alive and well.

David Harris January 1991

David Howells 1990 'Peace in the valley' in pens and water-colour; previously unpublished (see page 12).

Friedrich Poppl 1968 'Bluthochzeit'. Sketch for a poster (see page 104).

Bottom right **Lorenzo Homar** (*see page 28*).

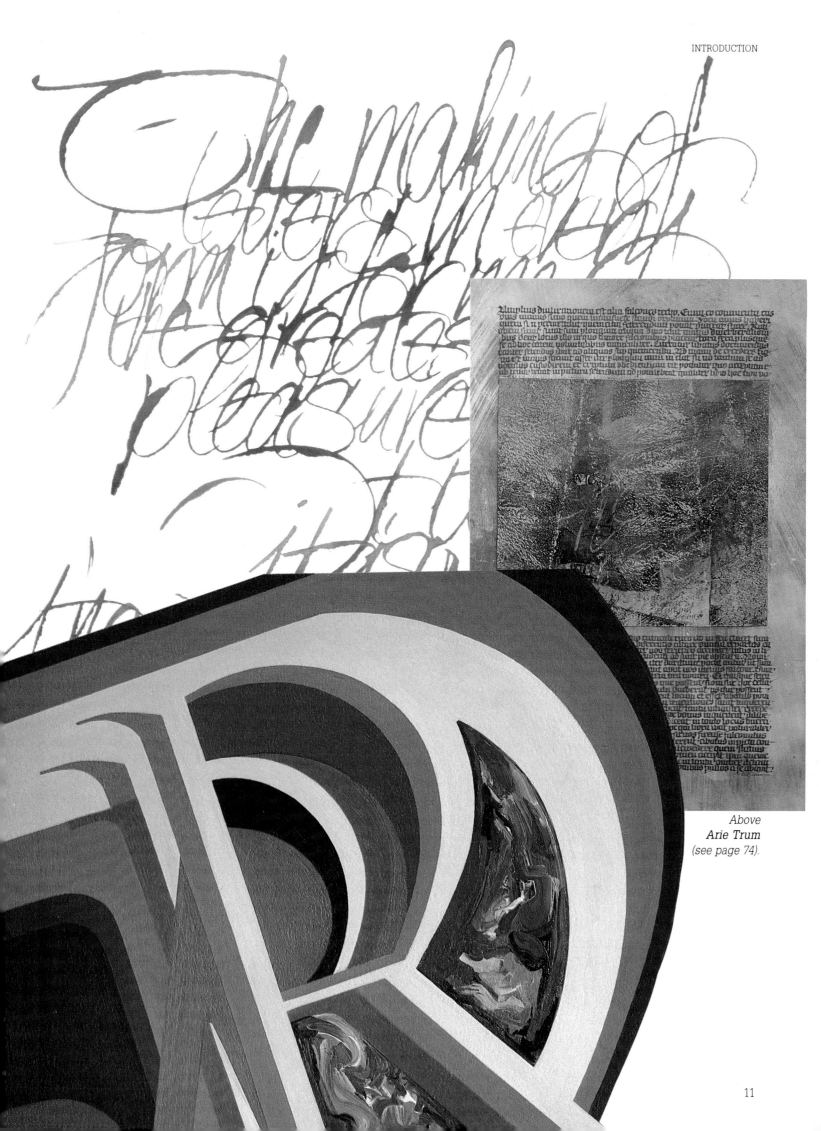

Above
Arie Trum
(see page 74).

11

David Howells

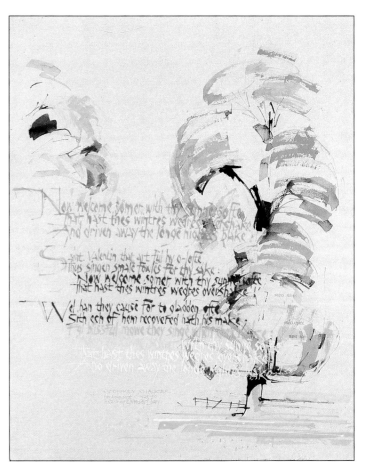

Kidsworth Spring 1979 An extract from The Winter's Tale Pens, brush and watercolour (previously unpublished). 50.8 x 40.6 cms (20 x 26 inches).

In Praise of Elms Poem by G Chaucer (circa 1425-50); from a manuscript in Cambridge University Library. Pens and watercolour (previously unpublished). 61 x 45 cms (24 x 18 inches)

Pen activities 1990 Pens and watercolour (previously unpublished).

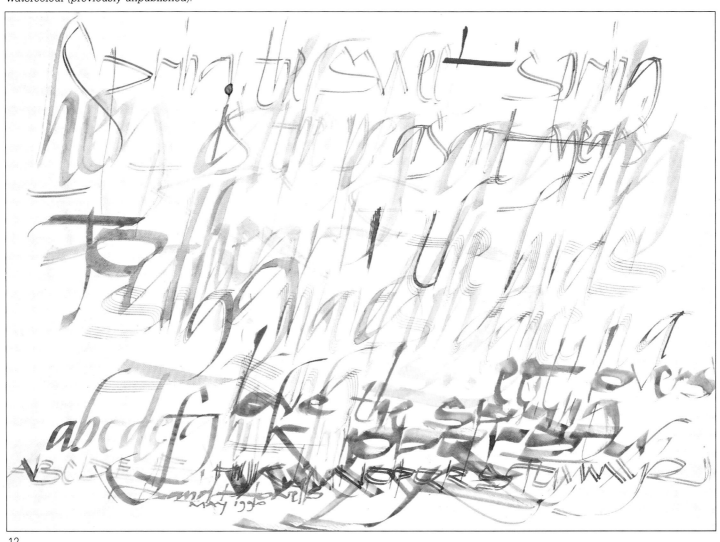

'My work is pure self-indulgence: I love playing about with a drawing/writing instrument and I love writing out poetry: I especially enjoy some of the passages from Shakespeare. When writing, one turns the words over in the mind, repeating them and wallowing in them.'

David Howells was for thirty-one years Professor in Calligraphy and Letterform Design in the School of Graphic Design, Leicester Polytechnic. Here, as well as teaching students penmanship and drawing, he tutored students studying for BA and MA honours degrees in Design and Illustration, Textiles and Fashion, and Ceramics and Industrial Design.

He is visiting Professor in Calligraphy to the Royal College of Art; he teaches courses within the Society of

Calligraphy based upon a musical theme.

Japanese alphabet Not previously published.

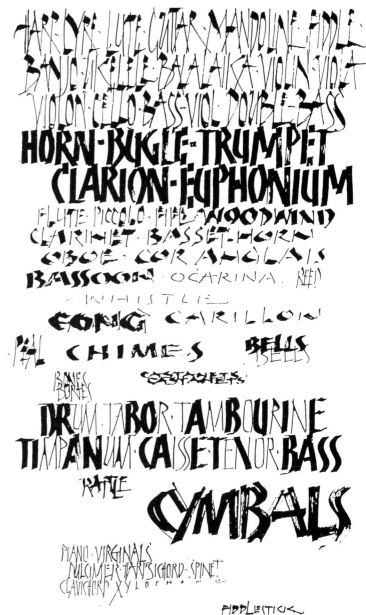

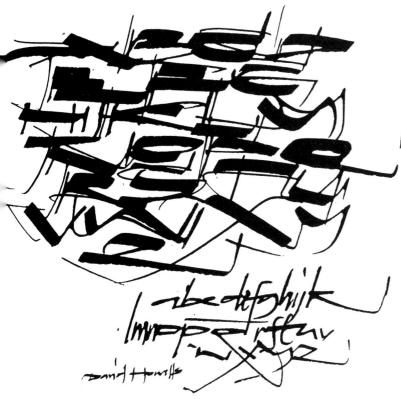

Scribes and Illuminators programme; and with his wife conducts workshops throughout Great Britain and the United States. He has travelled throughout Europe and has assembled an exceptional collection of slides on lettering which he uses for lectures and workshops.

During the 1930s and 1940s, while serving in the Royal Air Force, he travelled extensively in Egypt, Sudan, Eritrea and India. From 1948 to 1952 he studied at Brighton College of Arts and Crafts, and was awarded the National Diploma in Design for Writing, Illuminating and Lettering and for Lithographic illustration with distinction. In addition, he

completed a fifth pedagogical year for the Ministry of Education Art Teacher's Diploma. In 1954 he was elected a Fellow of the Society of Scribes and Illuminators.

In 1956 David Howells visited the Klingspor Museum in Germany where the works of Rudolf Koch and Ernst Schneidler were a relevation to him, and he was so inspired by the enormous potential of free calligraphy that he broke away from the tradition of English lettering. Both this visit and one to Rotterdam to see the pen drawings of Rembrandt astonished and delighted him, especially when he was allowed the privilege of being able to handle the works.

Valentine alphabet 1978
Pens and watercolour.
(not previously published)
45.8 x 45.8 cms
(18 x 18 inches).

Henry V Act 11 Chorus
1974 Pen and watercolour.
(not previously published)
61 x 45 cms
(24 x 18 inches).

Through both Johnston and Koch, David Howells discovered his enjoyment of the edged writing pen as a letter-forming tool: while Johnston expressed his love of linear form, Koch had his fascination with texture. From both sprung a School extending these revelations and ideas. They were concerned with direct penmanship, and this is at the heart of David Howell's interest.

A particular development of the idea was seen at a summer school in Los Angeles in 1979 when David Howells introduced a writing theme inspired by the 'massed writing' of Rudolf Koch, which ultimately initiated a fresh approach to calligraphy in the USA.

Perhaps the most innovative contemporary extension of this theme is the graffiti artist who uses a spray can or felt marker as a writing (and thereby a letter-forming) instrument.

As David Howells paints with letters so they become the expressive medium for a pattern or texture, or have a pictorial or dramatic statement as the main intent. Movement, vitality, spontaneity and experimentation are important.

'It is interesting that the Greek root of calligraphy translated means 'writing and drawing' The Greeks understood the joy and feeling implicit in the drawing and writing instrument. The same feelings motivated Koch and Johnston and are gloriously exemplified by the grand calligraphers of Islam and Japan.'

David Howells uses writing instruments such as the pencil, pen, brush and wood. He feels the basis of a new alphabet rests with the rhythm of the letter strokes and the character of the square pen together building letterforms. Thus, when running workshops, he encourages students to pack the letters on the page so that the repetitive movement reinforces this rhythm and creates a visual pattern.

He suggests that for manipulation of the texture — from light to dark, condensed to open, or rich to delicate — one can vary the pen angle, reduce or extend the height of letters, stretch or condense the width, or change the interlinear space. David Howells' emphasis is on linear elegance, with the overall textural feeling dominating the structure of letterforms.

Extract from A Midsummer
Night's Dream *Act II Scene 1*
61 x 45 cms (24 x 18 inches).
Pens and watercolour

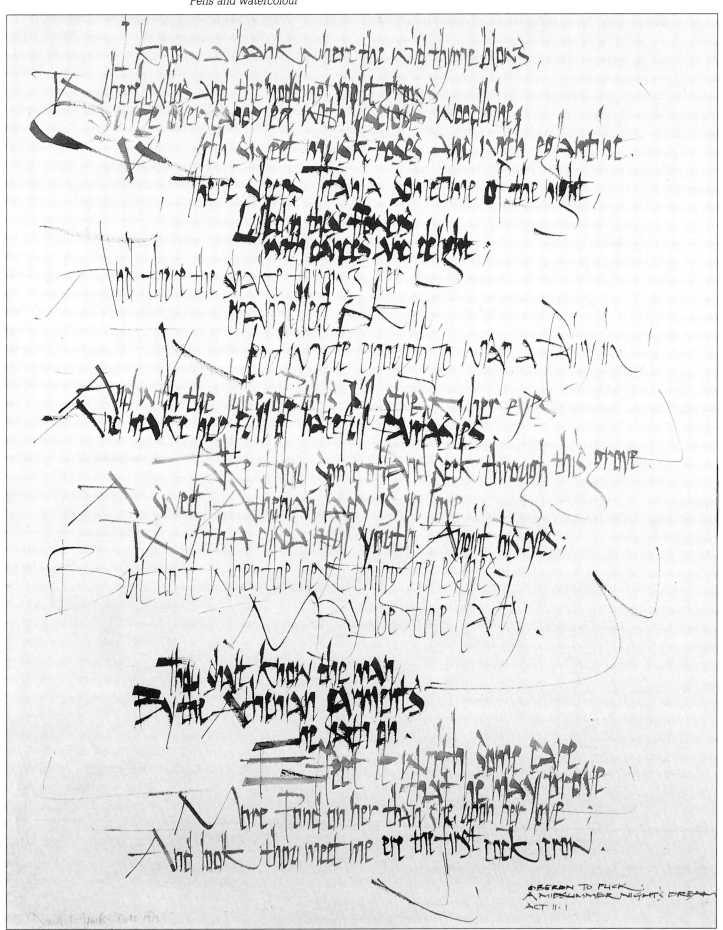

Werner Schneider

'With the coming of the third millenium, it is necessary to have a retrospective glance at the cultural treasures of 2000 years of Western writing, but at the same time to aim at the ever-valid quality properties in a contemporary mode of expression. The new will grow only on the basis of the improved historical form.'

Werner Schneider was born in Marburg/Lahn, Germany in 1935 and was fortunate in belonging to a family of outstanding calligraphers, whose work was a source of inspiration from early childhood. As a student at Weisbaden School of Applied Arts, he was doubly fortunate in having Professor Friedrich Poppl as his teacher. But it was the award of the Rudo-Spemann Prize, presented to him by the City of Offenbach and the Klingspor Museum, which finally set the seal on his calligraphic career.

After completing his studies, his association with Friedrich Poppl continued for another twenty-five years, first as an assistant and later as a colleague. This proved both formative and fruitful; Poppl continued to offer critical appraisal of Werner Schneider's approach to formal creative problems and in so doing helped to heighten Schneider's own ability for self-criticism.

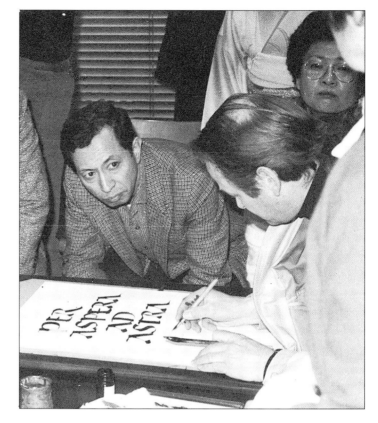

Werner Schneider demonstrates his art to Japanese students.

Geometry *Monumental capitals written with a Hiro note pen and with watercolour on a Roma-Bütten paper.*

Monumental capitals *written with a Hiro note pen on an Indian paper.*

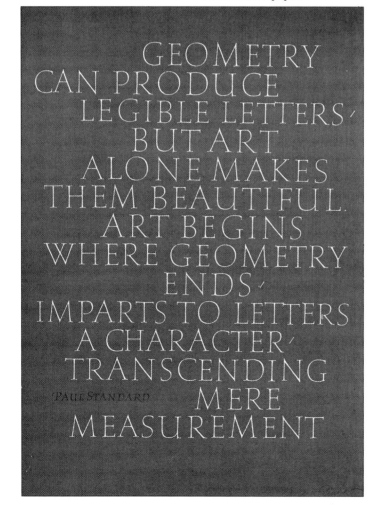

GEOMETRY
CAN PRODUCE
LEGIBLE LETTERS,
BUT ART
ALONE MAKES
THEM BEAUTIFUL.
ART BEGINS
WHERE GEOMETRY
ENDS,
IMPARTS TO LETTERS
A CHARACTER,
TRANSCENDING
MERE
MEASUREMENT

PAUL STANDARD

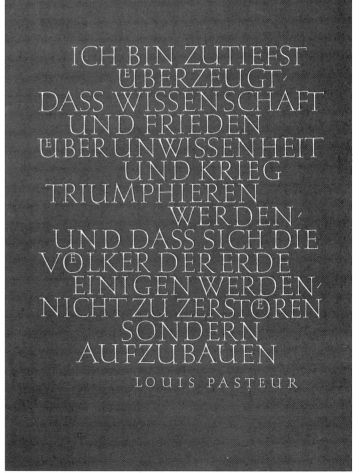

ICH BIN ZUTIEFST
ÜBERZEUGT,
DASS WISSENSCHAFT
UND FRIEDEN
ÜBER UNWISSENHEIT
UND KRIEG
TRIUMPHIEREN
WERDEN,
UND DASS SICH DIE
VÖLKER DER ERDE
EINIGEN WERDEN,
NICHT ZU ZERSTÖREN
SONDERN
AUFZUBAUEN

LOUIS PASTEUR

As well as being a calligrapher, Werner Schneider is a type-designer and book designer, and as such, he is primarily interested in the application of calligraphy as it relates to design. He is also a teacher and lecturer who believes in practice-orientated instruction.

It is from this angle that he views calligraphy: he believes the standing of international calligraphy today owes more to Hermann Zapf than to any other calligrapher, as shown by the awards of the Type Directors' Club of New York and the influence of the quality of his work on other calligraphers, especially in the USA.

As a teacher, he harbours considerable reservations about the amateur movement — an outlook he shares with Friedrich Poppl. For them, the promotion of the artistic conscience in matters of taste was an inescapable principle in their

The passage of time 'It should be the primary task of calligraphers to preserve the high level of Western writing which has lasted two millenia.'

'Calligraphy is like playing upon a very fine instrument.'

The passage of time Language, like the arrangement of notes of music, can be interpreted differently through the medium of calligraphy.

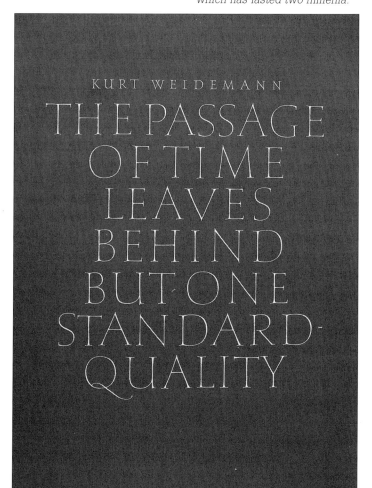

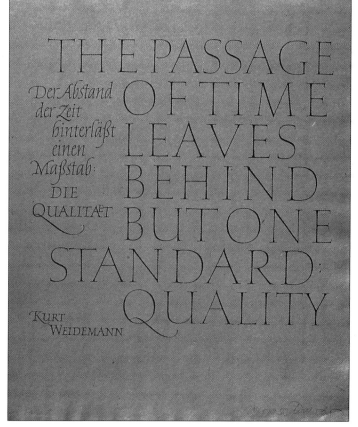

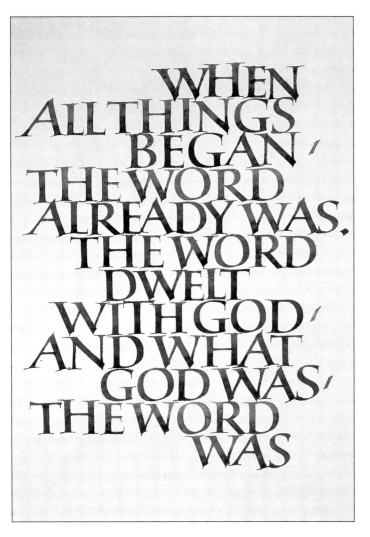

handling of calligraphy, and he doubts whether the current mass movement is really conducive to that aim, believing that as long as a doubtful level of taste is predominant, calligraphy as an artistic form will not be recognized. The actual quality of form should be paramount and where this is not so, a pseudo-art is being falsely admired, degenerating into 'commercial art illustration', while the actual quality of letterform itself is neither considered nor appreciated.

Werner Schneider believes that the word 'calligraphy' itself places it amongst the fine arts, and that from its original meaning it can be likened to playing upon a very fine instrument. There is a parallel between music and calligraphy as fine art. Depending upon the arrangement of notes — here the content of the text — the language can be interpreted individually by means of this

medium. Visual form corresponds to word-content and individuality finds its most dignified expression in the handwritten word. However, Werner Schneider believes that in the West calligraphy is still denied the recognition it enjoys in the Far East, where particularly in China and Japan, it represents the highest level of artistic expression. It should be the primary task of calligraphers to preserve the high level of Western writing which has lasted for two millenia: the Roman letter, used in conjunction with the Humanist minuscule, forms the basis of the development of Western writing and offers the best academic material for writing exercises.

As we approach the third millenia, it is important (in addition to preserving the historical treasure-house of letterforms) to apply new methods in a changing-media world.

When all things began…
Written with a wooden stick in watercolour on Ingres paper.

Italics *written in Chinese ink on Roma-Bütten with a broad metal pen.*

Rhythm is in harmony with nature and exists with manifold efficacy and form within all living creatures and within the phenomena of movement which surround us-in the regularity of our heart and pulse beats, in our breathing, or in the repetition of forms with like effects in plants of the same kind-everywhere we feel the rhythmical law of renewal. As a temporary phenomenon of a rule, in continuous change, we recognise lettering also as rhythmical form.

The flowing movement in writing may be compared to the undulation of waves of water. When we observe waves with their stronger and weaker oscillations, we have a full rhythmical experience. The observation of this movement can give us the completed film, but the single photograph showing only the rigid fragment of one event can never do so. So it is with writing: the writer has the rhythmical experience whilst the beholder of the written matter can only guess at the vivacity of the letter strokes. An attempt to draw the movement of the wave results in the wavy line. By circumscribing the up and down movement of the mountains and valleys of the waves we get the rhythmical experience. But if we draw in such a way that the mountains and valleys in the waves harmonise exactly in their reversed form, then the vivid impulse of the movement is destroyed, and is replaced by a mechanical form.

These explanations as to the nature of rhythm clearly illustrate the immense value of the hand-written letter as against the designed form, for no designed form or type-set line can bear comparison in rhythmical strength with the aspect of the written line. Though, to be sure, we notice in type-set letters a certain harmonious effect, given by the proportional balance of spaces, yet the rigid repetitive effect of absolutely equal characters cannot give to the whole appearance the liveliness of rhythmical undulations. Just as in the fine arts, spontaneity appeals to us more strongly than the composition which is deliberately constructed, so lettering written freely with feeling takes precedence over any designed form of lettering.

WALTER KÄCH - RHYTHM IN LETTERING

Calligraphy pieces *Created especially for this book; written in Indian ink on Ingres paper with a drawing pen.*

Cover design for Notentifel; layout created with Redis pen.

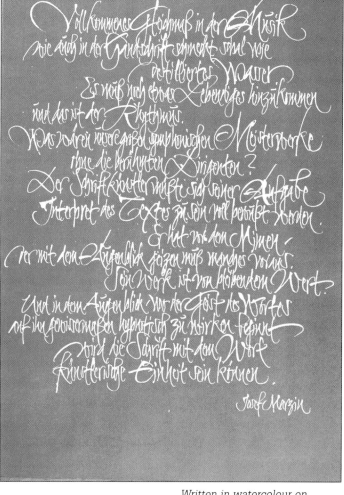

Written in watercolour on Roma-Bütten paper with a Redis pen.

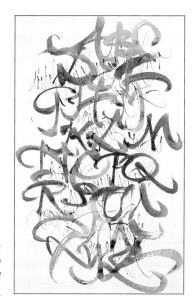

Alphabet *This was written with Chinese ink on handmade paper with Redis pen and brush pen.*

Written in Chinese ink on Japan paper with Redis pen and brush pen.

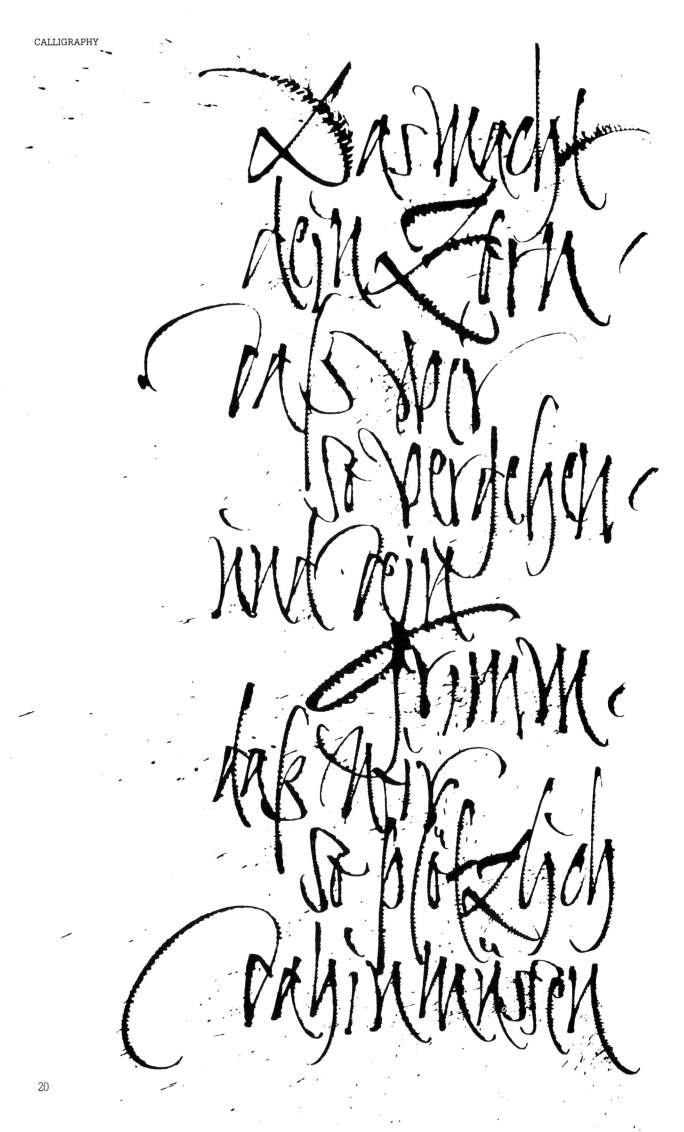

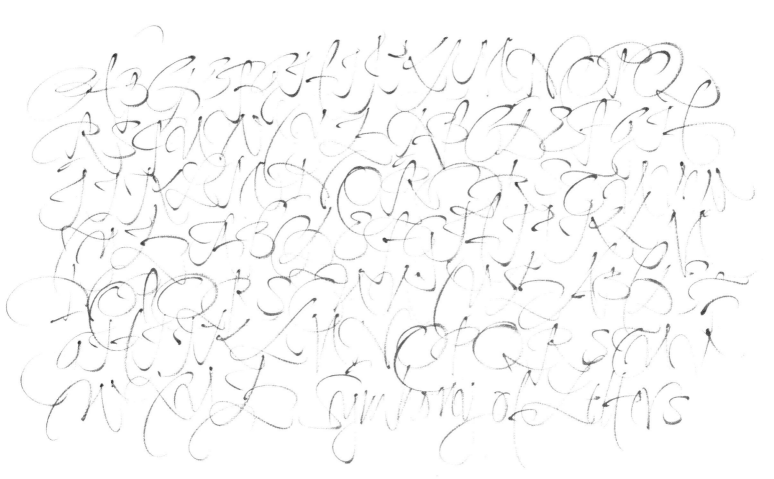

Werner Schneider's opinion is that a start could be made by exploring more expressive and spontaneous calligraphy. For example, calligraphy can be used as a contrasting element to typography, thus imparting a liveliness to type which can suffer from sterility in today's technological perfection. Calligraphy also helps to make the message to the reader more qualitatively attractive. Both the future potential and range of application of progressive calligraphy offer exciting possibilities in the years that lie ahead.

There is, more than ever, a necessity to promote writing, the conscious application of artistic design, and typographic standards. The preservation and cultivation of letterforms presents an immense challenge. We must aim to preserve one of the most significant inventions of mankind — writing at its highest level.

The Western development is almost exclusively a product of the broad-edged pen. Different broad-edged writing tools will create differences in letterform as well as the material on which the letters are written. Werner Schneider's basic writing tools are the broad-edged pen, the wooden scraper and the broad-edged brush, while watercolour and paper influence the result.

In contrast to this he is fascinated by the more immediate modes of delivery, and to achieve this will use unconventional tools and techniques as long as these methods are compatible with the interpretation of the text and will achieve the desired aesthetic quality.

He believes there is hardly a topic which cannot be a suitable subject for experiment, for the visual adventure of obtaining correspondingly semantic qualities from different texts.

The magnificence of calligraphy, whether in static, dynamic or expressive mode, holds for Werner Schneider, a fascinating, creative and hence real artistic dialogue.

Calligraphy This has been written with a Mars graphic pen on to handmade paper.

Calligraphic logotypes Made for a cover design with Redis pen and broad pen.

Matisse Written with brush pen and watercolour on handmade paper.

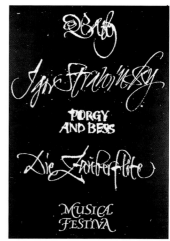

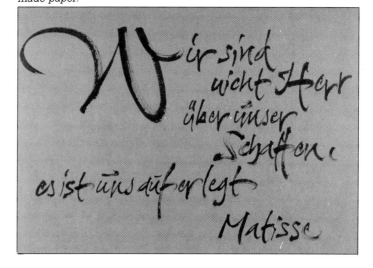

Leonid Pronenko

'My method is to launch myself intrepidly into the complex world of composition and technical manœuvre like a boxer in a difficult but absorbing contest.'

Leonid Pronenko was born in December 1939 in a village in Southern Russia near the Black Sea. Within a few months Russia was at war; his father, whom he never knew, was killed during the defence of Stalingrad; his Uncle was burned to death in a tank; and so he grew up the only male in the household.

By nature, he regards himself as fairly imperturbable, and cites the instance when a near miss from a bomb blew out all the windows of his family home, scattering glass fragments all over his cot, and the future calligrapher Leonid Pronenko remained fast asleep! He went to school in a small town on the Asov Sea and by

his own admission was a poor student. He left to take a number of menial jobs before serving three years in the army. Evidently this experience was beneficial, for he explains, 'I then became a little cleverer.'

He took his degree at the Faculty of Graphical Art at Kuban State University and upon graduation was given a position in the faculty of Decorative and Applied Arts where he still works as a lecturer.

It was not, however, as a student that he encountered calligraphy in any meaningful sense — rather the reverse. He was completely indifferent to the art of scriptwriting, caused no doubt by being expected to

Quotation from William Morris Flat felt-tip pens have been used for the colour and the calligraphy done with a broad pen and gouache.

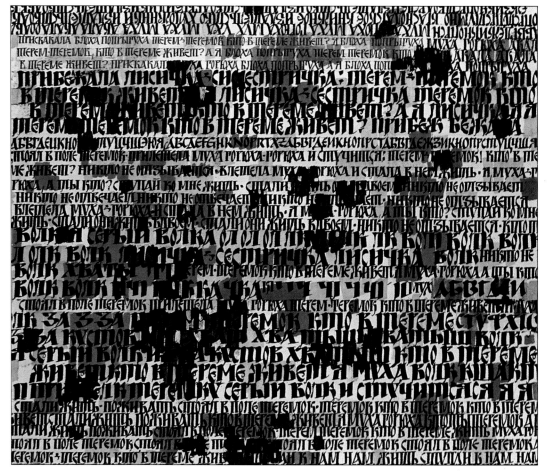

Russian Fairy Tale This piece was created with broad pens, using felt pens for the areas of colour.

write everything in a narrow grotesque' with a poster pen. This particular problem was simply overcome by handing in someone else's work!

It was some five years after graduation in 1975 that Leonid Pronenko chanced upon Villu Toots' book *Contemporary Script*. From then on, he realized that there was 'nothing more beautiful than handwritten letters', and set out to teach himself calligraphy. To be a self-taught calligrapher is never easy but in Leonid Pronenko's case it was made particularly difficult by a rare affliction which causes a spasm in the right arm when he writes, and his creative career has been a constant struggle against this problem.

Although initially self-taught, he has more recently studied as a post-graduate student in the Art Institute of Tallin in Estonia under Professor Paul Lukhtein and has worked there with Villu Toots. In 1983 he became a Member of Artists of the USSR.

Leonid Pronenko's work seems at variance with his own assessment of himself as 'fairly imperturbable' Never lacking inspiration, he will attack a sheet of magnetically clean white paper with pen or brush without, he declares, any method, literally not knowing how to follow his first letter or line: 'I rely on instinct and allow my hand to do everything which seems appropriate. I have no method,' he declares.

Leonid Pronenko works under extemely difficult cirumstances in a small two-roomed flat which he shares with his wife and daughter, both artists. The vigour and verve of his work starkly contrast the circumstances in which it is created.

Earthquake in San Francisco
Created with a flat brush,
using gouache.

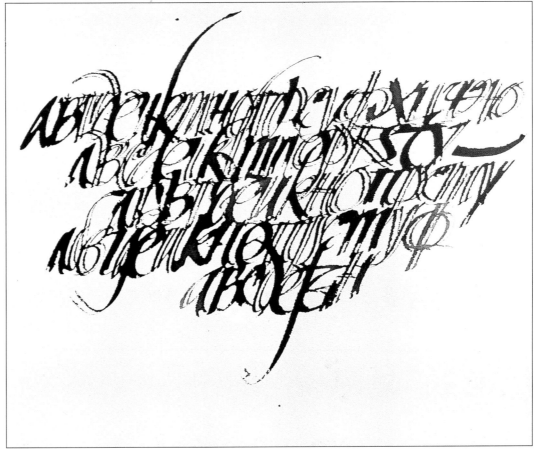

Composition 1988 This calligraphic composition has been created with a broad pen and ink on paper.

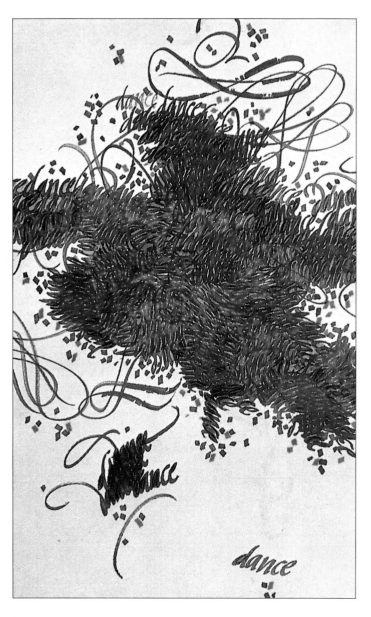

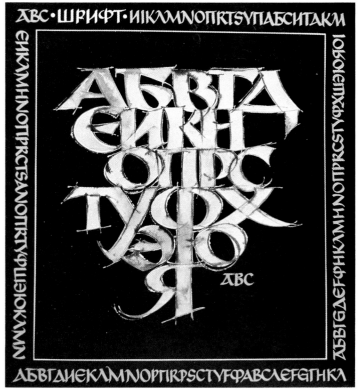

Composition 1985 Simple
bold use of mixed media, this
piece was made with broad
pens, flat brush, watercolour
and gouache.

Dance 1 An exciting piece of
calligraphy, using flat felt pens

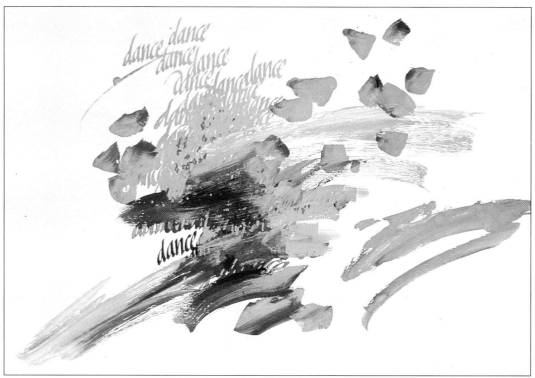

Dance 2 Created with broad
pens, flat brush and gouache.

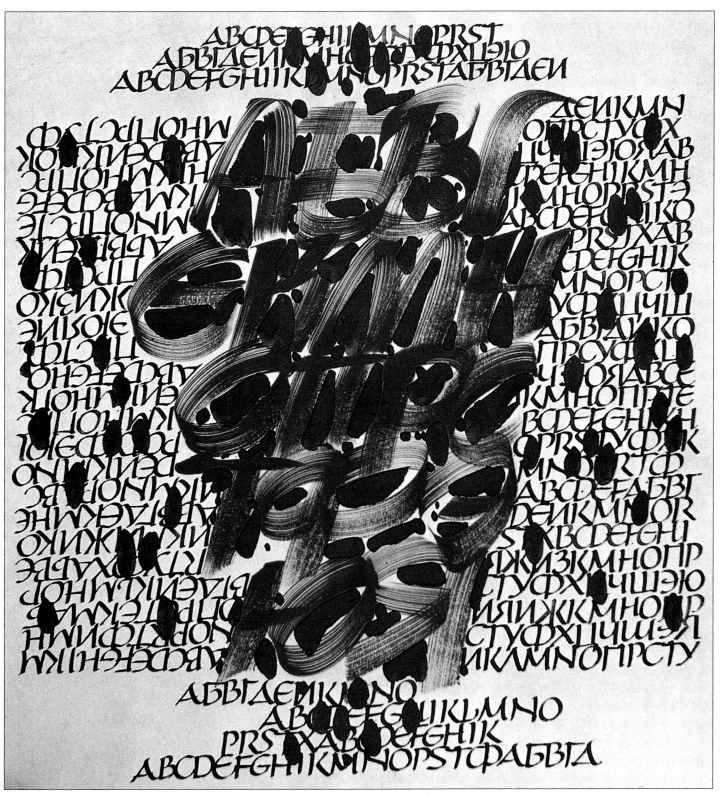

Composition 1990 A piece
created especially for this book,
using the broad pen, flat brush
and gouache.

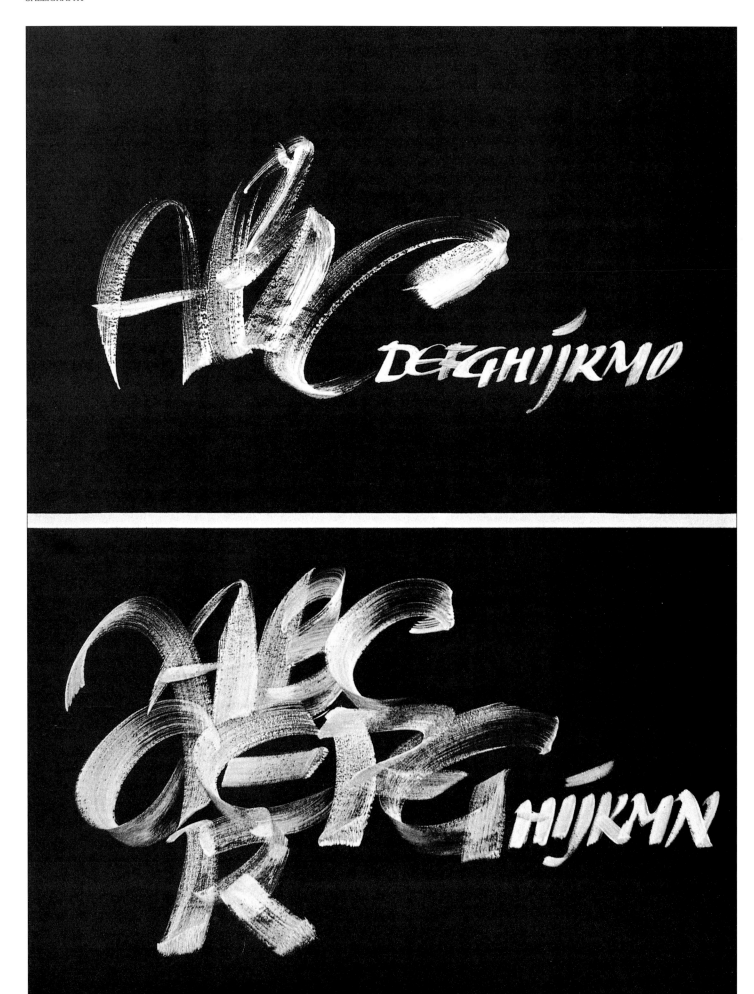

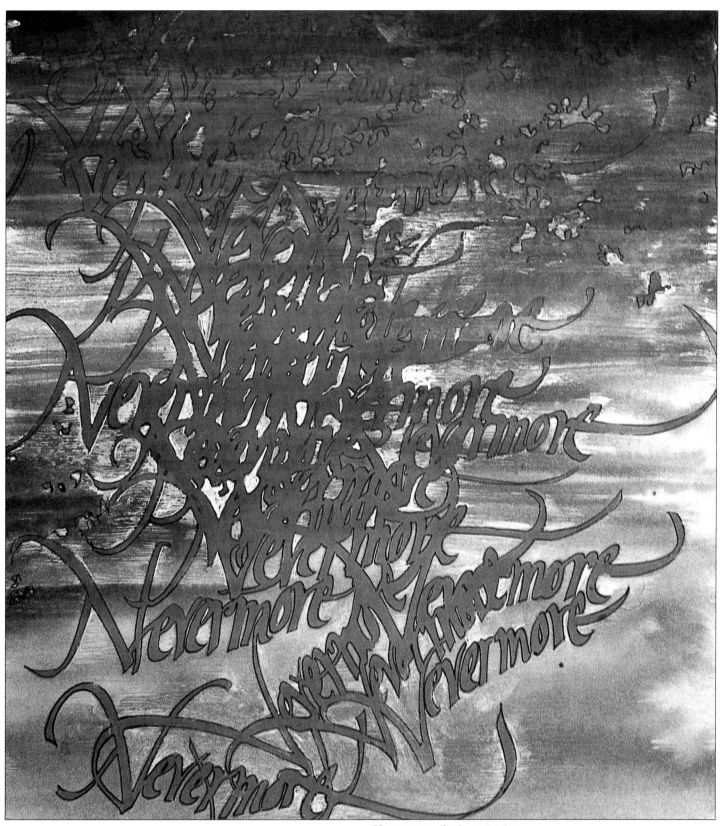

Nevermore *'I rely on instinct
and allow my hand to do
everything which seems
appropriate.'*

Composition 1989

Lorenzo Homar

'The study of letterforms is as important to me as the study of calligraphy, whether in relation to typography or to fine art. For me, lettering is a great theme for painting, and I often practise it.'

Lorenzo Homar was born in 1913 in San Juan, Puerto Rico. At the age of fifteen he moved to New York with his family. By the time he was seventeen, he had decided that his future lay in the world of art, and to this end he studied at the Art Students' League and at the Pratt Institute.

As a youth, his experience was both wide and varied and included lettering for cafeteria placards ('Pie à la Mode 10 cents') in Manhattan. He was also an acrobat in a circus and it is reported that in his seventies he could still do cartwheels for the entertainment of the local children!

He worked for ten years as a designer of jewellery for the House of Cartier and it was as a designer that he first met Reginald Marsh, an American artist, with whose encouragement he studied printmaking with two of the leading experts of his day, Fritz Eichenburg and Gabor Peterdi.

The wide experience he gained in those early years is reflected in his multi-faceted approach to art later in life as an engraver, printmaker, illustrator and

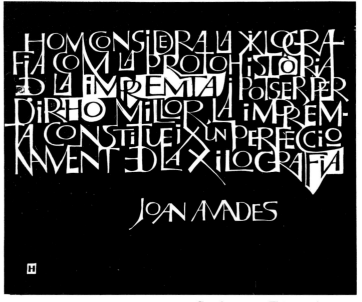

Catalan text *This text has been taken from Amades' book* 2000 popular Catalan woodcuts.

Acrylic painting on canvas.

caricaturist. But it is his original use of letterforms in which Lorenzo Homar makes his most distinctive contribution to painting and printmaking.

After the war, he returned to his native Puerto Rico with his wife, and together with José Torres Martinó, Rafael Tufiño and Félix Rodríguez Báez founded the Puerto Rico Art Center in 1950. In 1956 the Center received a Guggenheim grant and he subsequently became director of the Graphic Art Workshop of the Institute of Puerto Rican Culture.

In the small book museum, housed in a beautiful 18th century Spanish colonial building, the Casa del Libro, Lorenzo Homar discovered the historically and culturally vital tradition of Spanish penmanship of the writing masters of the 16th and 17th centuries, in particular the work of Juan de Ycíar (*circa* 1522-1573). In addition, the library also contained modern works by masters such as Eric Gill, Jan van Krimpen and Hermann Zapf. This exerted a powerful influence upon Lorenzo Homar and he adapted and assimilated the traditional elements into his work. The flourishing italics and the floriated versals held a particular fascination for him.

For many calligraphers, the starting point is the broad-edged pen or, occasionally, the broad-edged brush, and although Lorenzo Homar's work accepts their importance, the overriding emphasis is upon letters derived from the medium in which he is working, the joy of working with the counters of letters and playing with the spaces between them. Indeed, it might be said of him that he is more concerned with the patterns created in the spaces between the letters than with the letterforms, that he is working with negative space.

In fact, he has a certain reticence about styling himself a 'calligrapher'. Probably his nearest approach to the epithet

Typographic answer from Martin Furio to Galileo: epoch of the computer.
Inspired by the words of José Hernández:

'One is the Sun, one is the World (or universe).
Alone and unique is the Moon: Therefore you should know God created no quantity whatsoever.
The Lord of all Lords only formed unity.
The rest came about by man after he learned to count'.

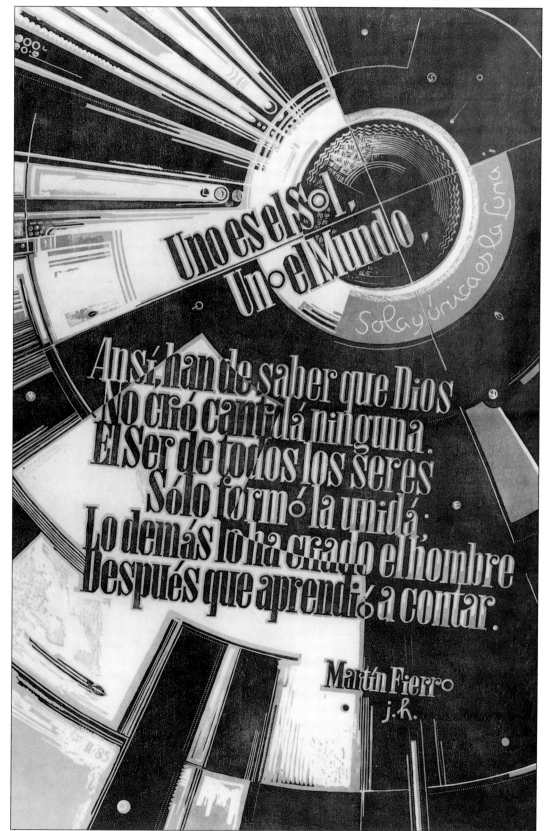

29

is 'a painter and printmaker who does calligraphy'. But within the definition of calligraphy as 'beautiful writing', who would deny Lorenzo Homar this accolade?

It is the design potential of letterforms and their creative possibilities, and the use of colour and abstract elements, which combines with his virtuosity to mark out so much of his work as distinct from, but complementary to the work of other calligraphers.

While enjoying the individual company of other calligraphers and students, his reticence keeps him away from the 'bunfights' and congresses attended by many calligraphers, and leads him also to reject the university atmosphere.

'After all', he says, 'look what it has done for fine art!'

His great joy was when he joined forces with Elmer Adler upon his retirement from the curatorship of Graphic Arts at Princetown, and together they created the Casa del Libro.

One detects that here is a man who had at last found his role in being at one with both the cultural and the social struggles of Puerto Rico during the last few decades.

His pioneering work at the Division of Community Education in San Juan and his contributions to the Institute of Puerto Rican Culture indicate the social commitment which is reflected in his work.

His reputation as an artist and teacher rests upon the excellence of his work and the demanding standards which he sets — both for himself and for his students.

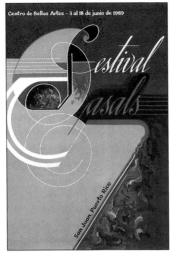

Festival poster 1989 *Printed in litho offset.*

The Spanish Alphabet
Based on a text cut in wood in the cloisters of a Toledo church.
35.5 x 36.6 cms
(14 x 10.5 inches) and somewhat resembling Frutiger's letters cut in wood.

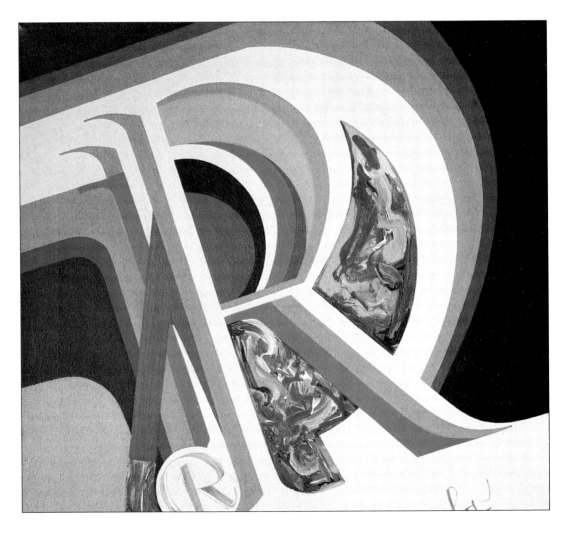

Acrylic painting on canvas.

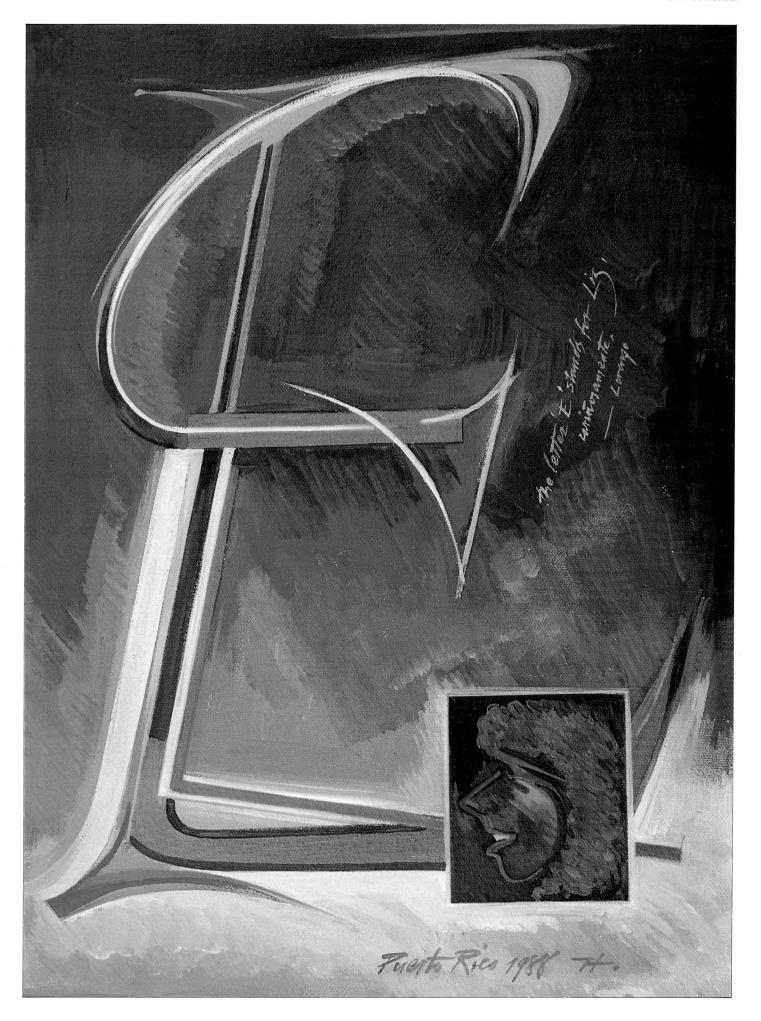

The letter L stands for L15, uniñquamente.
— Lorenzo

Puerto Rico 1988 H.

Charles Pearce

'Being a calligrapher has certain responsibilities which require one to be involved in all of lettering, whether it be brush lettering, sign-painting, lettercutting in stone or wood, commercial lettering or type-design.'

Penny Lane '*I end up with a piece of work in which, if one were to isolate any single square inch there would be something of interest to be seen in that small area*'.

Charles Pearce was born in England and received his art college education at Camberwell School of Art and Crafts in London during the early sixties. He was fortunate enough to have some of Britain's foremost calligraphers such as Dorothy Mahoney, Ann Camp, William Gardner and Donald Jackson as his teachers.

At this period, lettering and calligraphy were still very much part of the syllabus and students were taught to look at early manuscripts and analyse them in order to improve their own writing skills. Undeniably valuable as this experience was, Charles Pearce admits to being less than assiduous in this field of study, being much more interested in the work of present-day scribes than those of the past, and believing that modern calligraphers are far more aware of the shapes they are making than were their medieval counterparts. He likened the experience of the medieval scribe to that of sitting at a modern typewriter — with all the excitement of letter-form that engenders.

With the arrogance of youth behind him, he is now much more aware of the importance of historical manuscripts and, very significantly, believes that we sell ourselves short if we think we are not considerably better than they were.

'Just because a thing is old does not mean that it is good' he argues. He believes that perhaps less than ten per cent of surviving manuscripts contain good letterforms worthy of our serious study.

Charles Pearce believes that Camberwell School of Arts was the spawning ground of a second calligraphic revolution, being spearheaded by Donald Jackson's ideas and tutelage. Although the traditional work and training of the scribe remained much the same, (illuminated manuscripts, citations, rolls of honour, and so on) Donald Jackson understood calligraphy's potential to be so much more, and his students were encouraged by the use of mixed-media to experiment with a kind of calligraphy which had as much to do with painting as with writing. Another important influence on the youthful Charles Pearce were the painting and poetry of David Jones and his work with freely drawn Roman capitals.

After leaving art school, Charles Pearce moved to America where he spent eighteen months as Sydney Bendall's assistant, and he regards this period of cutting letters in wood and stone as one of the most satisfying and educational periods of his life, leading to the other great influence in his life, America — and specifically, Thomas Ingmire.

Although they met for the first time only in 1981, they were aware of each other's work and were able to experiment together at the Calligraphy Connection II in 1984. Charles Pearce believed that ideas which had been given birth at Camberwell twenty years before had reached maturity in the hands of Ingmire in his concept of making words and background into a cohesive work. One of the techniques for achieving this was to wash off

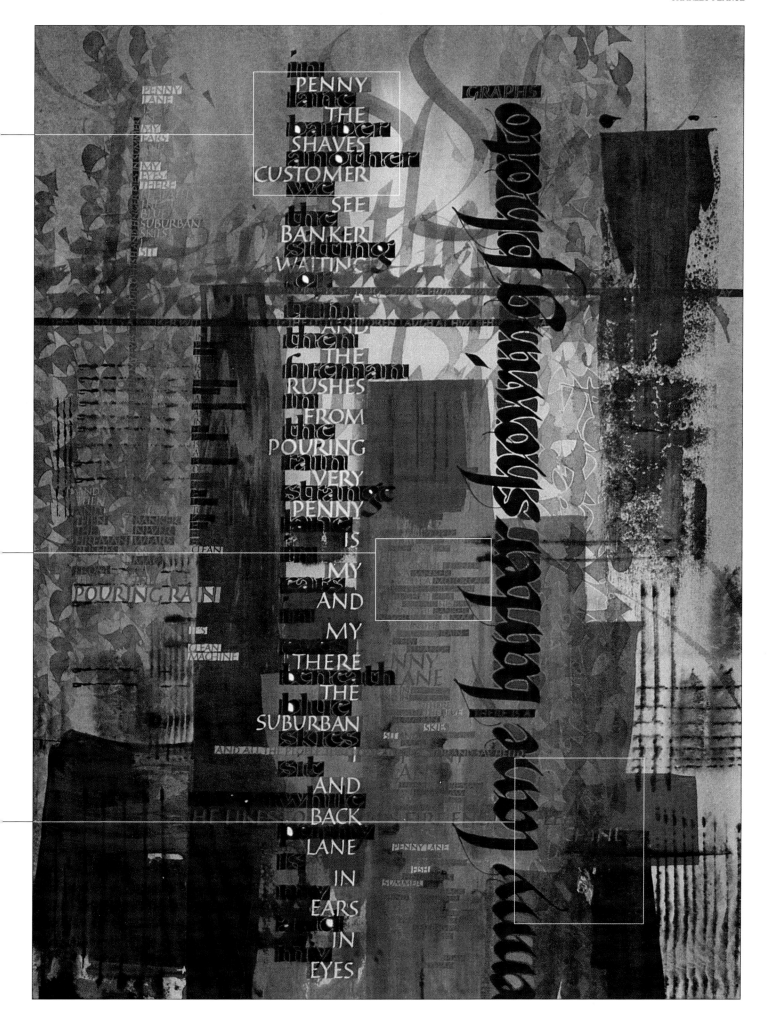

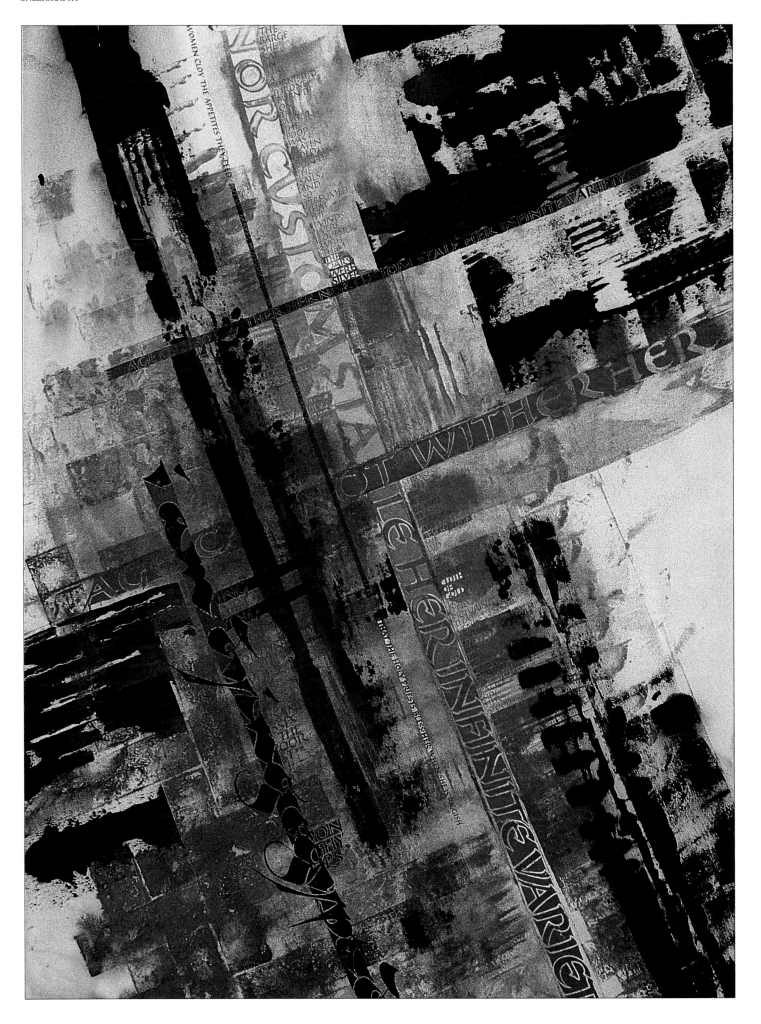

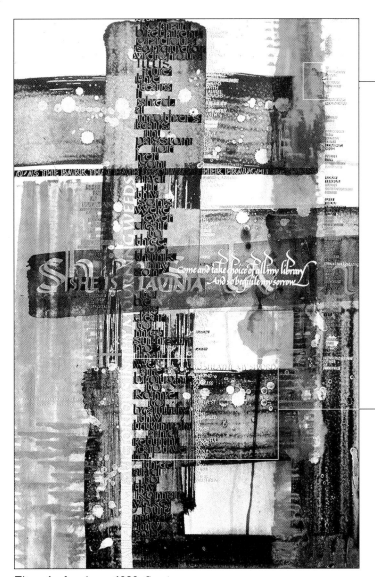

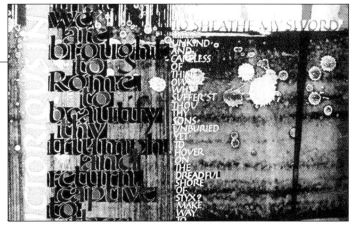

Titus Andronicus 1989 Sumi ink, gouache and shell gold have been used on Arches Hot Press. It measures 47 x 69 cms (18.5 x 27 inches).

the gouache after laying it down, leaving little more than a stain on the paper, the letters then becoming decorative in themselves rather than the traditional method of decorating and illuminating the letter in the medieval style.

That Charles Pearce is so generous in his acknowledgement of his influences should not lessen our perception of his very considerable talent. Indeed, in the agony of his personal artistic quest he became in 1986, in his own words, 'burned out'. We are fortunate that after a break of three years he emerged feeling renewed and invigorated.

Anthony and Cleopatra 1989 Gouache and gold leaf on Arches Hot Press. 47 x 69 cms (18.5 x 27 inches).

The work presented here is from a group of thirty-four calligraphic paintings based on Shakespeare plays and entitled *Expressions of Shakespeare.*

It places Charles Pearce firmly within the leading ranks of world-class calligraphers.

Charles Pearce believes that creative people in any field can be divided into two groups — the intellectuals and the instinctives. The intellectual, in the graphic arts, is the person who gives much careful thought and consideration to his work, perhaps producing many roughs, and is then able to translate all of that effort into a finished piece while still maintaining considerable verve and freshness. The instinctive, on the other hand, will see a piece of white paper and, deciding that it needs instant improvement, will jump headlong into doing just that.

Talking about his personal way of working, he finds himself in the position of having constantly

to 'save' his work. He finds that whatever piece takes his fancy will suggest a colour and maybe a shape, and he starts with that. Once having laid down the principal shapes or swatches of colour, he washes most of that off in the shower and is then left with a number of controlled 'accidentals' which suggest the next step.

With this gradual build up of calligraphy and painted areas, he ends up with a piece of work in which, if one were to isolate any single square inch, there would be something of interest to be seen. He hopes that people will look at his work in two ways — first as a cohesive whole, and then, on closer inspection, at the very small pieces which go into the makeup of the whole and which should prove equally interesting and satisfying.

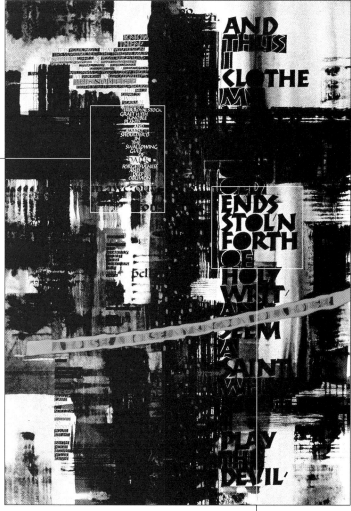

King Richard III 1990
Gouache, watercolour, Sumi
and waterproof ink have been
used on Arches Hot Press.
47 x 68.5 cms (18.5 x 27 inches).

'Modern calligraphers are much
more aware of the shapes they
are making than their medieval
counterparts.'

King John *1989* Gouache, watercolour, Sumi ink, gold leaf and shell gold on Arches Hot Press. 47 x 68.5 cms (18.5 x 27 inches).

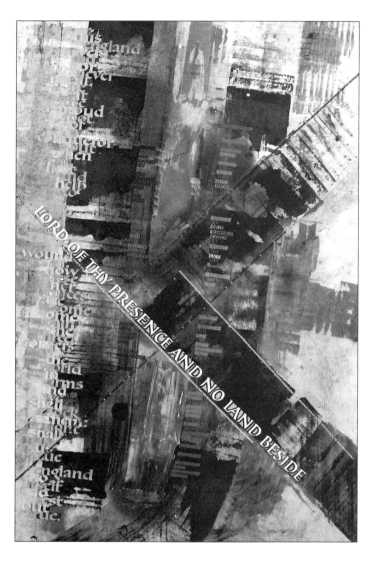

The Comedy of Errors: detail *1989* Gouache, watercolour, Sumi ink and gold leaf on Arches Hot Press.

Strawberry Fields forever: detail *1990* Gouache, watercolour, white and yellow gold leaf on Arches Hot Press.

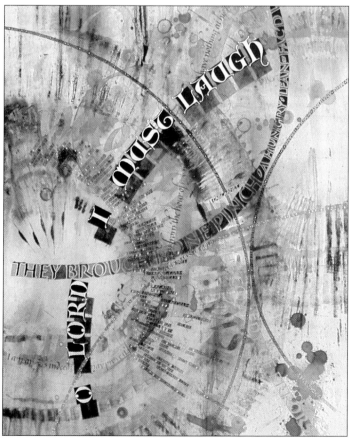

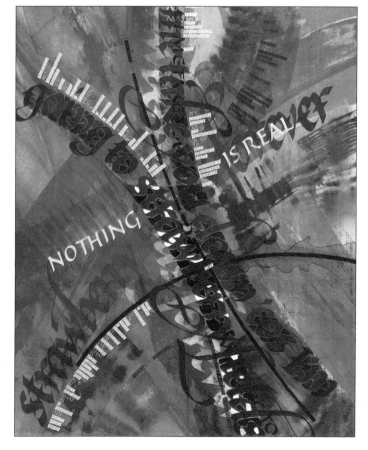

Julian Waters

'I look at lettering as a huge palette which includes calligraphy, type forms, and everything in between. The colours of that palette can be mixed into an infinite variety of blends.'

Julian Waters was born in England in 1957. His parents were Peter Waters and Sheila Waters (who is also featured in this book on pages 80-85). Both his father and mother studied at the Royal College of Art in London under one of Edward Johnston's most distinguished students, Dorothy Mahoney.

Superficially the style of his work may not seem to reflect this traditional background but many of the principles of solid English lettering tradition, together with a sense of taste and craftsmanship, have filtered down to him. His calligraphic training started with studying and copying historical styles but today he is interested in doing work that is very much of the 20th century.

He usually begins by designing loosely with a fibre-tip pen to quickly get ideas down on paper, thinking not in terms of a particular historical style, but more in terms of the visual flavour: light, dark, soft, hard, rounded, angular, and so on; whatever he thinks will best reflect the subject matter. At some point he decides on the line quality and will experiment with different tools and different surfaces to achieve the effect he is seeking. When he is really stuck for ideas, he may go back to historical sources. This often turns out to be the most useful approach, particularly when a period flavour seems most appropriate.

Apart from doing general graphic design work, most of his time is devoted to calligraphic and typographic lettering for print, for applications which include logotypes, headlines and titling for posters, advertising, books and magazines, signage, and so on. Although he also designs with an Apple Macintosh computer, eighty per cent of his work is still done with a pen, brush, ink and paper. He is one of the younger contributers to this book and it is interesting to note the fluency with which he will embrace modern technology, most particularly the way in which he will use it as his servant, keeping as much control over a computer as over a drawing instrument.

Occasionally he does original calligraphy for his own enjoyment or for exhibition but finds it is difficult to allot proper time for it when his desk is always full of commercial work and his friendly clients are constantly breathing down his neck and fax lines! Given the opportunity, he enjoys doing more spontaneous work because it is so much in contrast to much of the very pre-planned, designed lettering for publishers, design studios and agencies.

Wildlife America Book 1987
While I enjoy writing long calligraphic texts I am more stimulated by the __design__ aspects of lettering, especially the possibility of interpreting different emotions or subjects by using different styles, tools and materials. My ideal might be to develop a new and totally different style for each job because each should have its own personality. This book seemed to be tailor-made for these aesthetics. The United States Postal Service publishes special books which contain and complement their large and commemorative sets of stamps. Wildlife America was a set of fifty stamps, each depicting a native North American animal or bird. The accompanying book showed a reproduction of the stamp, a description of each animal or bird with some remarkable and beautifully printed wildlife photography. My job was to design calligraphically each of the fifty names, cover title and section headings.

Initially, I thought it best to keep __one__ calligraphic style thoughout the book for continuity but as I started working on the first few, I simply could not resist the temptation to vary them. With the page layouts and wild-life photography in front of me I tried to capture the essence of each animal into my calligraphy and, with few exceptions, the ideas came quickly. With some projects you can do dozens of roughs and they can all lack any real spark. But with Wild-life America everything just flowed beautifully. For each title I would make one or two quick sketches and then go straight to the final pen and ink rendering, with practically no need for retouching. Each title became like a little logo. I think the final lettering gives the reader a whole new level of visual play as one looks at the text, stamps, and the animals.

I always look back at this project with fondness.

AUDUBON

Endangered Planet Calendar 1991

WILD ANIMAL CALENDAR 1991

Wildflower Calendar 1991

SEA LIFE CALENDAR 1991

Wild Bird Calendar 1991

NATURE CALENDAR 1991

Audubon Wall Calendar series Macmillan Publishing asked Julian Waters to redesign the titling for the six Audubon wall calendars. This had been purely typographic before and Julian Walters felt that 'it looked a little generic and at large sizes lacked detail and serif definition.' He sought a more sophisticated look, with the same kind of finish as type but with greater thick-thin contrast, letterfit and attention to detail. He hoped to develop six distinct styles to reflect the themes: Wildflowers, Endangered Planet, Sea Life, Nature, Wild Animals and Wild Birds.

'I first did the Audubon name in capitals, to be used as a logo on all of the calendars, and then launched into the rest of the lettering. In addition to the six main titles of the calendars I was responsible for the seventy-two separate month names. Over the past few years I have developed alphabets and partial alphabets which have grown out of various lettering projects and book jackets. I was able to use these as the basis for some of the calendar titling styles. Much of the finished lettering falls somewhere between calligraphy and typeface design.'

Bill of Rights Stamp 'In 1988 I was commissioned to design the lettering for a special United States postage stamp commemorating the Bill of Rights. It is unusual for a United States stamp to incorporate hand lettering and also for such an abstract and graphic looking design to be approved. The lettering was roughly laid out with a felt tip, then written with a flexible copperplate nib, and finally enlarged, carefully rendered with a pointed brush and retouched with gouache. The lettering had to hold up at both the tiny size of a stamp and at larger sizes for the posters.

'A year or so after the stamp was issued, the Commission on the Bicentennial of the United States Constitution asked me to design a logo and catch phrase: The Bill of Rights and Beyond which would be used on all kinds of promotional materials. Rather than try to imitate my lettering for the stamp, I decided on a more splashy, modern calligraphic treatment which would include the motif of a quill pen. I wanted the calligraphic illustration of the pen to carry the same weight and line quality as the calligraphy, since all the parts would always be used together, whether in one, two or more colours. The hairlines were kept fairly thick so that the logo would reproduce well in small sizes.

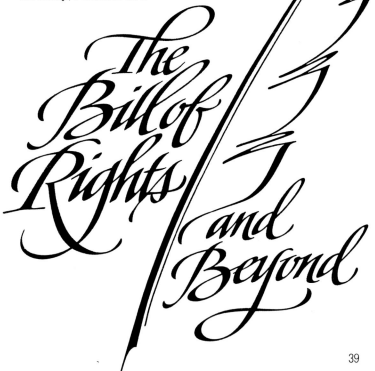

Textures Series: Rudolf Koch quotation In 1988 the San Francisco Public Library commissioned Julian Waters to do a piece with no brief other than saying that he could do whatever he wished! After a few months of not settling on any one particular idea, he decided to take a text, treat it as a pure pattern or texture, and do variations on a theme.

'At first I rapidly churned out the quote in different styles to test textural ideas, packing the writing line to line. Many of these experiments involved alternating weights to create an even unevenness in the texture. At some point I took a very small pen and wrote the quotation in tiny capitals and repeated it ten more times underneath, creating a very even, grey texture of lettering with no word spaces.

'This texture was the building block for a series of monoprints printed on different 28 x 43cm (11 x 17 inches) papers using my Minolta zoom copier. Some of the sheets were fed through the copier as many as twenty times to lay the writing texture over itself in different juxtapositions. The three-dimensional build up of toner ink on paper was especially interesting.

'I next made a copy of the original texture and filled in the spaces between the letters with black to create a new random pattern of simple positive and negative shapes.

'The quote was made up of seven distinct phrases which I left unfilled as they recurred each time down the text block, allowing the quote to be read if one took the trouble. They also created a contrasting random element breaking up the monotony of the text.

'This new texture became the basis for a second set of monoprints. In both sets I applied metallic heat colour transfers to the toner printing which showed up particularly well on black paper.

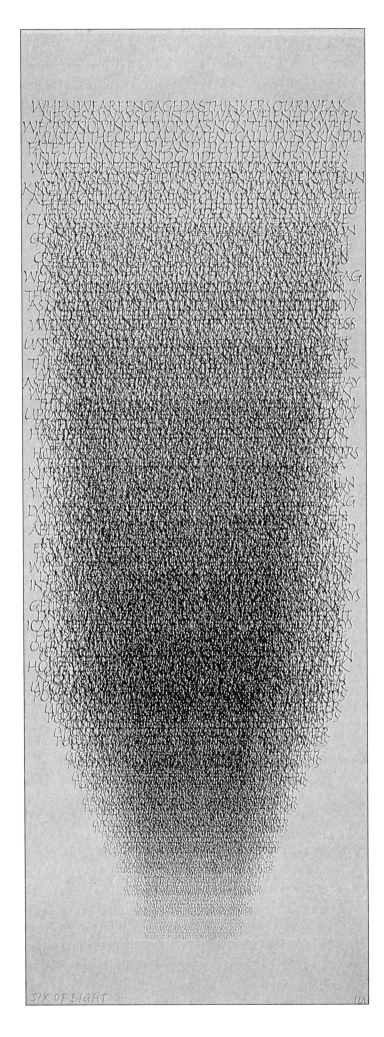

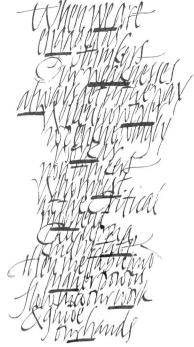

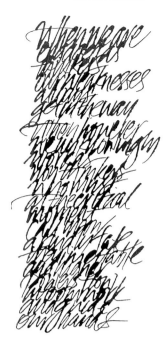

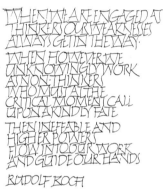

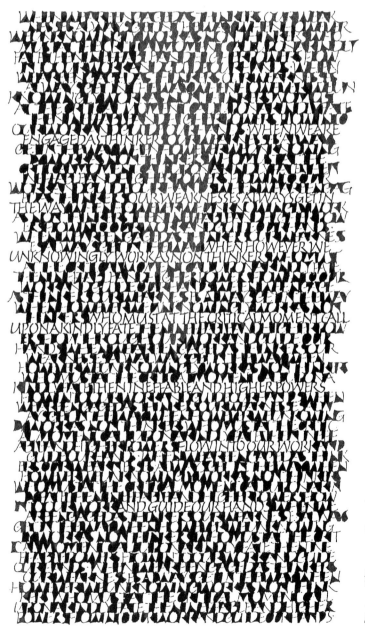

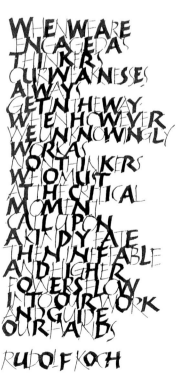

41

'Q' logo for Bell Atlantic
Increasingly, logos and lettering are being rendered with drawing programs on personal computers. Once drawn in Postscript outline form with programs such as Aldus Freehand or Adobe Illustrator, a design can be manipulated, printed in different sizes and stored digitally within the computer for future use or manipulation. The 'Q' stands for Quality, and the client — a national phone company — wanted a fancy decorative design which would be used on various printed pieces, most of which were being designed using Macintosh computers. First I made some sketches by hand, until I arrived at a satisfactory arrangement. A fairly careful ink sketch was scanned in and saved as a 'template' over which I could carefully render it on the computer as smooth Bezier outline curves in the Illustrator program. Using

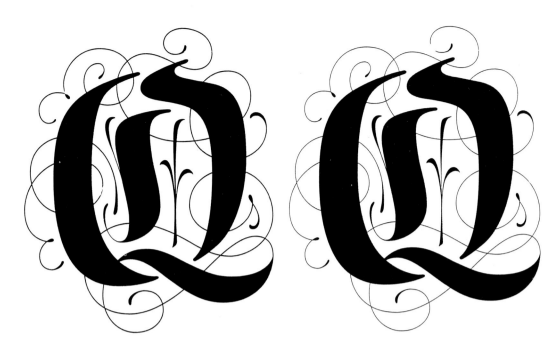

the computer simply means you are picking up a different tool, which influences the marks you make. Sometimes it is difficult to draw just the right curve which you have in mind, just as it can be when using French curves. On the other hand, a benefit of drawing this 'Q' on the computer was being able to test different line weights for the light hairline swashes. I ended up giving the client two versions: one with heavier hairlines for reproduction in small sizes and another one with lighter hairlines for large sizes. To draw these two versions by hand with extreme edge smoothness would take much longer. In addition to a smooth high resolution print out, I also handed the client the design on a floppy disk.

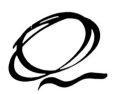

 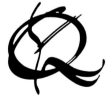 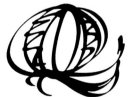

'Q' logo for designer Susan Costa *Coincidentally, a couple of months after doing the Bell Atlantic 'Q', Susan Costa asked me to design a logo for her new design firm, once again a 'Q' standing for Quality. Some of my ideas were worked out on the Macintosh, but Susan's favourites were done very spontaneously with pen and ink. I am showing some of the several dozen trials here. At this time of writing we have not decided which one is best, and she may actually prefer to use a different 'Q' on each of her printed pieces.*

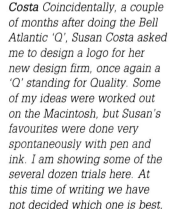

Littera Scripta Manet 'This piece began as a spontaneous exercise of writing Roman capitals in watercolours. Using a large handmade brass poster pen I started the alphabet in the middle of a page and spread out towards the margins at random, sometimes over-lapping when the spaces or shapes seemed to require it. Using a fairly limited palette, the letters were built up very carefully in multiple direct strokes. Some of the uprights and curved shapes were double stroked and the colour blends were achieved some-times by loading the pen with more than one colour at a time, sometimes by watering down the colour and sometimes by dropping colour into a stroke, wet in wet … all very much done in the moment, not with preliminary colour studies.

As I went through the alpha-bet, visualizing where the next letters should be placed, I decided to make a very short piece of wording as a contrast: Littera Scripta Manet *which loosely means 'Letters made by Hand.*

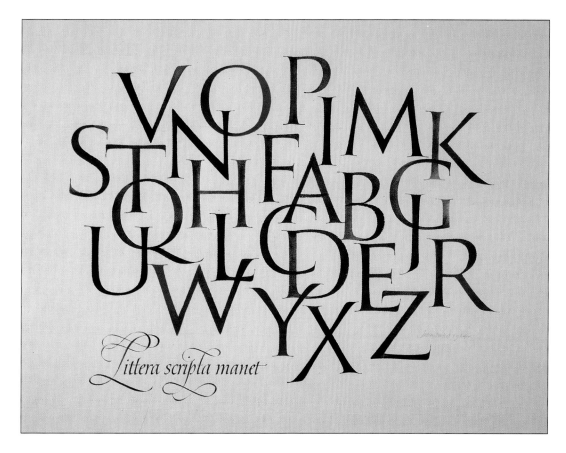

Every Day… 'This piece was a birthday gift for my mother and the black writing was done spontaneously, without prelimi-nary layouts, using an old-fashioned ruling pen and stick ink. The ruling pen was held on its side at a shallow angle to the paper and the writing was done using the whole arm. The big fat initial was done with the same pen as the rest of the text. This tool and tech-nique can give the writing an unusual accidental quality.

The pattern of condensed letters was randomly inter-rupted by using wider closed forms, for a feeling of excite-ment. The colour was applied in gouache with my fingertips.

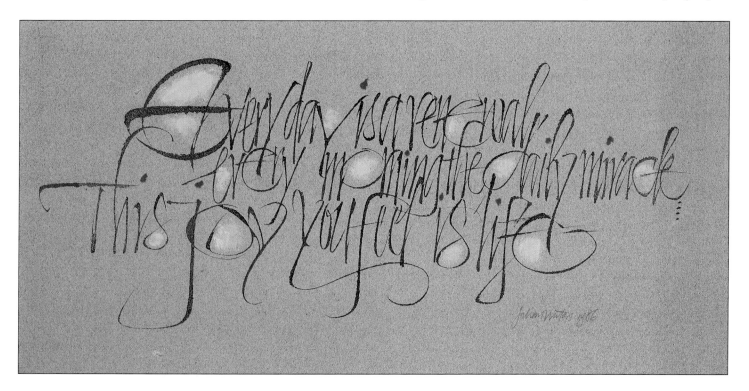

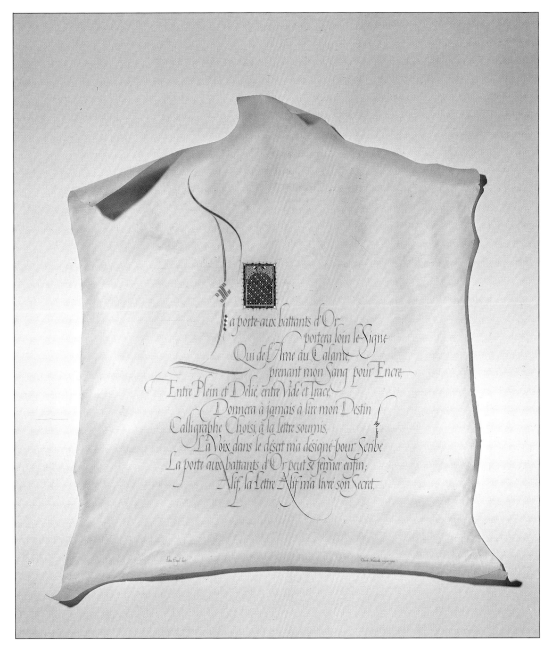

The Scribe, a poem by Lotus Engel Written with a turkey quill on parchment, the red colour is cinnebar (red mercury sulphide), the gold applied is gold leaf and shell gold. It is to be noted that he used a brush with a special point prepared for miniature.

'If we want to realize a serious miniature, we must observe some definite rules. Most of the miniatures illuminated by modern artists are caricatures and look slightly affected and kitsch. The reason for this lies in the weakness of drawing, and ignorance of geniune pigments. It is still possible to obtain colours like indigo, azurite, lapis-lazuli, smalt blue, tournesol, malachite and munium. If these conditions are not respected, we cannot call this work miniature, but only illustration.

Claude Mediavilla — FRANCE

'Calligraphy is defined by harmony of forms and quality of proportions. Handwriting, on the contrary, needs legibility; therefore, legibility is not the main calligraphic criterium. Considering this, it is possible to develop a principle which involves a lot of possibilities.'

Claude Mediavilla was born in 1948 in Toulouse, France. He was a student there at the School of Fine and Applied Arts from 1965-71, where he studied printing, paleography and calligraphy. Upon graduation he was asked to teach at the

School of Fine Arts in Limoges. In 1975 he worked in Paris as a professional calligrapher and as a graphic designer with clients such as the President of France and the Minister of Culture. Then, in 1985, he was nominated expert to the Centre of Typographical Research at l'Imprimerie Nationale.

Perhaps one of the most outstanding things about Claude Mediavilla's work is its tremendous range. On the one hand we have the exquisitely drawn letters of the most elegant copper plate and the visual concepts and executions

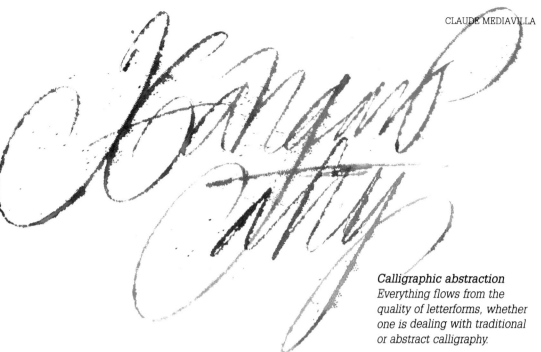

of logotypes for some of the leading companies in France, America and Japan.

On the other hand, we have calligraphy taken to its most abstract form, painted in bold brush-strokes on to sacking, paper, wood or sand — and executed with apparent ease and expertise.

The evolutionary progress from letterform to pure abstraction is clear: consider the abstract calligraphy painted in 1970, using conventional tools and materials, and those of 1987. The quill pen of the former has been replaced by a large tool but has kept within the strokes all the calligraphic elements and qualities with the addition of colour and texture. This demonstrates the skill required to keep the strokes within the spirit of calligraphic abstration. The progression between the two sets of work is clear and discernible but perhaps even more innovatory and revolutionary is the gap between the earlier piece and what, in 1970, were current calligraphic norms. For Claude Mediavilla, the rules which govern traditional and abstract calligraphy are the same:

'The key idea which we must bring out is the importance of the quality of letterforms. Everything flows from that. Whether one is dealing with traditional or abstract calligraphy, the criteria remain exactly the same — both forms of calligraphy are subject to the same 'laws'. Many people, calligraphers included, overlook this basic fact.

For an illustration of the principles involved in assessment of abstract calligraphy, see the How-to and Tools section.

Quotation from Jean-Antoine de Baif *Written with a reed in Windsor and Newton watercolour on rough Arches aquarelle paper. The author's name is written with a turkey quill.*

Calligraphic abstraction
Everything flows from the quality of letterforms, whether one is dealing with traditional or abstract calligraphy.

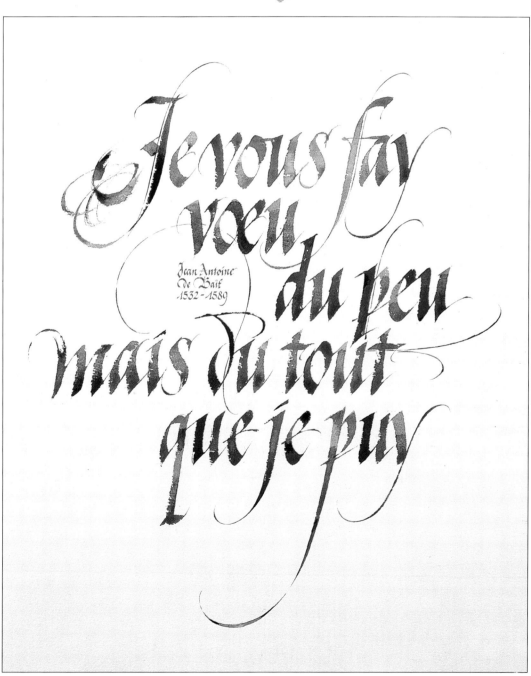

Jean Antoine
De Baif
1532 - 1589

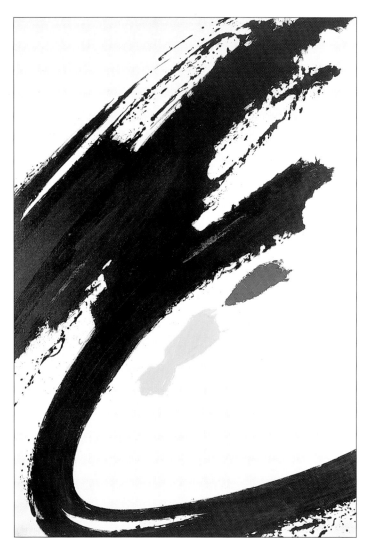

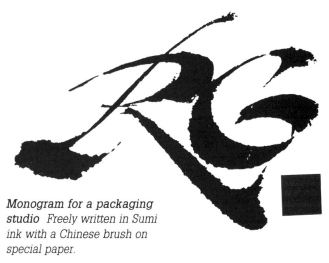

Logotype for a design studio
This was written in Sumi ink with a Chinese brush (a wolf hair brush).

Monogram for a packaging studio Freely written in Sumi ink with a Chinese brush on special paper.

Abstract calligraphic painting Acrylic on canvas.

Abstract calligraphic painting Acrylic on canvas
150 x 150cm (59 x 59 inches)

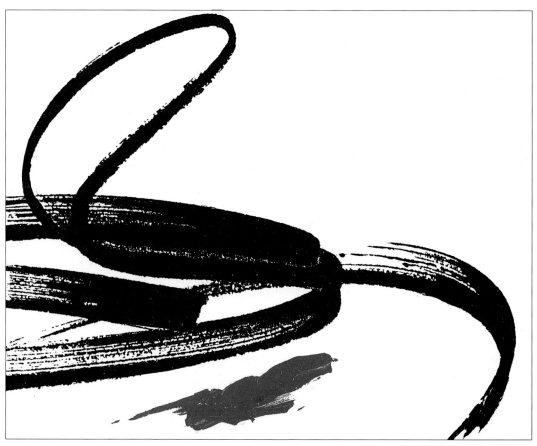

That there are divisions within the field of calligraphy and arguments between traditional 'copyists' and abstract expressionists is perhaps inevitable and unlikely to be resolved in the immediate future; in many ways it reflects the healthy state of calligraphy that such controversy exists.

Claude Mediavilla feels strongly that whereas calligraphy is a wide-ranging art form, the copying of text is a skill, an acquired craft and the two should not be confused. He is equally forthright on the subject of abstract painters:

'Hans Hartung and many others were inspired by the Leipzig school of calligraphy in the 1930s and later by the New York school [Pollock] which clumsily copied Western and especially Eastern calligraphers. The mediocrity of these painters was due to the inadequacy of

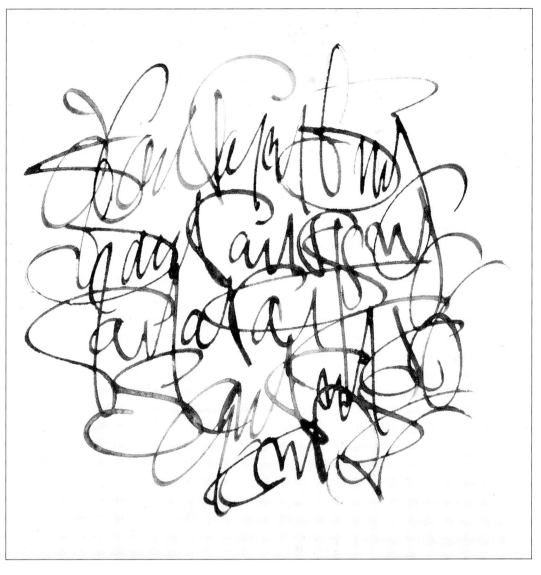

Abstract calligraphy 1970
Freely written with a goose quill in black watercolour. This work is considered to be central to his thesis in the sense that it represents a breaking point and a possible start for the future of calligraphy. Indeed, this is one of the first times we completely see abstract calligraphy.

'This piece has to be interpreted only as signs and forms, which is the real purpose of calligraphy. Only handwriting necessarily needs legibility.'

Title for calendar *Written with a reed in watercolour on Arches aquarelle paper. The author's name is written with a turkey quill. On this very rough paper, the reed pen easily allows long fine hairlines.*

their training in calligraphy which left them unable to deal with the problems of abstract art specific to calligraphy.'

Mediavilla is concerned that calligraphy is not given the same credence as an art form as is its Eastern counterpart but he believes this is in part due to the attitude of the calligraphers themselves, many of whom show a lack of understanding of their work and its inherent responsibilities:

'Without proper paleographic training they can neither write legible texts with elegance; nor can they research into abstract forms.' Only when this is finally appreciated will Western calligraphy attain the highest standards, cease to be a 'cottage industry' and take its proper place as an accepted and challenging art form.

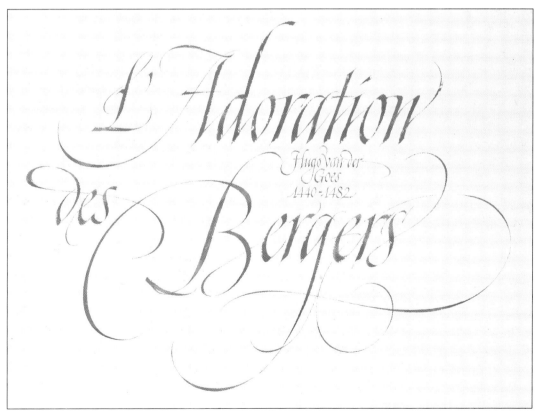

Karlgeorg Hoefer

'The furthering of calligraphy in our own time above all serves self-realization by developing man's creative talents. Calligraphy frees emotions and abilities which are hidden in the depths of personality. It activates the power of the soul.'

Karlgeorg Hoefer was born in 1914 at Drehnow in Silesia, and his career began at the age of sixteen when he was apprenticed as a typesetter. His understanding of calligraphy was self-taught although his discovery of calligraphy and letter-design began while participating in evening classes at Hamburg Technical College. It was Rudolf Koch's examples of calligraphy which provided his first delight in letters but the desire to study with the great master at Offenbach was not to be realized. Rudolf Koch died in 1934 before Karlgeorg Hoefer could begin his further studies at Offenbach.

The great English, German and Austrian teachers were a vital

source of inspiration — and Karlgeorg Hoefer still adheres to Edward Johnston's teaching:

'The letter craftsman will discover many ways of "playing" with letters, and of expressing — or concealing — names and numbers. In other words, he may take every liberty he chooses in his private pleasure provided he does not clash with public convenience.'

Moreover, Hoefer is sustained by Rudolf Koch's 'We are all drawing strength from the love and confidence of the few who understand us'.

Although Karlgeorg Hoefer owes many of his fundamental ideas in letter creation to such pioneers as Larisch, Schneidler and Trump, in his own work he is also a pioneer and innovator, ready to use and adapt any new writing material or instrument: the brush scripts he created with a pointed brush were fresh, exciting and virtually

Free calligraphy with a pointed brush.

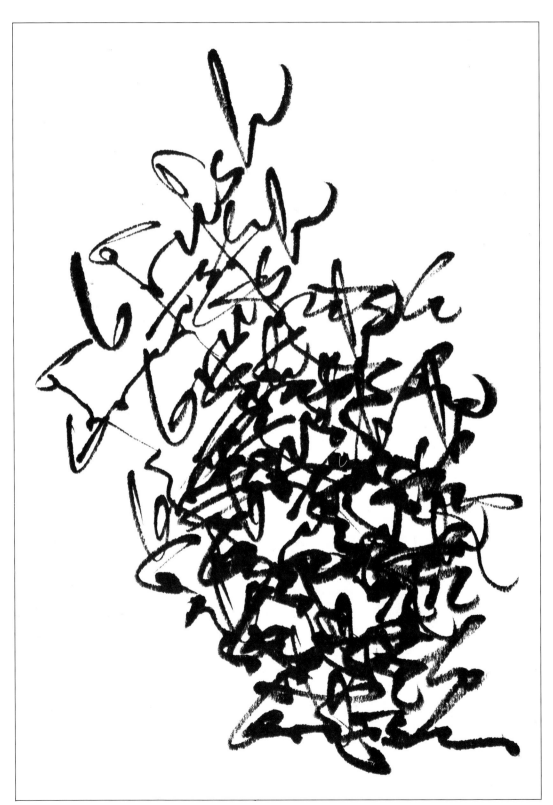

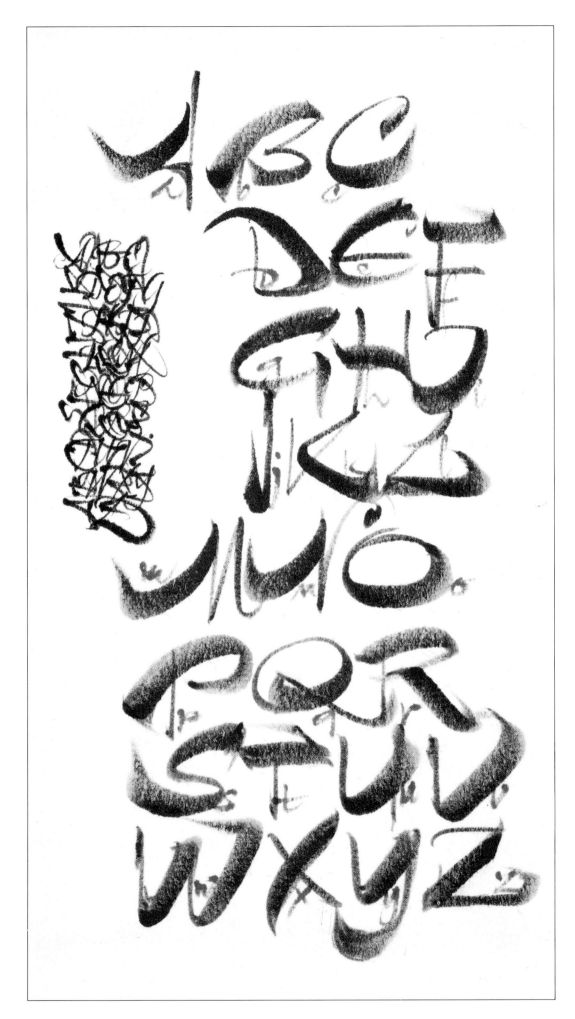

*Chinese brush alphabet
This was created with a
Staedler brush marker and a
Mars Graphic 3000.*

unknown in calligraphic circles when first encountered in the 1960s. He had already aroused much interest in 1952 when his Brause '505' pen was shown at the Hanover Trade Fair where it was an instant success. This pen allowed grotesque letters to be drawn with rectangular terminals as well as sweeping flourishes and hairlines and could produce even the effect of brush calligraphy.

His students at the School for Arts and Crafts at Offenbach, where he taught from 1979, recall the excitement he could engender among them with the use of writing materials. He would bring to the classes tools which filled most calligraphers with horror, from felt and fibre-tips to synthetic brushes. Perhaps underlying this is the simple concept that each tool and each material has an aesthetic potential for the calligrapher to discover and then exploit.

True to the Offenbach tradition, Karlgeorg Hoefer's explorations are all-embracing, working in textiles, wood, stone, glass, metal, concrete, parchment, leather and film. They ranged from writing with a flat brush on large surfaces, including church walls, to the minutia of designing typefaces.

Indeed, some of these typefaces sprang directly from his Brause 505 pen: Salto, Saltino, Saltarello and Monsun.

This multi-faceted approach to calligraphy and lettering is reflected in Karlgeorg Hoefer's pragmatic philosophy to his work. He will dip into his historical rucksack and, depending on the demands of the commission or the theme, his work will be constructive, intuitive, or graphic. Over the years he has amassed a considerable collection of sketchbooks filled with innovative writing which now forms a source reference for developing new ideas. It has been said of him that success or failure do not enter into his philosophy,

only exploration, discoveries and solutions.

This echoes his own personal philosophy which is based upon three favourite words: 'beginning', 'moment' and 'it'. According to Zen Buddhism: 'It is happening'. He says, '"It" amazes me, enchants me. Often I am only looking on as "it" is happening. One must always continue to make new beginnings; one must always act in the moment.'

For him, writing is not a question of tradition, restoring, setting an example, or excelling in imitation. It is coming to terms with the present and the future. He extends this idea to his dislike of egalitarianism and of uniformity, believing that these contradict the will of the Creator — who prevented the occurrence of an identical fingerprint in mankind!

Karlgeorg Hoefer has now retired from full-time teaching but his energy and passion for letters have not diminished. Since 1981 he has been giving calligraphy workshops in the USA and in 1982 he founded an open school for calligraphers, the *Schreibwerkstatt für Jedermann* in Offenbach. The Society is a non-profitmaking group of calligraphers whose activities focus upon the great German tradition of Rudolf Koch and the Klingspor Museum. There are now one hundred and forty members from fourteen countries, with evening classes, weekend and summer workshops taught by calligraphers from both Europe and America.

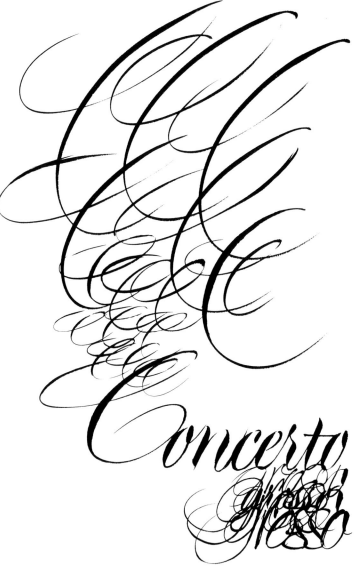

Concerto Created with a pointed brush.

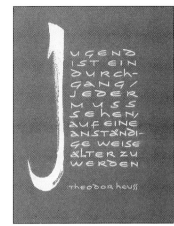

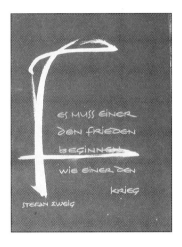
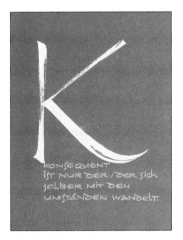
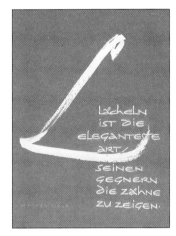
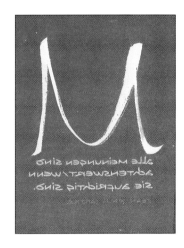

Twelve letters *Work with a pointed brush.*

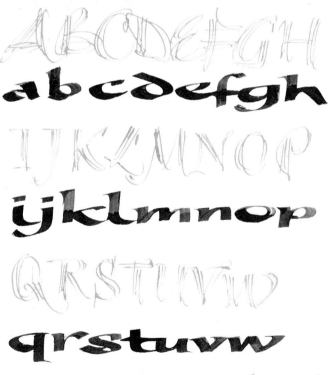

Musikalische Schrift-Etueden
*Created with his Brause 505
pen and a broad pen.*

Donald Jackson

'The process whereby man learned to embody his language in writing is one of the greatest miracles in the history of civilization and lies at the heart of his success as a species. Writing was how collective memory could be stored and maintained and information shared. It was a medium for story-telling and provided essential means by which men were able to build empires and administer them. At various times and places, it also assumed the quality of art, becoming an object of great beauty.'

Donald Jackson is one of the world's leading calligraphers and since 1964, Official Scribe to Queen Elizabeth II and the House of Lords. He is also a Fellow and past President of the London-based Society of Scribes and Illuminators, which is the world's premier calligraphic society.

Born in 1938, he went to Bolton College of Art at the age of thirteen and was a post-graduate at the Central School in London and Goldsmith's College, University of London. At twenty he was appointed lecturer at Camberwell College of Art. In 1964 he also became the youngest person to have an exhibition in the Victoria and Albert Museum. His current exhibition, now touring the world, is called *Painting with Words*. As well as all his work on the preparation of letters patent and royal charters, Donald Jackson is the author of the classic treatise *The Story of Writing* and co-author of *More than Fine Writing*.

Donald Jackson, probably more than any other individual, has been the catalyst responsible for the revival of calligraphy in the United States — from his first lecture there in 1968 and the many workshops and lectures he has given on the North American continent since then. At a packed lecture he held in Los Angeles in 1973, names were exchanged at his suggestion, and arising from this, the Los Angeles Society for Calligraphy was formed. This was again repeated in 1974 in New York, resulting in the formation of the New York Society of Scribes. In 1976-7 he was the Distinguished Visiting Professor of Art at the California State University.

Most people's first experience of attempting to make a mark with a broad-edged writing tool is a terrifying one. To look at the skills of a professional can be awesome, and the ability to express oneself in this way can seem beyond our reach. As a teacher, Donald Jackson is very aware of these problems and advises his students that the last thing they should worry about is how to express their personality in their work. This is something one cannot avoid.

Vellum. Executed in gouache and raised and burnished gold. 22.3 x 14.6cm (8.75 x 5.75 inches). Study of a medieval miniature representing the Nativity, 1957. Student copy of a 13th-century Sarum manuscript made while still at the Bolton College of Art. Copying has always been the basis of developing a visual as well as verbal vocabulary; painstaking imitation of medieval sources quite quickly led to a more modern use of the 'old' language of illumination.

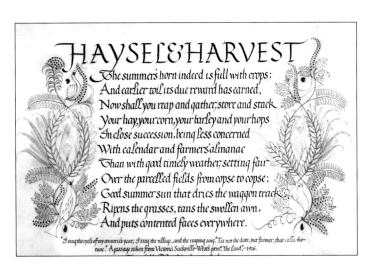

Haysel and Harvest 1958
Vellum: written and decorated with black Chinese stick ink, gouache, and raised and burnished gold. 28.3 x 35.8cm (11 x 14 inches). Irene Wellington's influence on the pastoral content, with its decorative whimsical drawing and echoes of M C Oliver's jagged italic, are quite clear to see in this student piece, made at Central Art School, London. The text is from the poem The Land *by Victoria Sackville West.*

Every calligrapher's individuality is automatically expressed in their work. That it may not be expressed as they would wish is another matter — this is achieved only through practice and skill. Donald Jackson advises, 'In the meantime by working at enhancing your skills, you will undoubtedly develop ideas and discover sources of inspiration: at worst you will have done a lot of useful ground work. However, inspiration alone is not enough; it will be no good at all unless you are equipped with the means to express it. A basic understanding of letterforms should be used as a jumping-off point for experimentation and play rather than just a means to produce more of the same; neater than the same, or prettier than the same.'

No one particular course of instruction is necessarily better than another. Some people will embark on a very structured course and then look at a free piece of work and realize a desire to loosen up. Some will start by throwing paint all over the place and think, 'this is great' but then when they see a piece which is finely finished they realize the need to control what they are doing. People find their way from different angles and eventually most reach a point where they can bring freedom and skill together. There is no single right approach and there are certainly no short cuts; most people find that it takes a long time to find their full potential but every stage of development will have its value.

'Calligraphy', says Donald Jackson, 'is to graphic design what life-drawing is to fine art — a basic stem from which all kinds of blossoms may appear, but its roots lie in two thousand years of mark-making and understanding of letterforms and it is from here we should start, however we approach calligraphy. Ideas are triggered in people's minds because they were there in the first place. Hundreds of years ago our

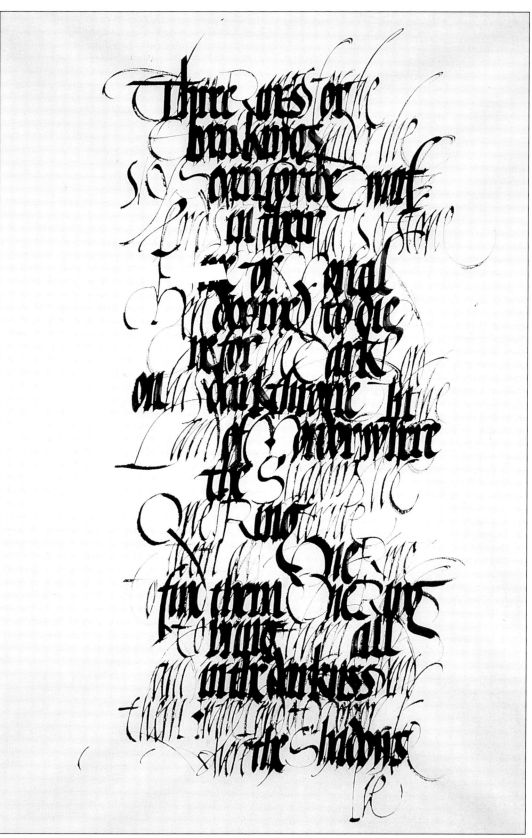

In the Land of Mordor where the Shadows lie 1988 This is Variation 5.

It has been written with black Chinese stick ink on Bodleian handmade paper. 72 x 51 cms (28 x 20 inches). It has a Johnstonian flavour still, thirty years later but this time student temerity has given way to a freer looser exploitation of the hand. The words are from The Lord of the Rings *by J R R Tolkien.*

ancestors were making marks to communicate with each other and to express their thoughts, and this knowledge is in our genes.'

Perhaps an underlying key to Donald Jackson's work is his understanding and love of the tactile materials at his disposal; and one sees this repeated in work after work. While admiring the creations of others on computers he admits to a dislike of using them himself. 'It is nothing to do with technology. They're a wonderful toy. It is just that they're not wet, and I like fooling around with wet stuff like ink and paint.'

He continually refers to the intrinsic quality of materials and looking back over the last twenty years, sees that where once the emphasis was on the handmade book, now calligraphy is hung on the wall. His desire is to return to the handmade artist's book because of its accessibility. He wants to play with the finished object and enjoy it with all his senses, and for others to do so too. He has discovered that he no longer likes looking at things behind glass.

'A book has a certain smell, you can touch it, it has a sound as you turn the pages and, of course, you can see it. It brings into play all the senses and allows a total involvement.'

While admitting that his desire to be involved with the making of books is a personal one, he also believes that the future of calligraphy lies in the artist's book, and cites as an example Picasso's book made up of etchings or lithographs. It will therefore come as no surprise that his favourite writing tool is not the steel nib but the quill — not for purist reasons, but because it is a wonderful drawing instrument with an immediate tactile response.

'Using the quill, you have to move your hand more quickly and at speed, like skating on ice, which is an essential

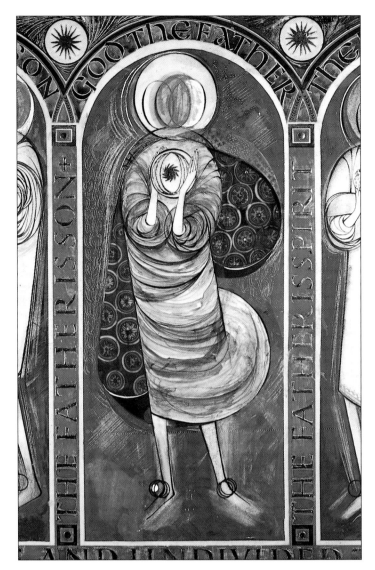

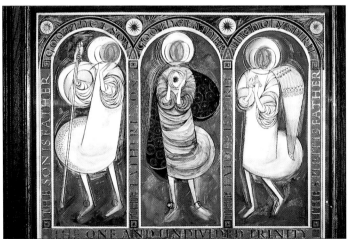

The Trinity 1960
Vellum stretched over board. Executed in gouache and raised and burnished gold 53 x 44 cms (21 x 17.5 inches). This piece submitted for SSI Craft member election in 1960 earned Donald Jackson the epithet 'the Henry Moore of the SSI'. The process of development has two main strands — technical and inspirational.

Technical influences
Methods very often quite faithfully follow medieval procedures for similar practical reasons: for example, burnished gilding still needs to be completed at an early stage in an illumination to avoid pressing excess gold leaf on to painted areas where it is likely to spoil careful work by sticking to its surface.

ingredient of calligraphy. The quill will do this for you where the steel nib cannot. It will leave you high (or low) and dry. You have to go quickly with the quill. It has acceleration and flexibility. Learning calligraphy with a steel nib is like learning to play the violin on a synthesizer. The quill is so flexible that it can be bent right back on itself and go back together again. If you feel good about the tool, you write well and it unlocks feelings in you. I feel very strongly about this. The smell of paper, paint, especially oil paint — redolent of all the art schools in the world — triggers things off.'

This is not to say that the steel nib does not have its place, and Donald Jackson uses one for fine drawing, especially on gold work. However, his students begin with the quill itself, learning how to make one as well as how to use one.

He clearly thinks that the basic disciplines of calligraphy create a springboard for development. Yet its place in the world of art is more ambiguous, divided as it is between art and craft. The highest forms of Oriental art are calligraphic where words and form are married, and a whole section of the history of art is devoted to the illuminated and written book.

'Art is made by artists. It doesn't matter what form it takes. An artist can make a building and it will be art. Someone else will make a building and it will be just a building. Picasso made a pot and it was art; by someone else it would be a piece of craftwork.'

The situation has been bedevilled in Britain by the Johnstonian creed and the Arts and Craft movement where, in calligraphy (or 'fine writing' in Johnston's language), any hint of 'artyness' was anathema. Yet Donald Jackson believes, if anyone was an artist it was Johnston. He concludes by wondering whether, if we keep

asking the question 'is calligraphy an art or a craft?' and getting no answer, we are asking the right question.

He has developed this idea by looking at America where the craft-centred cultural bias does not apply, the Americans being far less class-conscious about the arts. In Britain's art schools there were arts and there were crafts, and if you were in the crafts section, you did not go through the door marked 'Fine Art', and in many art colleges this still applies. However, in the States no such divisions exist — it is all one and there was and is enthusiasm to have a go at anything. Exciting developments have therefore happened in that climate. The calligraphic tree, with its roots in Europe, has blossomed in the United States of America.

Looking at the sumptuous work of Donald Jackson, one has a vision of this exciting work being produced spontaneously under ideal circumstances. Yet here we have a calligrapher who, by his own admission, is full of self-doubt and who experiences the pain of forcing himself into self-initiated projects. He has done some of his best work against deadlines when the adrenalin has flowed because the job has not been completed until the last minute — what he would call 'operating on lowgrade fuel', and until recently most of his work has been in response to this external motivation. Lately, however, he has changed, and allows himself to do work personally motivated from within. 'Now', he says joyfully, 'I look forward to each week — I look forward to life.'

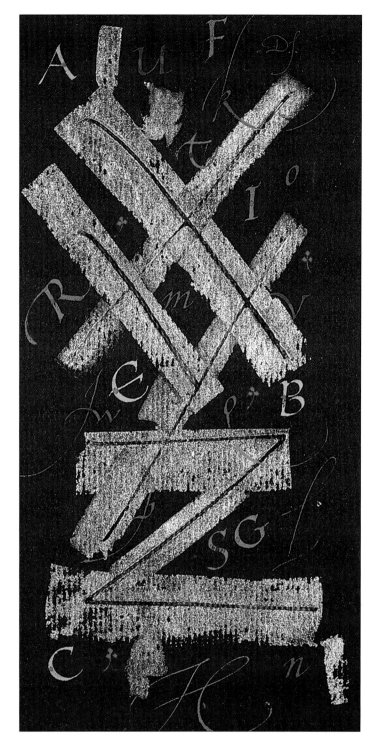

The inspirational or design process often begins with play: Series of scrapbooks 1987-88. A page from a scrapbook of doodles and jottings has wax crayon rubbings taken from a stone (itself a playful practice attempt at letter carving) with added pencil trails and a quill pen-drawn 'S'. Thirty pages of assorted papers, guarded and bound in handmade paper.

These scrapbooks contain texts from the writings of William Blake, John Keats, Teilhard de Chardin and Donald Jackson, together with sketches of work for reproduction and some photocopies of recent work embellished by hand. They give an impression of day-to-day work and show the development of ideas. Using mixed media: 29.7 x 42 cms (11.75 x 16.5 inches).

Ornamental Alphabet 1987
Black Fabriano laid paper. Written and decorated with gouache and raised and burnished gold in two colours, and measuring 14.1 x 16.1 cms (5.5 x 6.5 inches). 'XYZ' on black makes use of accidental effect caused by the cut-out shapes of gold leaf sticking to the sized paper surface after burnishing the gesso. The bold shapes of the leaf provide the main reflective strength of the design, supporting the random scattering of other letters dancing around them.

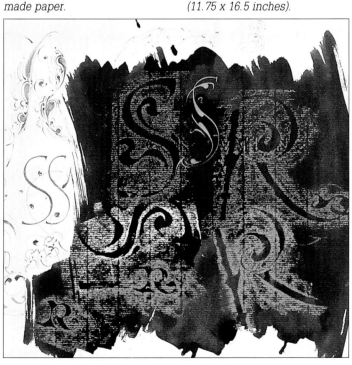

*In the land of Mordor where
the Shadows lie 1988
Variation 12*

*Vellum, partially washed with
thin black Chinese stick ink
and dragon's blood. Stretched
over board, with a surround of
six pieces of vellum also
washed with ink and stretched
over boards 6.5 cms (2.5
inches) wide and of various
lengths. Written and decorated
with black Chinese stick ink,
vermillion stick ink, gouache,
dragon's blood, and raised and
burnished gold. 71.8 x 47.7 cms
(20.5 x 18.75 inches).*

From The Lord of the Rings *by
J R R Tolkien and texts
selected from* America: A Pro-
phecy *and* Europe: A Prophecy
by William Blake.

*Play and skill combine to allow
'freefall'. The apocalyptic
words of William Blake and the
melodrama of Tolkien's poem*
In the Land of Mordor *provided
the starting point for a piece
which designs itself or is built
layer upon layer, one mark dic-
tating the next. The raven and
dragon-like images seemed to
creep out of the ring symbols
after they were made.*

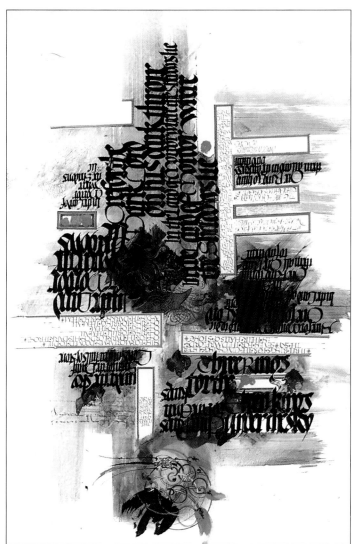

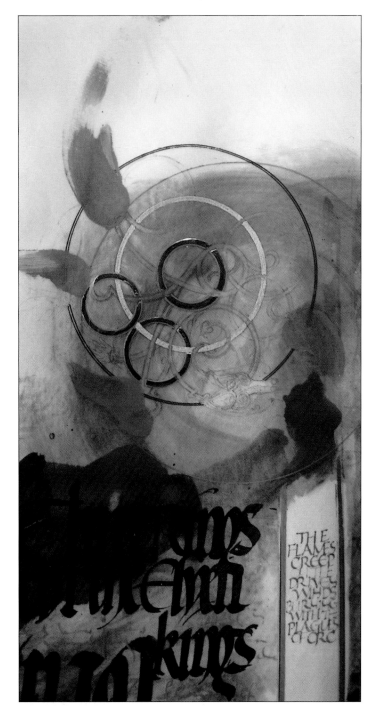

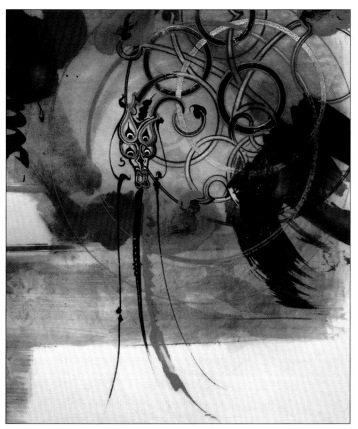

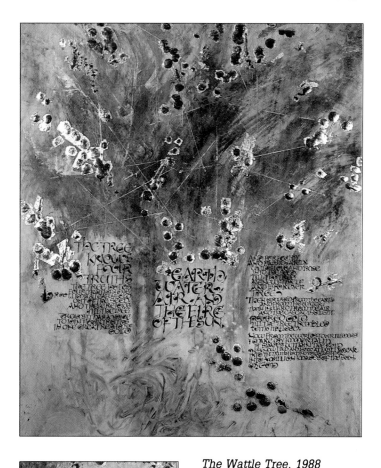

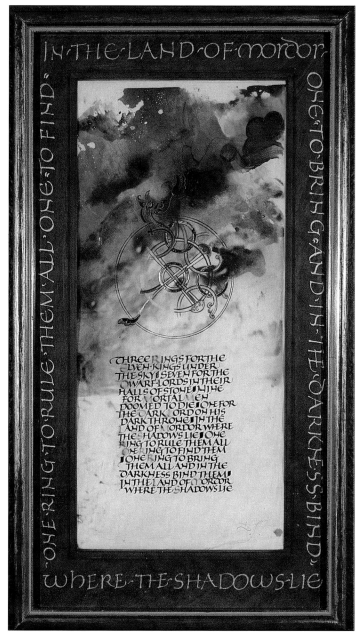

In the Land of Mordor where the Shadows Lie 1988
Variation 3

Vellum, partially washed with dragon's blood and gouache, with card mounts, painted with dragon's blood and gouache and lettered with powder gold. Written and decorated with black Chinese stick ink, dragon's blood, gouache and raised and burnished gold. 30.4 x 13.9cm (12 x 5.5 inches).

This is another Tolkien variation which works on the same evolutionary process with a more carefully planned block of text set against the smoky smudges of colour. The wheel with interlace which appears in quite a few of the Mordor variations is based on an illuminated initial 'O' seen by Donald Jackson in a 12th century manuscript. Here the wheel sprouts an enigmatic head, giving the motif a sinister quality.(From The Lord of the Rings by J R R Tolkien).

Planning
Some projects are almost entirely designed with elaborate preparatory tracings and formal treatment, as represented by two sample prototype letter 'E's used as heraldic initials for Royal Warrants and Patents of Nobility under the Great Seal.

The Wattle Tree, 1988
Vellum, stained with water-based lino printing ink in red and yellow. Written and decorated with gouache, raised and burnished gold, and powder gold. In places the gold leaf has been burnished directly on to the vellum. Most projects combine elements of careful planning and rehearsal with some room left for 'surprises'. The Wattle Tree (above) by Australian poet Judith Wright was made after a few pencil skirmishes and play with the quill (left) which produced the spontaneous-flexed flourishes which 'grow' from the capital letters (left centre) used throughout this place in celebration of the tree's relationship with the elements which enable her to 'bring forth gold'. The inspiration for this piece came from a visit to Australia in 1984. The clear sunlight and open skies, which bring out vivid colours strikingly different from the green-grays of his home country, made a profound visual impression on Donald Jackson and seem to mark a new direction for his work. 64.5 x 50.2 cms — (25.5 x 19.75 inches).

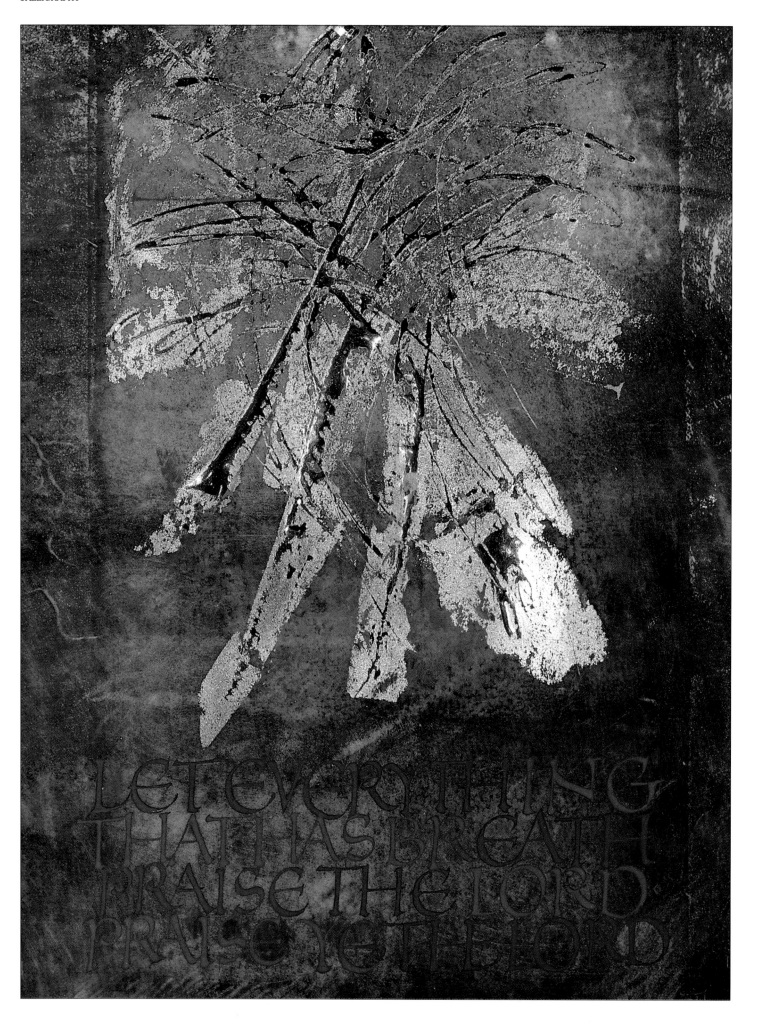

A Tribute to Teodoro Moscoso 1976

Plaster-based gesso has been spread from a quill within a pencil-drawn design. The uneven surface is later carefully scraped smooth.

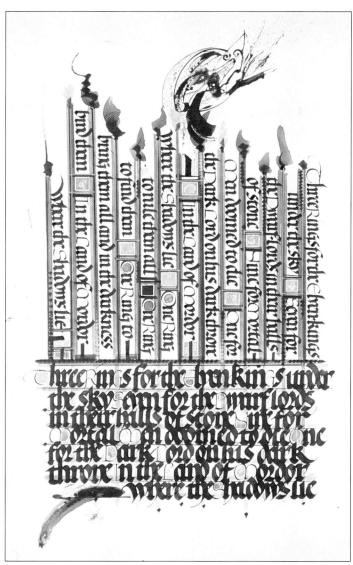

In the land of Mordor where the Shadows lie 1988
Variation 10
J Whatman 1961 handmade paper: written and decorated with black Chinese stick ink, vermilion stick ink and dragon's blood. Building layers of letters and stacking them can produce a powerful architectural effect accepted for its effect on our visual sense or — read literally — it can be a recipe for neckache. (Extract from The Lord of the Rings *by J R R Tolkien).*

Variations on an angelic theme *A recurring motif in Donald Jackson's work.*

'Praise Him with the sound of trumpets' 1988 *(copy 46)*

(Above) Burnishing goldleaf on to the gesso requires firm pressure from a smooth haematite burnisher. Excess gold sticks to the background which is later scraped clean.

(Below) Vellum stretched over board: written and decorated with black Chinese stick ink, gouache, raised and burnished gold, powder gold, and gold applied to gum ammoniac. The leaves were executed with a rubber stamp. The finished result varies from 'black' to brilliantly reflected 'white' light.

The burnished gold is complemented by a painted frame of shell (powder) gold which has a fine outline burnished on to it with a pointed agate. Commissioned by friends of Teodoro Moscoso to commemorate a life of public service, the main portion of the Spanish text arrived well after the decorative elements had been completed: 'I still remember the nervous tension felt when starting to write the final two panels with three months' work at stake if I made a serious error.'

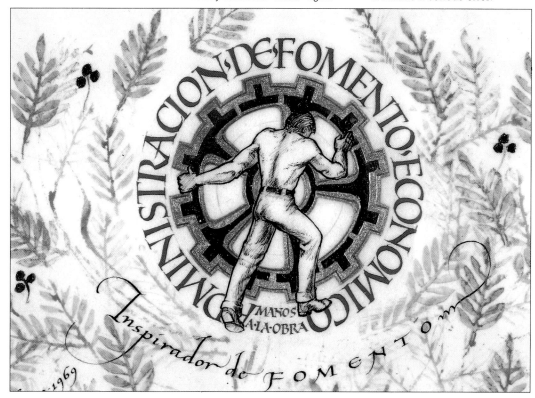

Gottfried Pott

'As a practising musician, I have an intense relationship with music…. Both in writing and in music, rhythm is the most outstanding element. It is rhythm which lends calligraphy the breath of the individual.'

Gottfried Pott was born in Germany. He attended the Werkkunstschule in Weisbaden in 1960, graduating in 1963, and as a student had the great good fortune to study calligraphy with Friedrich Poppl whose teaching proved a very formative influence. For the ten years after graduating he was employed as a designer and art director, finally leaving to establish his own design studio. In 1984 he started to teach lettering and typography at Weisbaden, and in September 1988 was appointed professor at the Fachhochschule in Hildesheim. He also teaches at the Schreibwerkstatt which was formed by Karlgeorg Hoefer in 1987 at the Klingspor, in, Offenbach, and which has been instrumental in keeping alive the tradition and teaching of Rudolf Koch. In addition, he is a member of the Bund Deutscher Buchkunstler.

As a musician, Gottfried Pott sees many parallels between calligraphy and music; he likens an appreciation of different interpretations of a piece of music to his love of the diverse interpretations of the alphabet. Again, an interpretation can be based only upon a detailed study and as far as calligraphy is concerned, for him this can be only the study of the historic form of letters.

From this study he has compiled a repertoire of form which provides an 'undreamt of scope for creativity'. The repertoire of form of two thousand years of calligraphic history represents, for him, the foundation of calligraphic building.

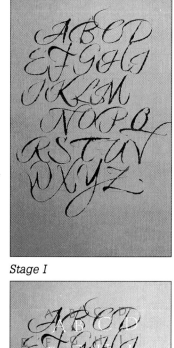

Stage I

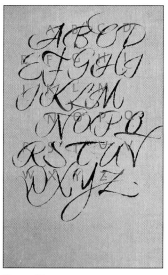

Stage II

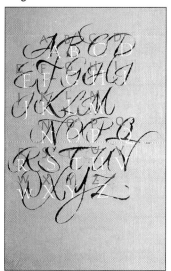

Stage III

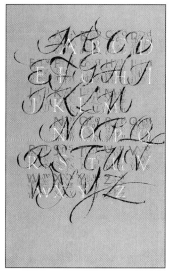

Stage IV

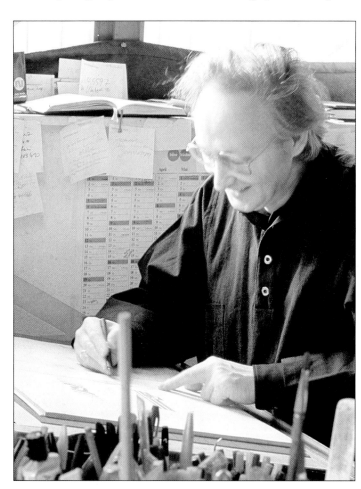

ABC-Symphony I 1987 This piece was done for the faculty exhibition of the International Calligraphy Exhibition in Portland/Oregan, USA. The work contains in each letter the development of the history of handwriting from Roman

Capitals right down to a free expressive interpretation of the alphabet. Four versions of this piece were done at the same time. Each version surprises by the way a different effect is achieved through changes of shape and colour.

Bodoni, from the Manuale Tipigrafico 1990 The text from the Manuale Tipigrafico reads: 'Letters possess gracefulness not when they have been written with listlessness and haste or with toil or diligence, but with heart and soul. This great calligrapher's demand for quality is still an obligation for us today.'

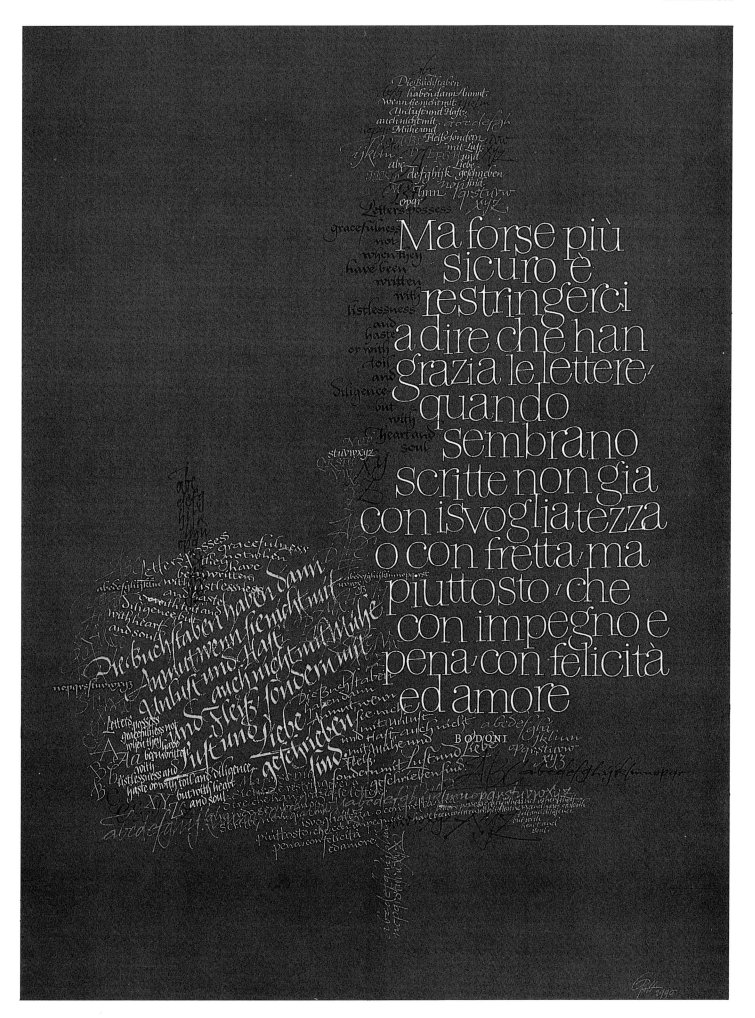

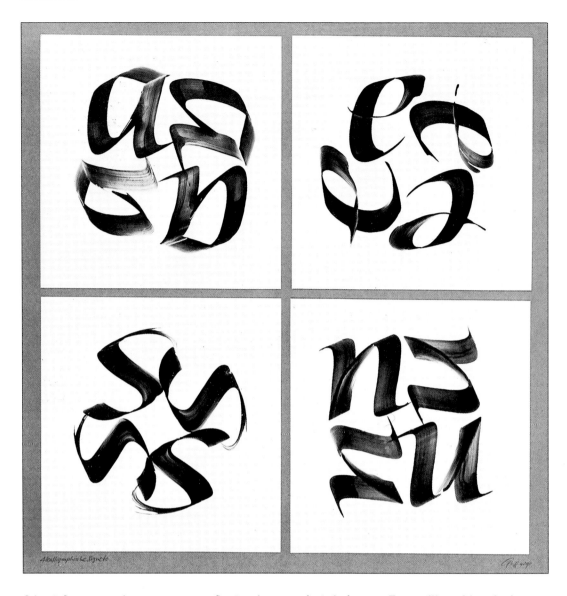

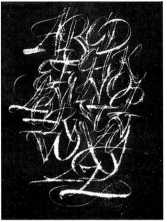

Initial Alphabet 1989

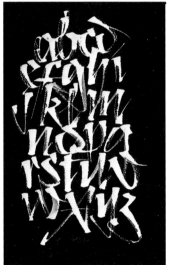

Bastarda 1990

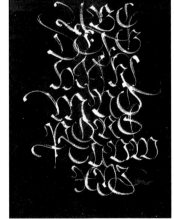

Fractur Initials 1988

Other influences such as painting, architecture and literature, as well as music, will exert their influence upon this historical basis, and must not be overlooked. Gottfried Pott also thinks that present-day technology such as computing should not be disregarded. Computers have introduced revolutionary developments in the design of type and will continue to gain importance as typesetting tools. These will, in turn, be replaced by better computers and in doing so, the gulf between their designs and original handmade letters will become increasingly evident.

Herein, Gottfried Pott believes, lies calligraphy's greatest opportunity. Calligraphy is a living organism which reflects the symptoms of its time, both positive and negative, in a similar way to handwriting reflecting the state of mind of the writer. People increasingly recognize the immense worth of the cultural traditions of calligraphy. Says Gottfried Pott:

'There is no culture without the written word. Writing by hand transforms language into images and expresses the sounds of language through its particular interpretation; it makes intermediate sounds visible. Calligraphy is communication, form and rhythm, since there is no form without movement and no movement possible without form.'

Four calligraphic colophons 1990 In black and white. 'As a designer I am forever fascinated by the graphic effect of the letter-shape. By turning it in all four directions, the phenomenon of movement and rhythm is revealed.'

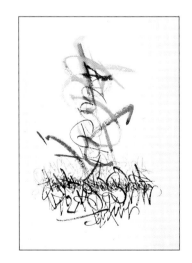

Brush Calligraphy 1990 The alphabet provides the building stones for this brush study. Here script becomes an image in its own right.

These three pieces were created with a specially-made ruling pen and show the considerable variations which can be achieved by dexterous use of the pen.

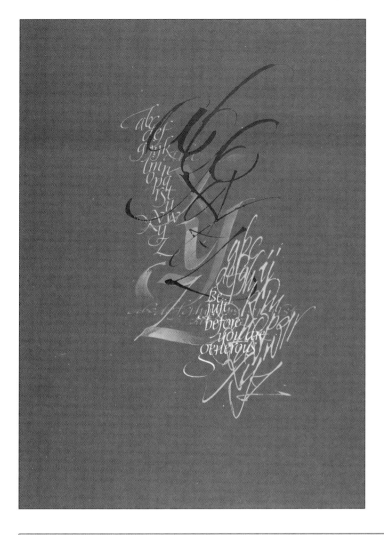

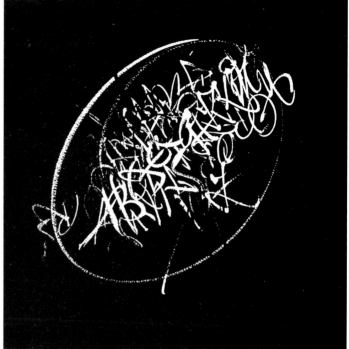

Be just before 1987 This sheet was done during a workshop conducted by the teachers, Larry and Marsha Brady, USA. The theme of the workshop was 'Variations on Italics'. Colouration and the different writing tools illustrate the great variety of italics.

Brush calligraphy 1990 In black and white. The use of the brush can endow the alphabet with colourful resonance. This succeeds in white, grey and black on handmade paper of the deepest black.

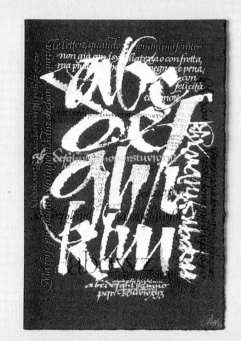 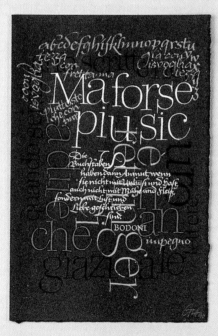 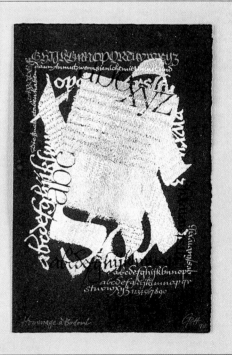

Homage a Bodoni: Triptych 1990 This piece honours Giambattista Bodoni, whose two hundred and fiftieth anniversary was celebrated in 1990. These were produced in the Spring of that year.

Denis Brown

IRELAND

'I believe that working only from the conscious limits one's creativity — whereas transcending consciousness can enhance the inner life of a work of art'.

Denis Brown, born in 1968, is the youngest contributor to the book and his achievements to date mark him out as a calligrapher in whose hands the future of calligraphy may lie. This is all the more praiseworthy in the current climate where education in the written hand has largely been neglected.

His interest was first aroused at the age of fourteen when a student at St Benildus College in Dublin. Calligraphy was offered as a craft subject by his teacher, Brother Tim O'Neill. His first major commission at the age of fourteen was the compilation of a book of remembrance running to some one hundred and fifty pages. He had in fact been selling his work since the age of eleven. At eighteen, he took calligraphy as part of his Leaving Certificate before going to art school in Dublin. After one year he was awarded a special scholarship by the British Government to study in Britain, and with this he commenced study with Ann Camp in 1987 at Digby Stuart College in Roehampton. The following year, at twenty, he was unanimously elected a Fellow of the Society of Scribes and Illuminators, the youngest person ever to be elected Fellow in the history of the Society, and its only Irish member. He now works full-time as a calligrapher from his home in Dublin.

The work reproduced has all been completed within that short timespan and may be regarded as representative of the different categories of Denis Brown's work — from commercial designs, for print and one-off presentation panels, to more personal interpretations of text and poetry and finally, to his expressive painterly work where the text (if any) is used simply as a thematic basis for further creative development.

Denis Brown says that he regards his *Presentation Address to Oliver Kearney* as a 're-lieving break' from his more personal and experimental work which can be taxing on both mind and body. He sees his more formal work as relatively straightforward. Because of the more formal nature of this work he has a fairly clear mental image of how the finished piece will look. The working method will be to progress through a number of roughs beginning with quick thumbnail sketches in which the approximate position, shape, size and weight of the writing blocks and finally, decoration, will be shown. The next stage is to proceed to full size, writing in the full text which, though rough in detail, tries to approximate the finished effect as closely as possible. Before working out the many final small adjustments he will decide on the colours to be used (as these may alter the spatial effects as well as the optical weight of the writing and decoration) and the background colour. In this piece the background was a grey-green paper, as white

would have been too glaring. Because of the deep tone of the paper, the writing was made bolder to compensate.

One of Denis Brown's simple yet eminently practical methods of working is to make up two sheets for the final piece. As he puts it, 'working on both allows me to make a mess of one, and even if I don't, I find the reassurance of knowing I can helps to eliminate any hesitancy in writing — and I can also keep a copy for my portfolio!'

What Anguish Between Us?, although relatively formal, displays a far more personal approach than the Kearney address, though as Denis Brown points out, this is not to say that illuminated addresses cannot be personal, citing Irene Wellington's Royal Accession and Coronation addresses of 1952 and 1953 as examples. The text of this piece is from a translation by Desmond O'Grady of *Y Gododdin*, a 7th-century Celtic poem and lamentation commemorating the battle between Gododdin (a tribe from near present-day Edinburgh) and the men of Bernicia and Doria.

The importance for Denis Brown was their timeless quality and the themes which bestride the centuries, expressing the same conflicts as those he is feeling at this point in his life. In this sense the work becomes a personal expression. He did not have a clear image of the final piece, only a general feeling, that of a hopeless struggle. Hands were used to convey personality.

He says, 'I tried to spread my fingers as wide as possible to enhance the expressiveness of the prints; I slapped the paper as hard as I could to give the prints more dynamic energy; my hands were red and sore. This piece needed intense concentration, yet it seemed as though I was not directing the piece but that it was developing autonomously. In fact, I did change the positions of the

elements in the composition as the work progressed but it was not until afterwards that I realized what I had done. The composition is a dynamically poised triangle made up of hard prints and writing, counterbalanced by a single handprint in the upper left which seemed to have evolved without my conscious interference.

'In this piece I was experimenting with the perception of shallow depth in a surface. The use of tonal contrast and overlapping give this effect and elements are placed on different planes in front of the viewer. Colour could have enhanced the effect but I felt that greys, black or white, with just a touch of red, were in more harmony with the tone of the poem and the feelings I wanted to convey. I have taken advantage of the advancing and receding properties of warm and cold colours in other pieces such as *Break, Break, Break.*'

Denis Brown is currently working on a commission for *Poetry Ireland*, producing a single handmade book which contains the work of seventy-five poets and sixty artists. The unifying factor will be the calligraphy which ties together the poets' handwriting and the artists' imagery. Arising from this commission and working with artists, he realized the possibility of calligraphy and painting becoming one. This idea was furthered by an interest in the American Abstract Expressionists, Jackson Pollock and Mark Tobey, and also by the influence of Thomas Ingmire with his recently published book *Words at Risk*. All these ideas became fused in *Break, Break, Break.*

In this piece, the visual elements are of primary importance and the literary aspects secondary. The words are from Tennyson's poem which is broken up and presented in a new way; the phrases are scattered about the surface, apparently randomly, with no fixed order in which to be read.

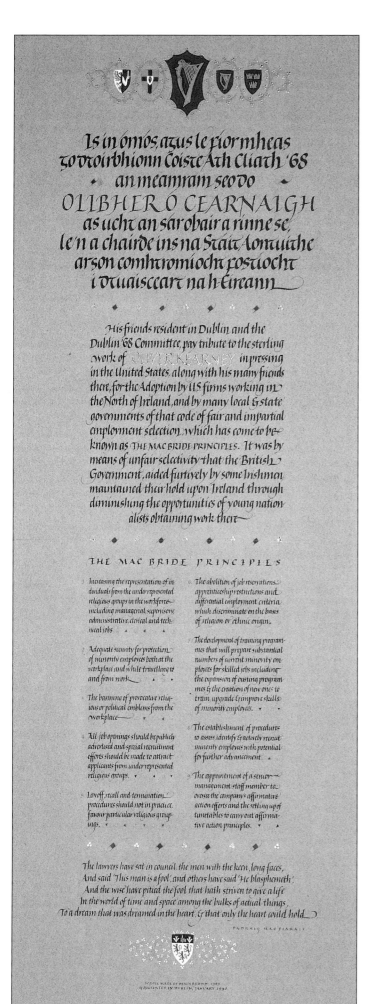

'I specifically wanted to move away from that [literal] form which would have been limiting. I was aiming towards a result which would express inner feeling through a subjective use of form, colour, rhythm, space, and Tennyson's poem was chosen because it expressed feeling which seemed to harmonize with my own. The poem was the beginning — it is not the end.

The visual form was inspired particularly by a certain phenomenon of nature I observed while walking along the promenade on the sea-front not far from where I live. I noticed a large rock just beneath the surface of the water and very close to the edge of the promenade. With each gentle wash and backwash of the waves as they reached the concrete side of the promenade, the water level increased and decreased. The large rock was at one instant clearly visible, barely below the surface; then when a wave lapped over, increasing the depth of the slightly murky water, it momentarily disappeared from sight. The visual effect was one of immergence and emergence, the rock receding and advancing in relation to the surface of the water. I tried to capture this feeling in *Break, Break, Break* and express it in a more dynamic manner.'

His method of working on this piece is illustrated by the photographs taken between progressive stages, the work being produced directly on to the surface with only minimal pre-sketches being made. A layer of writing was put down, then a layer of print applied on top of the writing, the whole process being repeated many times until the final painting was achieved.

Thus the calligraphy is not on the surface but within it and an integral part. The whole surface is active and not merely a ground for action.

Illuminated address to Oliver Kearney 1989
Japanese stick ink, gouache, shell gold, raised and burnished gold leaf. On Canson paper. 107 x 38 cms (42 x 15 inches).

What Anguish Between Us? 1990
Japanese stick ink, gouache and acrylic on BFK Rives paper. 121 x 57 cms (47.5 x 22.5 inches).

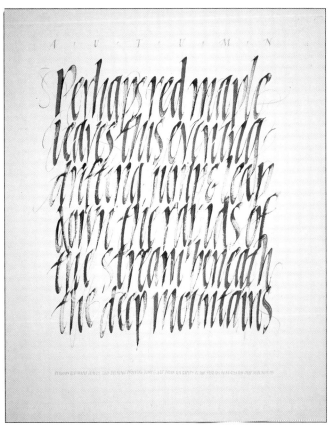

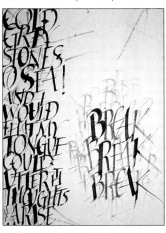

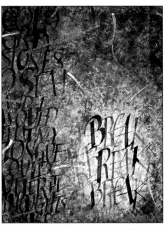

4 *This shows the piece after further layers of paint and writing have been built up. At this stage, top layer of orange and gold marks advance too much but they will be toned down by the next layer of blue/green.*

Two of a series of four wall hangings on the seasons 1989 *Due to the large size of these pieces which were commissioned to be hung in a restaurant, I felt very legible calligraphy would be inappropriate. I sought to prolong the viewer's interest at a conscious or subconscious level by placing more emphasis on colour or texture. After these qualities have been felt the viewer may (or may not) decide to decipher the text! Made with a 25mm metal pen and brushes on paper. 152.4 x 122 cms (60 x 48 inches).*

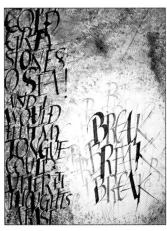

1 *First the large black writing was put down with 'automatic' pens. Diluted purple was then put down on top, which due to its transparency appears behind the black.*

5 *Original was beginning to disappear so the column of black writing (left) has been rewritten. Further layers of colour and writing have been applied and white splattered on with a toothbrush.*

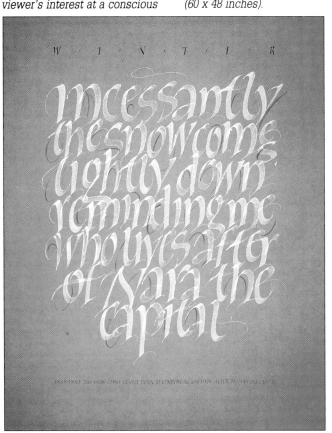

2 *Blue and green gouache is stippled over the surface with a rag. This pushes back the column of writing at the left.*

6 *The surface is almost complete. I cut the work in two and glued both parts to white painted board, leaving a white line between the two parts. This line, a physical break, advances from the picture plane, pushing the words 'break, break, break' back, increasing the tension as they struggle to free themselves from the surface.*

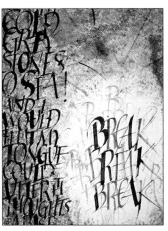

3 *Small lines of orange/red writing are applied (complementary colours to blue/green). Large pen strokes in gold (bronze powder) and complementary purple are added.*

Break, Break, Break 1990 *Ink, gouache, bronze powder, acrylic on BFK Rives paper glued to hardboard. 119 x 81 cms (47 x 32 inches).*

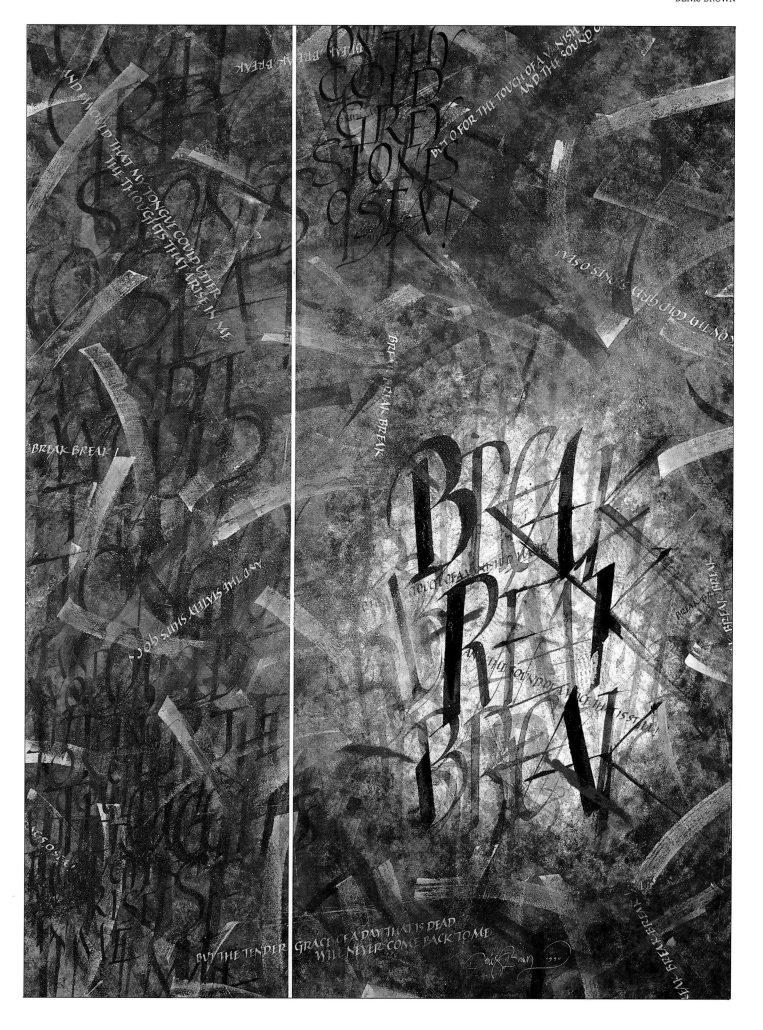

John Stevens

'Craft, traditional models, technique and function must become points of departure rather than an end in themselves ... the same is happening with calligraphy. Calligraphers cannot simply reiterate its past, but rather, must echo it, or resonate with it.'

John Stevens was born in 1953 and was brought up on Long Island, New York. His first encounter with letterforms was at the age of ten when he received his first assignment from his father to paint the word 'experimental' on both sides of his father's home-built Stits-playboy airplane! Having no education beyond formal high school, his very considerable knowledge and skills have largely been self-taught.

Leaving school in 1975, he worked for a year in the local sign shop under the tutelage of Anthony Perner, a well-known Long Island signwriter. After a year, the sign shop closed and John Stevens went freelance.

At this time, calligraphy seemed a remote discipline and it was in a copy of *Calligraphy and Handwriting in America* that he found a plate entitled *Trajan Letters and their Brush-written Kinetics* by Father Catich, which helped him to bridge the gap, for it was Father Catich, himself a sign and ticket-writer, who conclusively 'decoded' the method by which Roman capital letters were constructed — a quest which had exercised the minds of many paleographers since the Renaissance.

The plate demonstrated the role which the broad-edged brush played in the construction of Roman capitals, a brush which was the same in all its characteristics as that which John Stevens was using in his signwriting. Excited by his new discovery, he wrote to Father Catich, ordering all of his

books, and upon receipt he found enclosed with them a signed poster and plates. The relationship which he hoped to develop as a student with the Master did not develop however, because sadly, Father Catich died on Good Friday of that year.

The writing of Edward Johnston, John Howard Benson and Hermann Zapf also provided the essential background reading of ideas and information that initiated John Stevens

Alphabet 1989 headliners Written and illustrated on black Fabriano paper using various brushes, pens, quills; casien and gouache are the media. It measures 72.4 x 53.3cm (28.5 x 21 inches).

Excellence 1989 Text written with pens on paper with gouache illustrations. Coloured pencil and gouache have been used on a purple ground. 34.3 x 43.2 cms (13.5 x 17 inches).

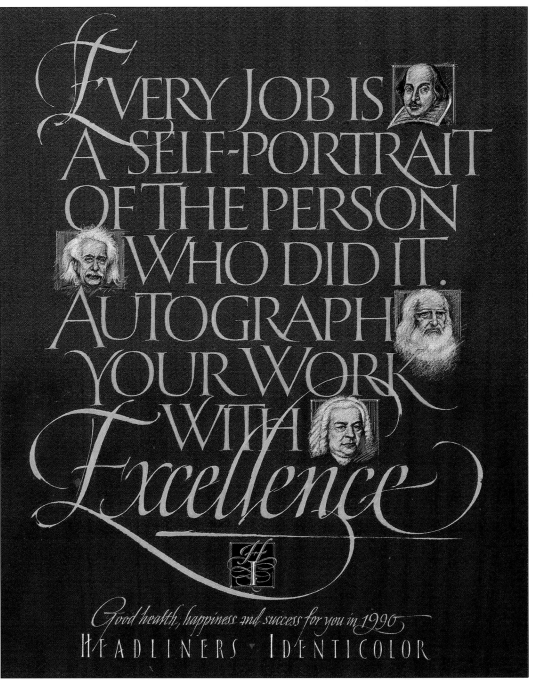

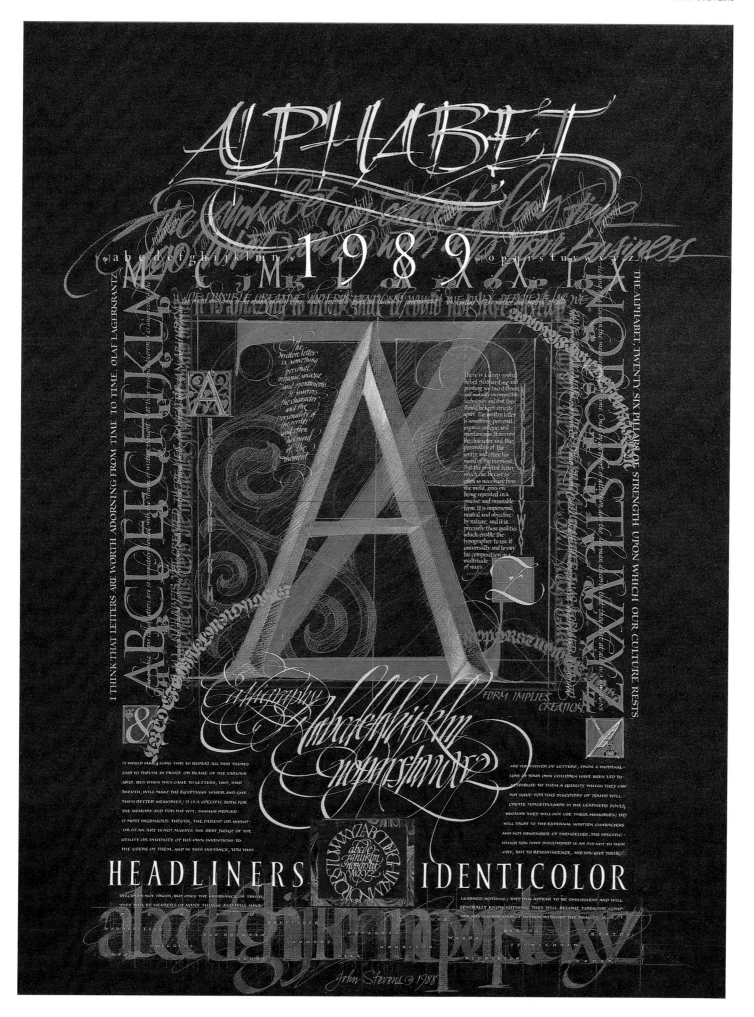

into the 'mystical and mysterious' art of calligraphy. Having the skills of brush writing he found a steel nib at first difficult and stiff but he persisted, believing Edward Johnston when he said that the broad-edged pen was the principal letter-forming tool.

Today, although a considerable amount of his work is done for industry, from book-jackets and record sleeves to advertising, packaging and posters, he believes that designing and writing formally is not 'quick' enough to catch the creative impulse. Formal work is important, representing the disciplined craft side of the spectrum and, for John Stevens, one of the challenges is trying deliberately to retain the freedom of things within the formal framework in the use of quality materials, deliberately designing and planning with text combined with a complete knowledge of letterforms.

Counterpoint to his formal work is his love of the complete spectrum of calligraphy which is evident in such spontaneous work as *Fraktur Alphabet* (opposite) and his *Alphabet Improvisation* (page 72). These pieces were produced experimentally without plan or layout, simply by his taking pleasure in the inherent beauty in letters. The immediacy, rawness, risk and resolve provide both counterbalance and stimulation and, in turn, encourage the feedback which enables John Stevens' commissioned work to retain its obvious freedom and freshness:

'My interest in calligraphy is in the visual themes first. I know this is contrary to popular stated beliefs, but I honestly don't view all this wonderful creative outpouring by the calligraphers of this world as "in the service of text". I do believe we are all moved and inspired by the different forms in all their infinite variety of

Ecclesiastes 1988 Black canson paper, written in personalized Rustic with broad-edged pen. Gouache. Page of unfinished book.
It measures 38 x 28 cms (15 x 11 inches).

Alphabets and quotations 1988 Title page of a book. Ink gouache and shell gold and pencil on Langley handmade paper using brushes and pens.
38 x 28 cms
(15 x 11 inches)

rhythms, line, movement, spatial relationships, and so on, that this ancient art form has taken throughout the history of the world. Add to this contemporary expression through marks and arrangements, the performance element (when visible) of this writing/drawing/ designing thing, and the command of hand ... all of this expressive potential to what was once a utilitarian endeavour: It's like a musical composition and performance at the same time.

'The artist, free from imposition (real or imagined), brings us living art through knowledge, discipline, heightened sensitivity and experience. By doing something very old in a new way, the artist brings out the timeless aspect of art that resides in the heart and mind, linking the past to the present.'

Hebrews 3:16 1986 Black stick ink and red ink on Langley handmade paper. 28 x 38 cms (11 x 15 inches).

Fraktur Alphabet 1985 In red and blue, experimental, freely-written with pointed brush. 50.8 x 40.6 cms (20 x 16 inches).

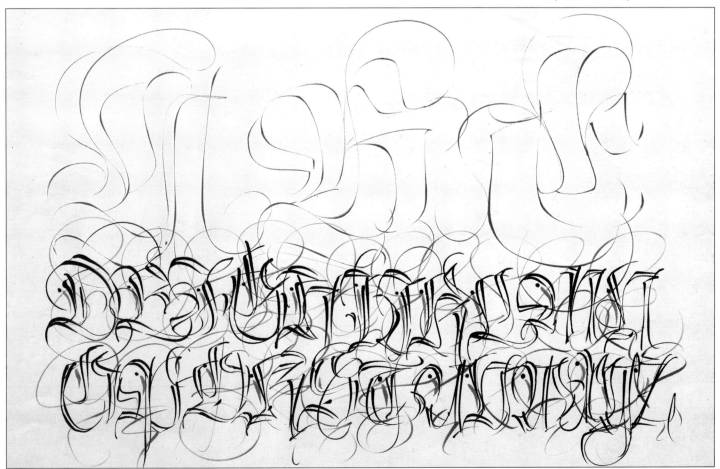

ABCDEFGHIJKLMNOPQRSTUVWXYZ

Alphabet Improvisation 1985
Experimental, freely-written
with pen in sepia brown ink
and coloured gouache.
40.6 x 61 cms
(16 x 24 inches).

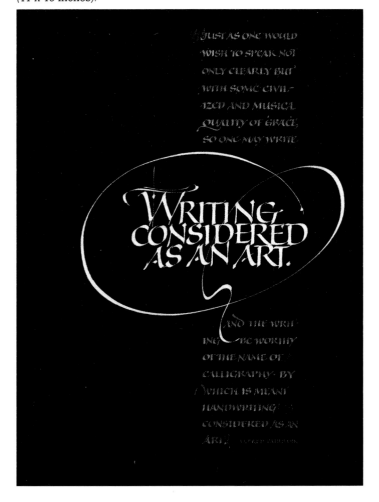

*Writing considered as an art
1988* Canson paper, gouache
and broad pen; modified
uncial. Page from a manuscript
book. Quotation from Alfred
Fairbanks. *28 x 38 cms
(11 x 15 inches).*

Superlatives 1985 Various
media and tools on Arches
paper: an exercise in composi-
tion and letterform modification
as well as in writing.
It measures *53.3 x 29.2 cms
(21 x 11.5 inches).*

73

Arie Trum

'Let go of the visual letters, words, lines and movements and let yourself be enticed into the depths of the work of art itself.'

Arie Trum was born in the south of Holland in 1946. The second son of a book printer and bookbinder, he grew up amongst printing ink, paper and lead letters, spending all his spare time in his father's workshop. There he developed a great affinity for colour, form and letters. After secondary school he studied at the Academy for Industrial Design in Eindhoven, Holland.

Today Arie Trum has his own studio where he works as a professional printer and calligrapher and teaches classes in painting, calligraphy and expressive handwriting. He produces paintings for exhibitions in galleries in Holland, Belgium, Germany and the USA. As a calligrapher, he designs lettering and illustrations for book jackets, posters and compact disc covers, as well as designing charters and lettering for tombstones. Much of his work has been bought by the City of Eindhoven, the State of the Netherlands, and by numerous art galleries, collectors and private enthusiasts.

Although 'lettering' was a compulsory subject during his education and that afterwards he spent a further three years developing his understanding of the subject through private studies with Margaret Paulsen, Arie Trum has always remained essentially a painter, rather than a designer:

"Read on, what is written is not that which is written."

'This line of verse comes from the Dutch poet, Martinus Nijhoff. Taken literally or rationally, this is nonsense: of course what is written *is* written. But the poet means: "If you let what I have written sink

in then you will discover that there is *more* written than just the written words. Only when you can see through the surface crust of words and lines does the text reveal its true secrets, its deeper meaning. And that is what is *really written.*"

'If we look no further than the outer surface, we shall tend to take that surface as a measure of our judgement. That is rational, technical and quite safe. You can point to, almost prove, a possible mistake and so discard the work on this judgement. But there is a different approach possible:

'You can let go of the visual letters, words, lines and movements and let yourself be enticed into the depths of the work of art itself, towards "what is not written and yet is able to be perceived".

'Take an unbiased look without wanting to understand everything, without knowledge or hindrance of surface details, without need of a framework of reference or a hasty judgement that could prevent a real "encounter" with the work. In this way, we do not confuse the skin — tasty or repulsive — with the fruit!

'In listening to music, we are used to this method; we make more use of our senses than our rationality. Without knowing anything about the technicalities of composition, musicology, tonality or rhythm, we can truly enjoy the music of, say, Bruckner or Satie. Nobody asks afterwards what it was supposed to represent.'

From this introduction, it should be clear that Arie Trum is not talking about 'calligraphic design' or the writing of deeds and charters. His chief interest is in exploring the forms of calligraphy which have escaped from the original literal meaning and function. No longer is it 'calligraphic writing'

or even expressive handwriting but rather the concept of handwriting, fragments of handwriting or the movements involved in handwriting, embedded in a scene of colours and accents, of nuances and subtle transition, through which pictorial and graphical elements form together an organic unity.

One is not merely integrated into the other but there is a feeling of natural symbiosis. Both aspects mingle and melt together, the one not more important than the other. A new order develops: writing becomes image, image becomes writing.

Arie Trum describes his method of working in the form of a 'travelogue' which follows the creation of a piece of art representative of his current work… 'My thoughts, my joy, my hopelessness and the inspiration accompanying all these.

'Each new piece of work is an adventure for me. Seldom or

never do I know beforehand what I shall make. If I do try to put down my thoughts on paper, in the form of sketches or drawings, then I get the feeling that I could just as well leave their working-out to somebody else.

'In contrast with a mathematical problem, in the creative process the problem itself must first be discovered and formulated. The only known fact in my case is an undirected, vague feeling of tension. Then follows a ritual of preparation in my workshop, a build-up of action: choice of paper, setting out of materials, searching for empty pots and so on. During this phase, I feel the need of music and, although a fervent lover of Middle-Age and Renaissance music, I prefer at this stage just the opposite: "heavy metal rock", "acid", the Stones, Tina Turner — and the louder the better!

'Seldom do I begin with writing. Just as the penetrating music serves as a symbol for

my spiritual upheaval, inner anxiety and chaos, so paint, colour and movement serve as a base, as an atmosphere from which I can draw inspiration and form associations.

'I always work on the floor. It has the advantage that I can walk around my work and view it from all sides. Above all, I want to keep it literally surbordinate for the time being. I also don't want to handle it too carefully, nor concentrate too hard on the result, and I especially don't want to find it important too early. The artist's easels in my workshop serve only as platforms of honour for those works that are finally considered sufficiently viable.

'I begin spotaneously with a large brush, broad and flat, painting with large strokes an atmosphere of pastel-tinted earth colours. Although oil colours would have the advantage of more effective glazing techniques, I prefer acrylic paint so that the work can be finished without too much delay.

'Whilst the first layer is drying, my eyes keep running over this "reality": a pleasant surface with fine colour nuances and subtle transitions — a bit too fine, perhaps, a bit too "goody-goody". With a damp cloth I am just able to disturb the smooth surface a little, giving it what I feel is now needed!

'I have learnt in the course of years to resist the temptation to put some quotation or saying in a flowing handwriting across this background. If people want to know whether I am really a calligrapher who can write beautiful letters, then I let them see one of the many charters, or one of the book covers or CD covers which I've designed for commercial projects.

'No, at this moment I am a painter, one who cannot refrain from using a pen, chalk, finger, stick or anything else which can be dipped into paint or ink.

'The earth colours suddenly remind me of the pigments of Etruscan vases and grave-paintings. With a small strip of carbon, I write in red and green something like: "to my Etruscan brothers, whose art was other than Greek art, not rational". Not bad as a beginning but, as a statement, still too dull. I rub most of it off again. Here and there a letter remains but most of the paint ends up in the background and mixes in with it.

'While I walk around the sheet of paper on the floor, less tense now a beginning has been made but still nervous, I philosophize about my Etruscan brothers and ask myself whether I can or will do anything with that association. After all, nobody can read what I have first written. Meanwhile, all sorts of thoughts swarm through my head about the Etruscan language and its interpretation, the ten thousand short inscriptions, the two

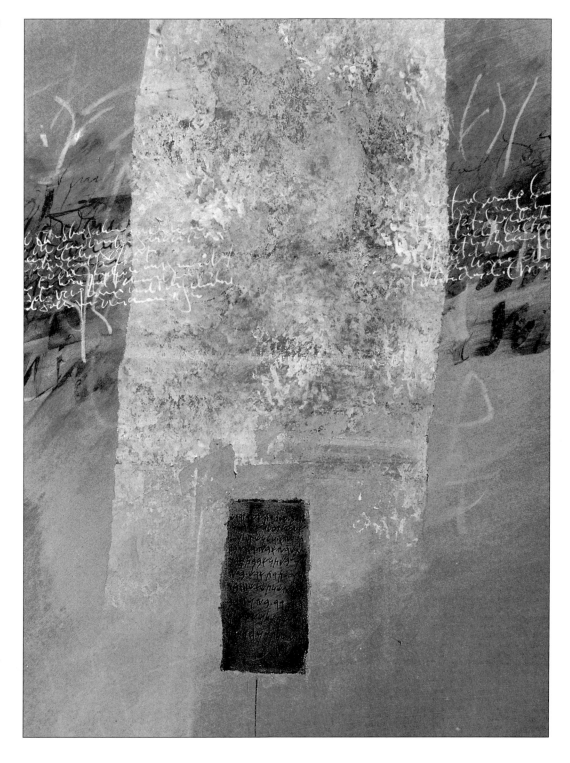

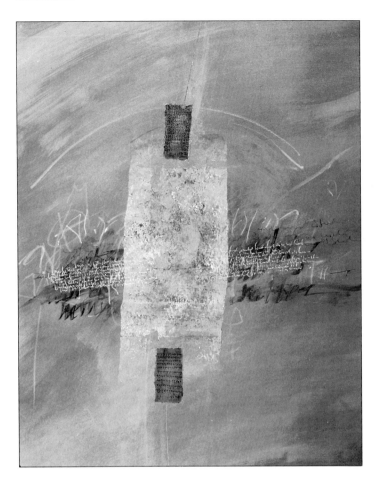

hundred words already known, the use of Greek characters usually to be read from right to left, the famous texts of Pyrgi, scratched in Punic and Etruscan on three gold tablets.

'I write with a white oil pastel a few shreds of the Etruscan alphabet — not as a school-example of how to write these letters but more as an attempt with this scribbling to come a little closer to my Etruscan brothers. Because I exert hardly any pressure on this pastel, it looks as though there are very faint, almost unrecognizable characters and symbols emerging from the background. A curved line above the text finishes this careful exploration

for the time being. I write now — almost illegibly, with a pointed steel pen in a stronger white across the full width of the sheet — scraps of thoughts that come to me spontaneously.

'I am not really dissatisfied with what I now see, but I have the feeling that I can easily make another one hundred and fifty of this sort of work without missing a heart-beat. This tells me that there is still a long and lonely road to travel. In one way or another, the white text in the red smudge must be broken up with something purely pictorial. The Etruscans, still haunting me, remind me of Tarquinia, where I once tried to capture in a hasty travel sketch the ancient, still ochre and turquoise-blue grave-paintings. That faded memory brings me exactly the picture I seek. By using paint which has been made transparent to give a glazed effect, I evoke this weathered world.

'The feeling that it is starting to become "something" must be resolutely repressed at this stage. Here with the Etruscan brothers, I am aware of the feeling that underneath everything in the world there is sacredness. And I want this piece of work to be a testimony to the overall human awareness of this.

'Am I here talking about religious art or a kind of piety? Of course not! Before the established religions existed, there were ancient religions, such as those of the Egyptians and the Greeks, which you might say originated through poets and artists. The artists created the form, the poets praised it and the priests celebrated it.

If the people found that in the chosen form the sacredness did indeed exist, then they had found something of their own awareness of sacredness in that religion. If there was no room for this feeling, the religion, the

art-form, the artefact was of no value and it just died out.

'What my work needs now is this extraordinary tension; this tension between myth on the one side and the ordinary everyday thing on the other: a few accents added at the right place, something very subtle, just enough. To finish the pastel middle section and strengthen it, I use the image of the gold tablets of Pyrgi. I make the inscriptions with a pointed pen on the surface of glazed gold leaf and, using a gilded line above and below, strengthen the vertical direction.

'To decide whether the work is now finished, I do not make judgements by asking: "Is the composition right?" or "Is the use of colour to my liking?" This has been thought about often enough during its creation. The work has not been created according to a rational plan. As a chess player, I

should have failed dismally because all the time I have thought only one move ahead. Subconsciously, I have used the power still dormant in all of us, to be appealed to by myth.

'At the moment I feel that I no longer view the work as creator but rather as spectator: I happen to have created it but now I can step back from it and think of it as a "story told". No longer do I perceive the work as artificially made but more as naturally developed, not as artefact but as myth. The transformation is complete and I have become an outsider, who, like any other viewer, can decide whether to begin a new dialogue with the work. In this way, everyone continues in his or her own way the process, once begun with the first stroke of paint and the first scribbles:

"Read on, there is perhaps more written than there is written…" '

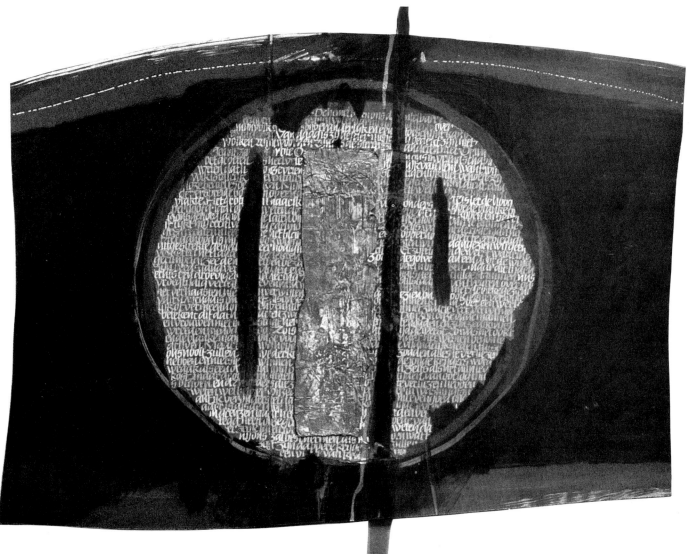

Composition with abstract symbols and written picture 1990 *(detail)* Acrylic, gouache, ink and variegated gold; lino-cut characters

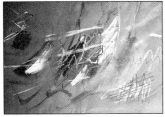 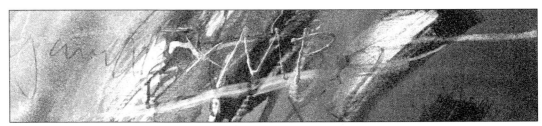

Memories of Margarete 1988 *(detail)* Acrylic, oil pastel, shell-gold in varnish, gouache, ink; specially prepared dyed paper

Composition with symbolic picture and writing 1990 *(detail)* Acrylic paint, gouache, ink, variegated gold; dyed paper

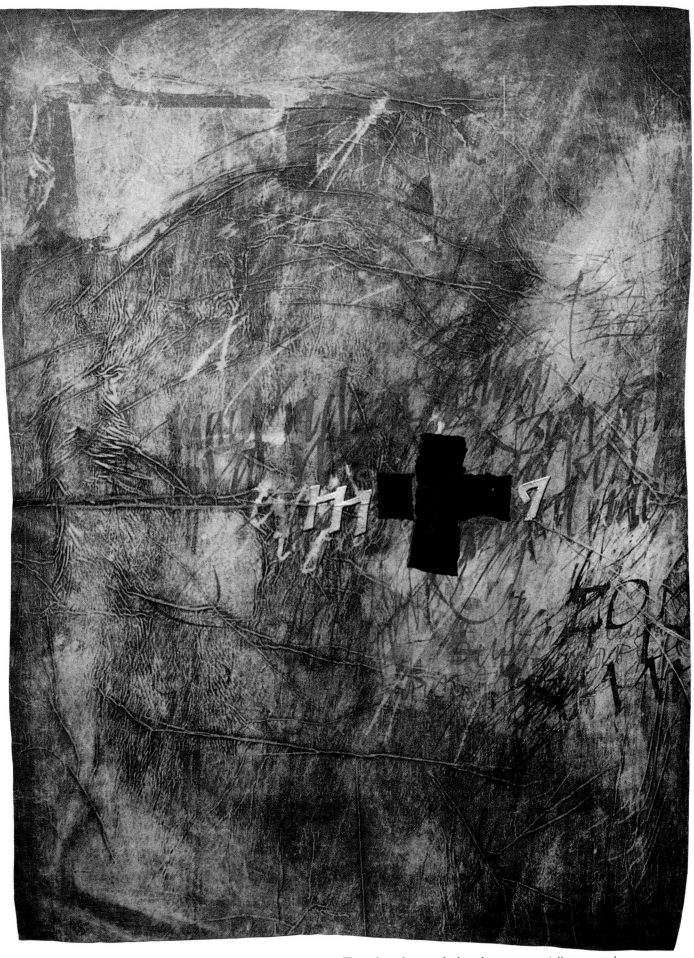

Thoughts about a dark-red cross 1988 Acrylic paint, gouache, ink and sandpaper on specially prepared dyed paper. It measures 70 x 90 cms (28 x 35 inches).

Sheila Waters

'Design is a process, not just an arrival, and for me it is often a long and frustrating, yet exciting kind of quest.'

Sheila Waters was born in England and trained at the Royal College of Art. In 1951 she was elected a Fellow of the London Society of Scribes and Illuminators. In 1971 she moved to the United States with her husband Peter and three sons (one of whom, Julian, is also featured in this book on pages 38-43). She is a founder member of the Washington Calligrapher's Guild.

While at art college, and later at the Royal College of Art, she specialized in calligraphy, lettering and typography and graphic design, in that order. Upon leaving college she admits to accepting every calligraphic commission which came along for the next twenty-five years, although since 1976 she has devoted more time to teaching which has enabled her to be more selective, choosing commissions which interest her and taking time to interpret in calligraphy the words of poets and authors.

This has enabled her to move in a direction which she considers to be 'fine art' rather than a utilitarian craft. Sheila Waters does not regard any calligraphic mode of expression

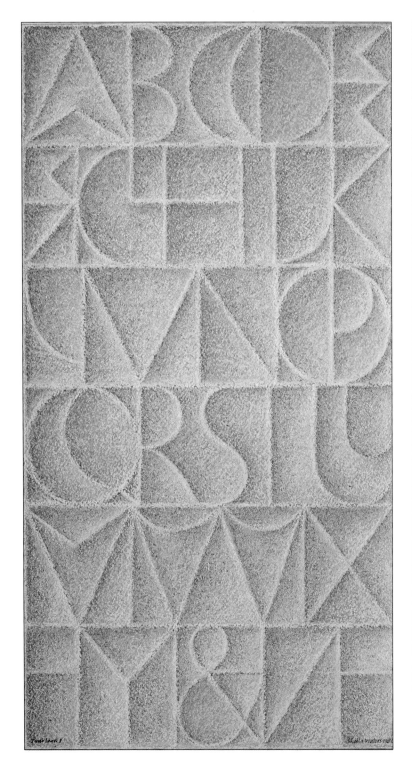

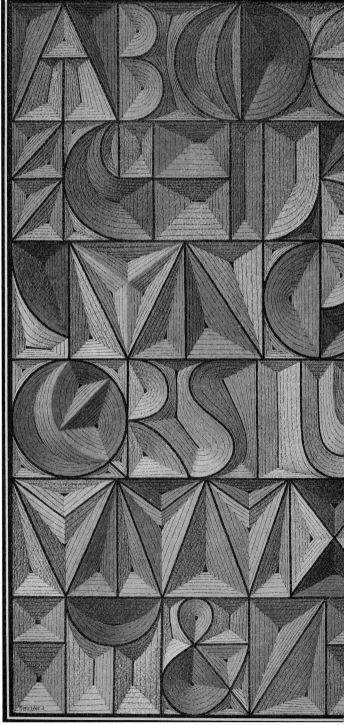

as higher or lower than another. The mechanics of problem solving in either instance are similar, concerned with the properties of good design — balance, proportions, contrast, consistency and also, where appropriate, the expression of mood and emotion.

'I think that conveying emotion is more difficult when the task is self-imposed, just as it is when creating a piece simply because of the desire to create it. The externally imposed restraints are gone and the motivation becomes internal, and therefore subject to all the constraints imposed by a lifetime of conforming.'

For Sheila Waters, this has become a major problem. How to be 'free and spontaneous' when one's training and then years of coping with rigorous specifications requiring meticulous craftsmanship all point in the opposite direction? It involves a change of deeply-rooted attitude, approach and method of working. Her attitude to every piece of finished work has always been to doubt that it could be right first time and to think that much work is needed to achieve the perfection she seeks. This high level of self-criticism makes it very hard for her to accept that she may be able to make a series of marks which should actually be left alone and not 'improved'. She sees this as a dilemma with which she will continue to struggle throughout her seventh decade and beyond.

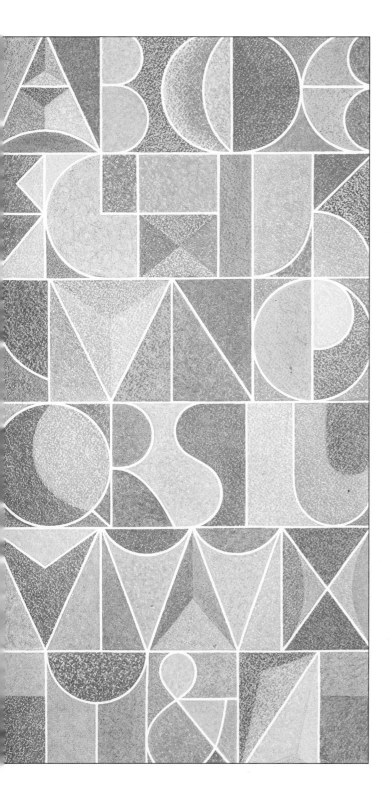

Time-Line Triptych 1986
Three paintings executed in gouache and oil pastel: the skeletal forms of the Roman capital alphabet are used as a structure through which to express something of the essence of three major epochs in the history of art.

The first, entitled Ancient, *contains a spectrum of grey, symbolizing the golden age of stone sculpture and incised inscriptions of Greece and Rome. An optical illusion causes the shapes within and between the letters to advance and retreat between the 'pincushioning' and creates the effect of shallow carving. The colours are very muted, occurring in the same locations as their brighter counterparts in the other two paintings.*

The second painting is entitled Mediaeval *and explores three-dimensional form in two dimensional space — to suggest the many past centuries of* representational art in easel painting and drawing. The planes recede as imaginary light from a single source falls on them. The effect is heightened by the perspective of fine line overdrawing.

The third painting entitled Modern *explores shape, colour, texture and pattern in a predominantly flat plane. The white divider lines are rigidly geometric and hard-edged.*

Even though the atmosphere of each painting is different, the technical means were the same. A ground of counter and interletter shapes was painted in gouache for each. This was followed by applying many varying colours of oil pastel which were layered and blended, the rough surface of the watercolour paper producing the texture. In the second painting the freely-drawn parallel lines were applied with pointed pen and black ink.

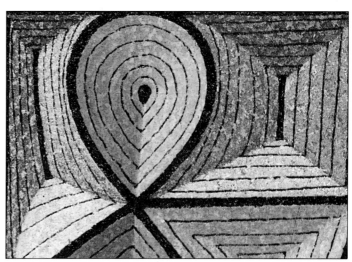

The Idle Flowers 1987 *A diptych of two panels written in gouache on to watercolour backgrounds.*

This diptych was designed for a double spread in the book Florilege *published by Alain Mazeran, Paris. Gottfried Pott, Alain Mazaran and Sheila Waters were the jurors asked to select calligraphic works on the subject of flowers for* Florilege

and its companion volume Flor-aison, *choosing these from over four hundred international entries. The long poem* The Idle Flowers *by Robert Bridges mentions a myriad of English wild flowers from all seasons. It reads like an inventory, and so Sheila Waters took the liberty of slightly changing the verse order. The poem actually begins at the top of the panel called 'Winter', radiating the*

verses clockwise so that each line begins near the centre. The poem switches to the 'Summer' panel halfway through, radiating the lines of poetry in a similar way.

The last verse about winter in fact forms the centre of the 'Winter' panel and has been created from built-up written panels, but the 'Summer' centre is filled with half of one of the verses, repeated in somewhat voluptuous uncials. The italic styles used in each half form a simple contrast from spiky and icy to flowing and summery.

Finally, the background watercolour washes carry through the winter/summer feeling.

This diptych was also included in the Renwick Gallery exhibition in 1990.

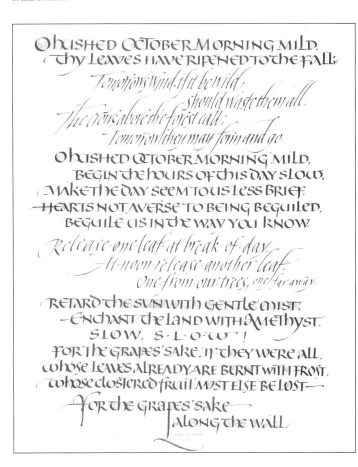

O hushed October morning mild,
Thy leaves have ripened to the fall;
Tomorrow's wind, if it be wild,
Should waste them all.
The crows above the forest call;
Tomorrow they may form and go.
O hushed October morning mild,
Begin the hours of this day slow,
Make the day seem to us less brief.
Hearts not averse to being beguiled,
Beguile us in the way you know.
Release one leaf at break of day;
At noon release another leaf;
One from our trees, one far away.
Retard the sun with gentle mist;
Enchant the land with amethyst.
Slow, slow!
For the grapes' sake, if they were all,
Whose leaves already are burnt with frost,
Whose clustered fruit must else be lost—
For the grapes' sake —
along the wall.

October 1985 A poem by Robert Frost, commissioned for Joanne Fink. Chinese stick ink and watercolours on white handmade paper.

This is one of seven original pieces chosen to represent Sheila Waters' work for an exhibition entitled *Four Contemporary Calligraphers* held in the Smithsonian Institution's Renwick Gallery, Washington DC, between May and October 1990. The other three artists represent Chinese, Arabic and Hebraic alphabetic systems.

This poem contrasts the fullness of autumn with the capricious winds which strip the trees of their leaves and herald the coming winter.

Sheila Waters uses two greatly contrasting styles to bring out these two facets of October. The uncials are rounded, fruity and relatively static while the

strongly slanted italic is 'windy', full of agitated movement. The device of separating the letters with large spaces and the words with dots (in the middle of the poem) is used to express the poet's longing that the process be slowed down to stave off approaching winter.

Of all the poems she has written out, Sheila Waters regards this work as the one which lends itself most easily to calligraphic expression.

CLOUD CONCEPTIONS
FROM ABOVE

THREE WHITE TREES,
equidistant, arise like plumes
From the gray-white floor of mist
Between the mountain chains
In morning sun, which slowly burns
the valley fog away.
The three trees change to sinister mushroom shapes
which stay awhile, and then dissolve.
In morning light, a snowfield I could walk upon.
My trees are gone, miles past,
Returned to parent vapor.

SUDDENLY, the windowscape erupts
as huge white mountains rise
From ice-blue glacier floors, an Arizona-Arctic —
HOW MANY WHITES IN WHITE?
From gold to blue, from gray to green,
Island woodland's soft tree-crowns
float in seascapes, pale and still,
Crumbling shorelines break at river mouths
Blue seas fade, mountains melt,
Becoming wide, white prairie lands
paradoxically pocked
with lakes of no reflection.

Cloud Conceptions From Above 1990 Triptych written in multi-coloured gouache on watercolour backgrounds. Three panels, each 45.7 cms (18 inches); total length 1.52 metres (60 inches).

This work is an example of a complete change of design midstream. After following through to the finished piece in a vertical format, this was

discarded and the work begun all over again. This time it was created in a horizontal format of three separated sections and in a greatly simplified style.

'Even though this was my own prose poem', she says, 'I had no clearer idea of how to express it than if someone else had written it. In fact, I went "all round the world to cross the road" more than usual. I made

the mistake of having October already in my mind with its vertical format and script changing according to the mood. I tried varying the style between free capitals and italic, but felt unhappy about the result in spite of dozens of pencil layouts and two full-size attempts in colour. I realized that the problem was my habitual one of trying to express too much, so that the overall effect

was busy and without focus. By "trying too hard", the calligraphic treatment was getting in the way of what I was hoping to convey in the poem.

'I tried to recapture the strong feeling I experienced when I wrote the words, while gazing out of an airliner window, totally entranced by the most varied and spectacular cloud formations I had ever seen.'

O hushed October morning mild,
Thy leaves have ripened to the fall;

Tomorrows wind, if it be wild,
Should waste them all.
The crows above the forest call;
Tomorrow they may form and go.

O hushed October morning mild,
Begin the hours of this day slow,
Make the day seem to us less brief.
Hearts not averse to being beguiled,
Beguile us in the way you know.

Stars 1989 This is a hand silk-screened print done in two colours on handmade paper. 45.7 x 33 cms (18 x 13 inches).

'I am reminded of this quotation from Emerson every time I pause to look up on a starry night,' says Sheila Waters. 'It expresses the grandeur of the universe yet implies that we take it for granted. My pencilled layout suggested a two-colour serigraph of silver on midnight blue, so I prepared the full size camera-ready writing for their superb craftsmen to interpret. The writing styles are confined to built-up and simple written capitals and a dancing italic, with small star-like embellishments, all the lines having an upward motion.

CLOUD LAYERS, just below, fly too,
at variable pace,
Layer over layer, transparent clusters glide
Journey with us, then are left behind.
Horizon clouds maintain their forms
of unimagined worlds.
Fantasy lingers, then flees
As higher, formless vapors roll
And engulf the WILD WHITE VISION
That has touched me for an hour
And held me in its loveliness.

Prose-poem & calligraphy - Sheila Waters ©1990

The single, large vertical piece became three horizontal small ones, linked by the colour and textures of the background watercolour paintings which echoed the words, but made no attempt to express them too figuratively, and also by the asymmetrical arrangements of the three 'verses'. The script was a horizontally stretched-out modern Carolingian style which she developed in 1961 for an illumination manuscript of Dylan Thomas' play Under Milk Wood. Because the lines were kept straight with the letters of even height, she found she was free to subtly change the colouring of the writing as the sense suggested.

'The solution seemed too obvious', she said, 'and I wished I had arrived at it at the beginning.'

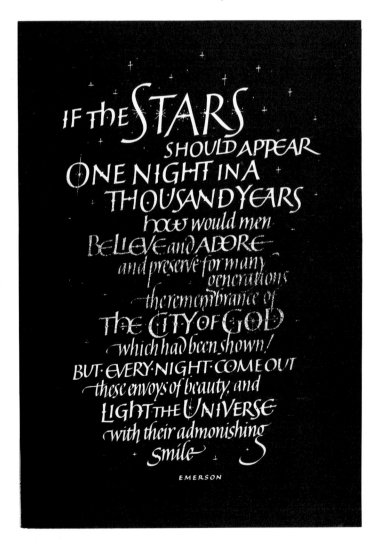

IF THE STARS
SHOULD APPEAR
ONE NIGHT IN A
THOUSAND YEARS
how would men
BELIEVE and ADORE
and preserve for many
generations
the remembrance of
THE CITY OF GOD
which had been shown!
BUT·EVERY·NIGHT·COME OUT
these envoys of beauty, and
LIGHT THE UNIVERSE
with their admonishing
smile

EMERSON

Jean Larcher ——————————— FRANCE

'Calligraphy is a personal adventure, bringing together mind and body through the harmony of hand and eye, with limitless possibilities and tremendous satisfaction in solving problems.

Jean Larcher is a Breton born in Rennes. As a student in Paris from 1962-65, he studied printing and classical typography, an experience which he still regards as being very productive. This education was supplemented from 1964 in the Ecole de la Ville de Paris, where he learned two more things: firstly, the drawing of letters as taught to signwriters, and secondly, drawing freehand with a brush Roman Capitals, Uncials, Gothic and Rotunda scripts. Although his experience of calligraphy at this time was 'rudimentary, uncreative and boring', he loved it simply because he liked drawing letters, instinctively feeling that drawing had so much more freedom of expression than traditional typography, especially as letters were usually drawn in colour.

On leaving college, Jean Larcher worked as an advertising designer, sometimes producing calligraphy for clients using a Graphos pen in the form of parchment imitations — such as invitations and wine-labels, drawing his inspiration from printing catalogues and, as a young designer, believing that that was all there was to calligraphy. This period

coincided with the advent of dry transfer lettering and for many, heralded the end of the professional letterer and further aggravated the isolation experienced by those lovers of lettering who remained.

In 1970, while on holiday in Spain, he discovered and bought his first book on calligraphy, a real treasure, *Bellezas de la Caligrafice* published in Barcelona in 1837, a masterpiece of copperplate engraving. Since then he has bought fifty books of Spanish calligraphy and is probably the only specialist and collector of Spanish calligraphy in France. These books, together with one or two others, were to provide the basis of his practical and historical education.

It was, however, an event in December 1978 that was to prove the turning point, the moment of awareness which he had so long been seeking. It was then that he visited a large exhibition of contemporary calligraphy in New York, called *Writing and Illuminating and Lettering.* He realized that besides typography there was another, more personal discipline through which an artist could communicate by the use of writing. He had never experienced this breadth in France, and although he was interested in calligraphy, especially old Spanish calligraphy, what he discovered in New York was a living contemporary art: Calligraphy was alive and well!

Jean Larcher at work

Original calligraphic lettering 1990 This calligraphy was used for the jacket of a book about French cooking. Untouched artwork was penned in black Indian ink on to Ingres d'Arches paper.

Several tight sketches were followed by the rendering itself with much care being taken over the spacing. This was reversed out for a full colour photograph on the cover. 30 x 50 cms (12 x 19.8 inches).

LA CUISINE DES TERROIRS

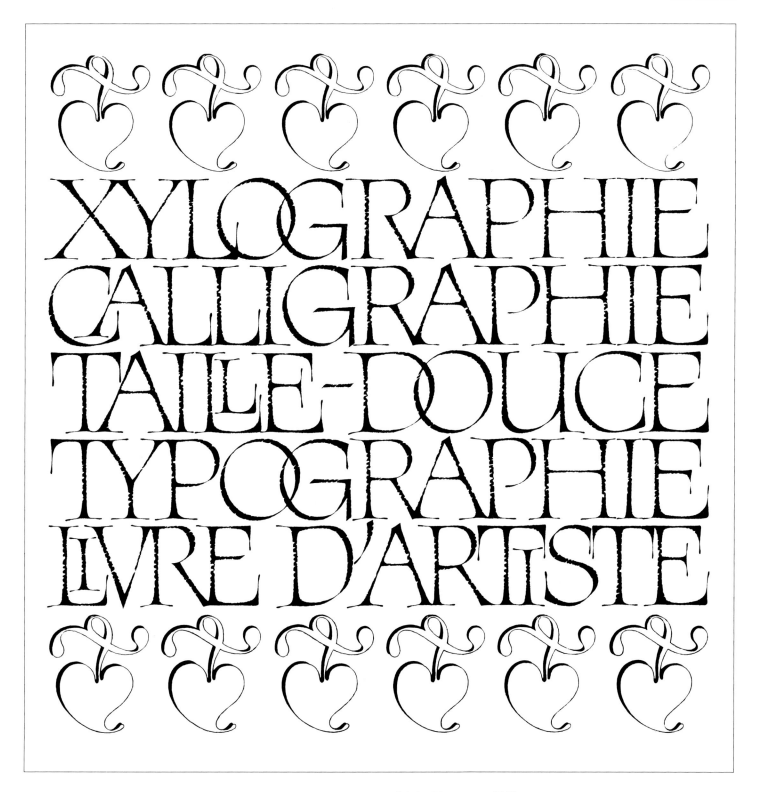

Original logotype 1989
Designed for an artists' fellow-
ship, this piece of calligraphy
was accurately planned, with
several tight sketches. It was
penned in black Indian ink on
to Ingres d'Arches paper; the
ornamental border was also
penned with a pointed pen.
It measures 50 x 65 cms
(19.7 x 25.5 inches).

From that time he became aware of the richness of Anglo-Saxon calligraphy and became a member of the Society of Scribes and Illuminators in 1981. He is by nature a perfectionist, and it is from this basis that he judges calligraphy, whether it is old or modern, commercial or expressive: namely that if calligraphy is done at all, it must be done well. In this dictum he is merciless: 'Calligraphy should be the art of perfection. If a person is a professional calligrapher, there can be no room for amateurism. With a student, however, it is different. Mistakes will be made — but how else is one to learn?'

'When I look at English and American books on calligraphy from the 1960s, they seem to belong to the last century.'

It is the rapidly changing face of calligraphy with which he is so much in tune. Dry transfer letters certainly took their toll but in other ways their advent released the calligrapher from some of the constraints of the earlier years.

'When confronted with photo-composition, computers, videos and technology in general, the only chance calligraphy has to survive is to remain above all creative, evolutive, unique, exclusive and very plastic.

'Calligraphy is an art; it is not a reproductive technique. Calligraphy in the most noble sense must remain "the writing of writing".'

At the same time he believes it must be experimental and evocative of the text it conveys, and above all, retain a plastic quality. The alternative is that it will disappear or be relegated to a *fin de siècle* curiosity.

Jean Larcher is undoubtedly a propagandist for calligraphy in France. He has written thirteen books on graphics, typography and calligraphy, as well as writing articles and organizing exhibitions. After seventeen years of freelancing, he has concluded that the only way to persuade the French to look at calligraphy (in exhibitions, books, workshops) or to buy it (through advertising agencies,

Catalogue cover 1990
Unretouched work done with brush pen in black and white.

Calligraphic lettering 1989
Used as a masthead for an in-house brochure, the original artwork was done very quickly from scratch without sketches. Rendered in black Indian ink on to white Canson paper with a broad American pen called Steel Brush. 50 x 65 cms (19.6 x 25.5 inches).

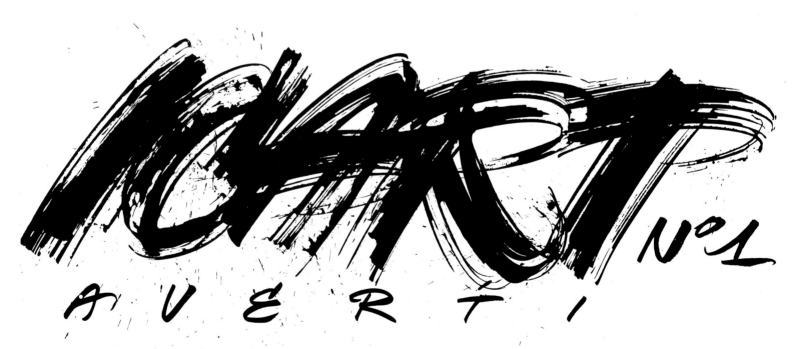

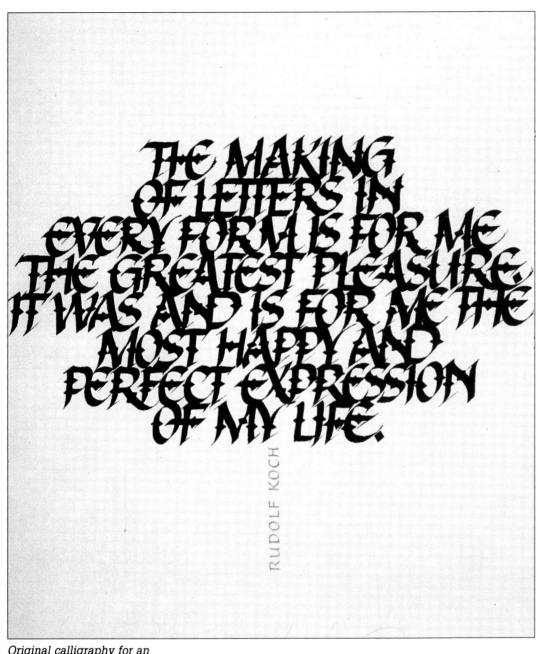

THE MAKING OF LETTERS IN EVERY FORM IS FOR ME THE GREATEST PLEASURE, IT WAS AND IS FOR ME THE MOST HAPPY AND PERFECT EXPRESSION OF MY LIFE.

RUDOLF KOCH

Original calligraphy for an exhibition 1990 Black Indian ink on Ingres de Rives paper, slightly dyed with a metal pen Speedball C.0. 30 x 40 cms (11.8 x 15.7 inches).

editors, institutions and museums) is to sublimate it — sell it as art. In other words, one can market it as an equivalent of painting — a unique piece — not as an example of workmanship but of *Art.* Only in these terms is calligraphy bought and appreciated.

Knowing this, his aim is to give back to calligraphy its nobility by his own work which is above all experimental and contrasts with the ubiquitous typography where content is seen to be more important than is form.

The absence of a modern national tradition can be a two-edged factor. On the one hand, the source, traditions and cultural references are largely absent but, on the other hand, because of their absence calligraphers enjoy immense freedom to explore and create their own cultural parameters.

This is borne out in Jean Larcher's work and reflects his belief that he does not belong to any particular school. While appreciating the work of Zapf, Julian Waters, Reynolds, Schneider, Howells, Jackson and Dieterich, he feels closer in spirit — because of the freedom, controlled and superbly mastered — to Toots, Stevens and Poppl.

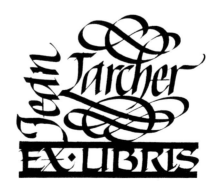

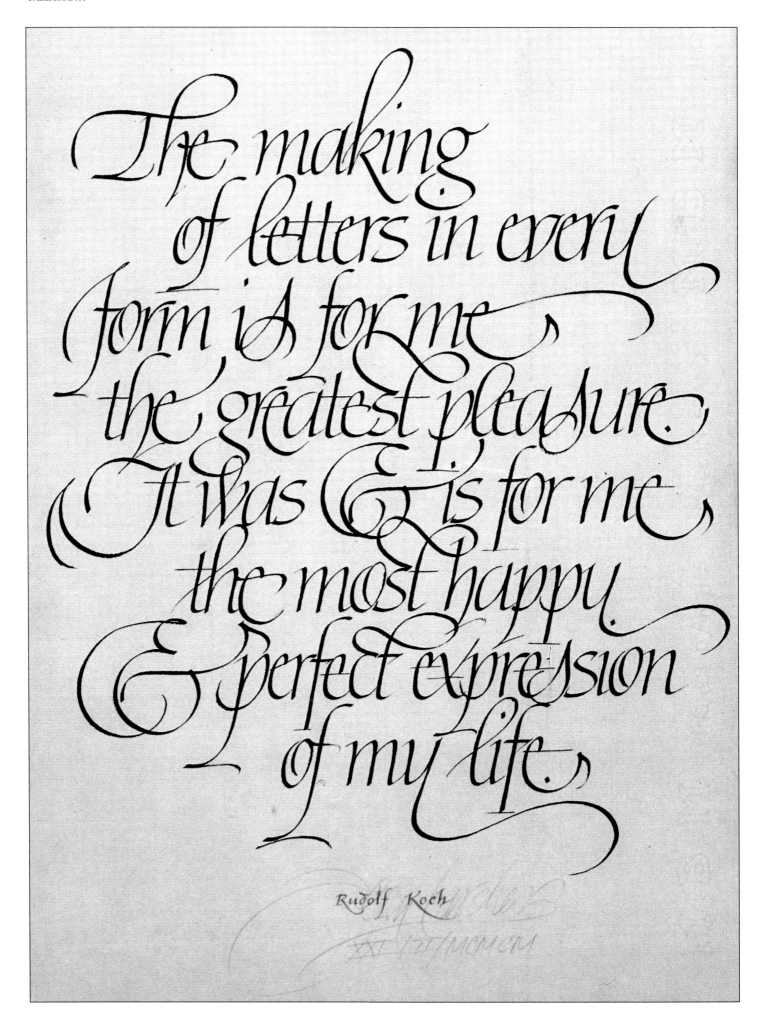

The making
of letters in every
form is for me
the greatest pleasure.
It was & is for me
the most happy.
& perfect expression
of my life.

Rudolf Koch

Calligraphy for a Jean Larcher exhibition 1990 Black Indian ink on to Ingres paper slightly dyed and water-marked, using a metal pen Speedball C.3. Dated and signed; measuring 30 x 40 cms (11.8 x 15.7 inches).

Calligraphy for an exhibition 1990 Watercolours Ecoline brandt applied on to white Aquarelle paper, with free use of the ruling pen. 30 x 40 cms (11.8 x 15.7 inches).

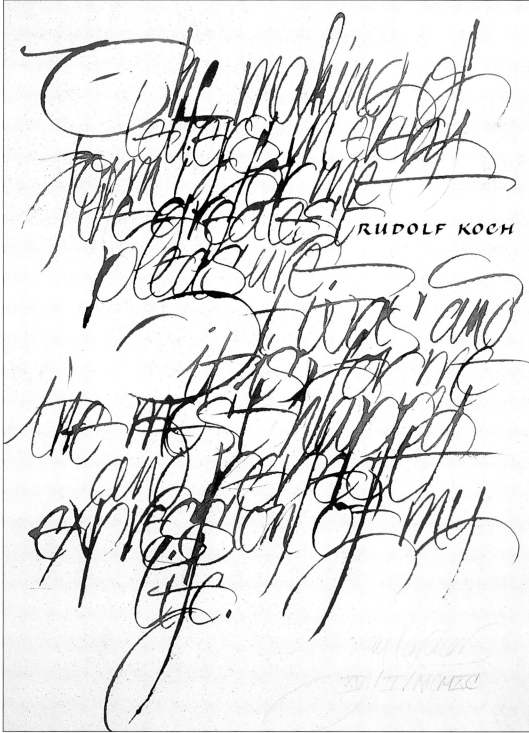

RUDOLF KOCH

Ex Libris Number 25 of a set of 100 prints — a present to the author, David Harris.

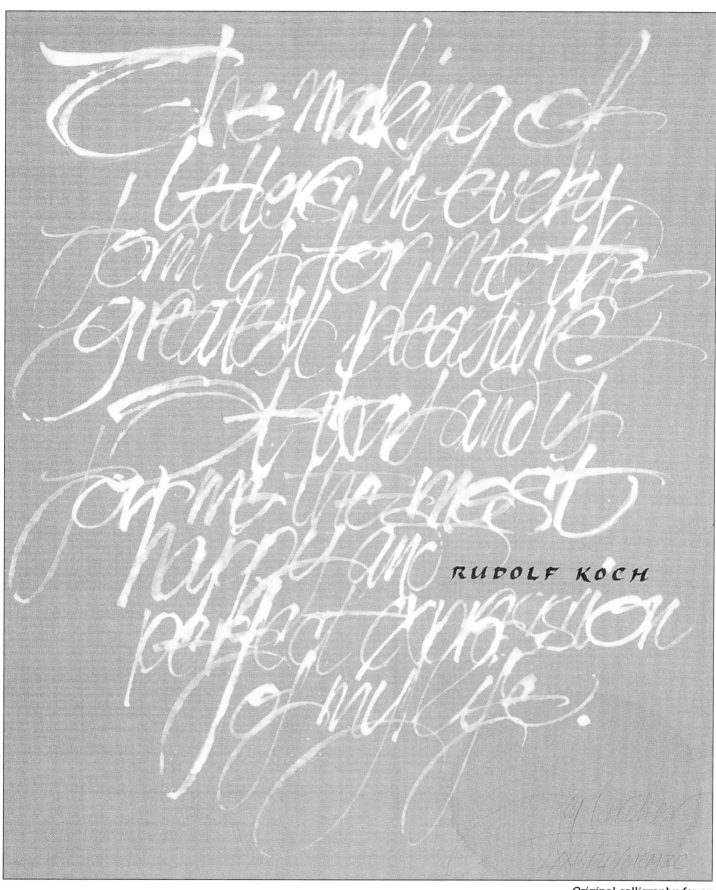

The making of letters in every form is for me the greatest pleasure. Her hands form me the most happy and perfect expression of my life.

RUDOLF KOCH

Original calligraphy for an exhibition 1990 Here white acrylic paint has been used on Fabriano Roma paper, dyed and watermarked. A ruling pen was used freely. 30 x 40 cms (11.8 x 15.7 inches).

Alphabet 1989 Used for an invitation card and printed in four colours in off-set lithography for a one-man exhibition in Lyon. Watercolours Ecoline brandt have been used on Canson Lavis white paper and a metal pen Speedball C.2. It measures 30 x 40 cms (11.8 x 15.7 inches).

Thomas Ingmire

UNITED STATES OF AMERICA

'My challenge is to paint the music of poetry, the motion of poetry, the part that cannot be understood.'

That Thomas Ingmire is a relative newcomer to the world of calligraphy perhaps makes his impact upon this all the more remarkable. He began his career as a landscape architect in San Francisco and it was by chance that some classes in calligraphy were brought to his notice. Thinking that this would be a useful addition to the stylized script which he was currently using, he enrolled. Ultimately, it was his introduction to Donald Jackson at the Calligraphic Workshops in California that opened up a whole new world for Thomas Ingmire. Little did he realize that within a few years he too would be opening up new worlds for other calligraphers in the same way.

He now feels that with so many of his friends enthusiastically entering into the modern world of computers, his ideas are becoming old-fashioned — an attitude which can surely be challenged. His fondness for the history and craft of calligraphy, the freshness of the handwritten letter, the depth and richness of pigment colours, the magic and mystery of burnished gold are manifest in all his work. However, this adherence to the traditional craft of calligraphy in no way impedes experimentation and application to the other artistic fields of music, dance, poetry and painting.

Poetry is Thomas Ingmire's greatest inspiration and the key to his work. He recalls his surprise at how much attention and concentration was required to make a letter with an edged pen — he felt that the words

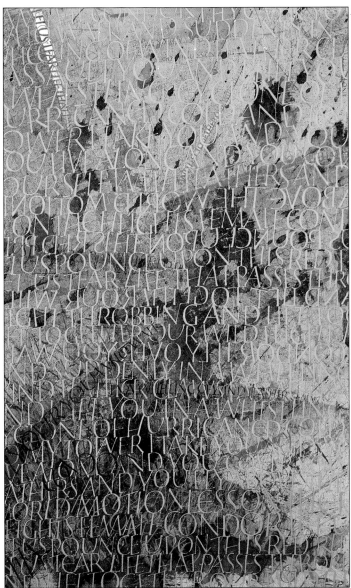

Let us tear life 1989 I sought to capture the idea of breath as an image built up and layered with words from the poem. I intended that the page be full and complex ! 45 x 59 cms (23.5 x 18 inches). Mixed media on paper.

Night terrors 1990 The Night is very powerful and emotional. It presents dark monotone deathly images interspersed with brilliant flashes of colour and sound. It is a poetry of madness — the madness of night and mind. That is the image I was trying to explore with the ragged, torn and textural collage. Paper collage with writing, painting, acrylic, gouache, watercolour, ink and gold leaf on gesso. 47 x 70 cms (31 x 24 inches).

thus enscribed should be worthy of the effort. This led to his first serious exploration of poetry, though in the early days he used it only as a means to practice his new craft. The words themselves are now of major importance, becoming a constant point of reference and frequently a source of inspiration. Thomas Ingmire uses them as a painter uses a model. In his own words:

'The painter rarely tries to create a picture which is an exact reproduction, but instead interprets the model to make a statement'.

Although for the most part words are the main source of Thomas Ingmire's inspiration; he has his own very definite ideas on the nature of the creative process. For example, a specific poem will help him to determine how a piece of work will evolve and how it will look, but 'inspiration' (which actually motivates him to embark upon a work, or indeed to work at all) is far more difficult to define. He says:

'It presumes that one can actually define inspiration, in the same way that one might jot down a recipe. The honesty and inner consciousness that is required to do this is probably beyond most of us. I feel this very strongly and conclude, at least to myself, that anything I write (on this subject) today would be different from what I would write tomorrow. And to be even more blunt, I doubt that I could ever take seriously any of my thoughts on the subject. With that background, what follows is my recipe on inspiration for today:

My ultimate motivation is fear — fear of not being able to pay the rent, or to put food on the table.

The work that I do is what I know how to do best.

I experiment a great deal because I do not know what I am doing.

Thomas Ingmire Working with students.

Not knowing what I am doing makes it easy to experiment.

I am not sure that I have a choice about what I am doing in my work, which suits me just fine.

Some of my work is guided by a slightly rebellious nature. I do not like to do what others want or think I should do.

I am curious about mythology and the mysteries of life — the unknown, the darker side.

If I see an idea that I like, I copy it ... an innocent form of thievery.

I am cynical.

He concludes that the bottom line is that inspiration is the product of hard work — the old adage that inspiration is ninety cer cent perspiration — of working every day. It is not something that one waits for or

which appears out of the blue, but which involves trusting one's own ideas and having faith in life itself. Most importantly, it is fostered by a willingness and ability to accept failure and by keeping an open mind to new ideas and new ways of looking at the world.

Let us Tear Life is the last of eight pieces which were interpretations of Neruda's poem *El Condor.* The poem is one of three poems of desire that Neruda wrote about his love for Matude Urrutia, whom he married in 1955. Thomas Ingmire's work with this poem was provoked by an interest in visually expressing the theme of passion. The first visual image which came to his mind was of a page filled with wild windswept, expressive marks. He says: 'While working with the poem, I became aware of its similarities to the Greek lyric poets' descriptions of Eros. The poem reminded me of the

Sappho fragment... "Without warning, as a whirlwind swoops on an oak, love shakes my heart".

'I also came across the book Eros, the Bittersweet, by Ann Carson which provided critical insight into the mythology of Eros. It was fascinating to discover that the wild and raw images of the Neruda poem had their roots in this tradition. Carson also draws an interesting analogy between the nature of Eros and the genius of the Greek alphabet.

'The unique aspect of the alphabet was the introduction of consonants which imposed edges on the sounds of human speech. The alphabet, visually,. with its symbols, portrays ideas. But through speech, which requires breath, the ideas are communicated by sound. For the Ancient Greek, breath was everywhere, and the breath of desire was Eros.

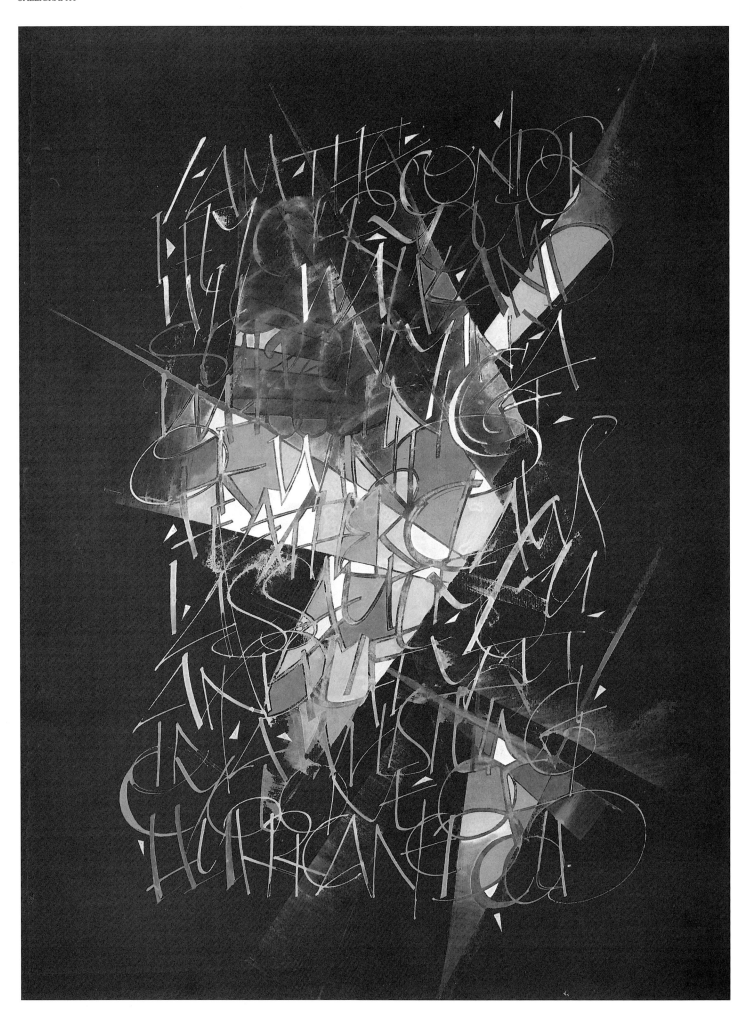

'Just as wings and breath transported Eros, wings and breath convey words.

'This connection between Eros and the alphabet provided the starting point for the development of *Let us tear at life*. When I began, I sought to capture the idea of breath as an image entirely built up and layered with words from the poem. I intended that the page be full and complex. The actual forms took reality as I worked.

'At one point I felt that specific shapes were becoming too dominant and the overall vision of the page as 'breath' was being lost.'

A number of techniques were being used to bring about more of an overall evenness. The entire page was 'washed', a process of running water across the page to remove some of the pigment (see 'How-to' section).

Another technique involved a light spraying of white with a hand-held atomizer, which created a more muted background: 'And in a more or less made fury, I threw some diluted ink water on the page. However, the final decision, which brought the piece to my original vision, was to write the poem in large letters as an even texture over the entire page. I used gesso (the same gesso used for raising gilding minus the bole) which resulted in raised white letters. Some points on the letters were then gilded. Occasionally the Greek boustrophedon style of writing (alternate lines in different directions) and reversing of letters employed to make the link, at least symbolically, of

El Condor *This work was inspired by Thomas Ingmire's fascination with the theme of passion and how to express this through visual media.*

the Neruda poem to Greek mythology.'

The bringing of more information to his work is a common part of Thomas Ingmire's working process. He has found that poets' biographies and various forms of literary criticism are helpful in giving another perspective. He initially read these as an aid to understanding or interpreting a poem. However, he found that because literary critics often gave conflicting commentaries on a work, interpretation seldom resulted from his searches. They were, nevertheless, extremely valuable as the multiplicity of viewpoints generate a multiplicity of images and as he works these images trigger other thoughts and ideas which again foster even more images.

For Thomas Ingmire, this constantly evolving process keeps the work and his interest fresh and alive.

At the time of publication *Night Terrors* is Thomas Ingmire's most recent work representing a significant departure for him, particularly in technique. The abstract imagery, dominant over the words, is made up primarily of paper collage. The working process involved a variety of steps, including pasting papers together, crinkling and shaping paper into permanent forms with glue, painting into the collage surface and tearing away and re-attaching portions of the work. The gold letters are gold leaf on gesso which were executed on a separate sheet, then torn into strips and glued on to the collage. These techniques were used as a means of creating a rich dimensional surface texture to express his thoughts about the poem.

'For me', says Thomas Ingmire, '*Night Terrors* is very powerful and emotional. It presents the reader with dark, monotone, deathly images, interspersed with brilliant flashes of colour and sound. Grey towers, bleak ferns and crystal blossoms are

intertwined with fiery beasts, golden fires and hellish grimaces. It is a poetry of madness — the madness of the night and mind. This is the image or sense I was trying to explore with the ragged, torn and textured collage.

'The poem has actually been difficult for me to interpret and understand. Usually in my process of working, my grasp or sense of a poem becomes quite clear. *Night Terrors* is the fifth piece that I have developed based on Trakl's poem, yet I am still confused about its meaning. I have found some solace for this dilemma in Robert Firmage's introduction. He states that the "language of this poet is dark" and that such darkness renders the work opaque both to translation and interpretation.

'Trakl's poetry is certainly the most abstract and at the same time the most visual of all the texts I have chosen. The poem in English is a translation from the original German. In a curious way there may be some advantage in using translated works. By nature, a translation is a step removed from the original. It is, in effect, an interpretation of the poem. So a translation can be viewed as a verbal transformation of the poem, in much the same way as a "painted" calligraphic image can be viewed as its visual transformation.

'With Trakl's poetry being so abstract in meaning, it is possible that an expressive presentation, which emphasizes the visual over the verbal message, may actually be close to the truth of the poem which evokes an emotional response through its visual imagery rather than relying on the reading of words.'

I do think that words must be very carefully chosen.

Words which inspire the mind to seriously contemplate ideas are probably best interpreted by the calligrapher in a simple

transcription. Didactic poetry, inspirational speeches by historic figures, and most religious texts would fall into this category of being best complemented by a simple approach.

Works of transformation, that is calligraphic pieces which visually transform, distort or interpret the verbal message must be based upon works of a different nature.

The following description of Trakl's poetry by Walter Sokel provides a hint to what I am suggesting:

"Just as Kandinsky creates pure compositions of colours and lines, so Trakl creates pure composition of autonomous metaphors.... Each poem has an inner coherence, not the coherence of logical thought, but of a musical composition... the metaphorical image acts somewhat like the note of a musical score indicating that a certain tone or chord is to be played. Or it can be compared to a shade of colour in an Expressionist painting, that does not describe the object to which it may be attached, but designates a certain mood that the painter wishes to convey."

The selection of poetry which fits this description will ultimately be viewed as essential to the success of calligraphic works of transformation. The abstractness of such poetry with its emphasis on emotional and perceptual characteristics, plays in the calligrapher's favour. It does not provide us with facts, nor is it concerned to have us understand or arrive at interpretation. But the words, like music, allow and encourage us to arrive at an experience — an experience that we can express and share through our work.

This idea comes closest to defining the link between the words I choose and the work I create. My challenge is to "paint" the music of poetry, the emotion of poetry, that part that cannot be understood.'

Hermann Zapf

'We don't create things to earn fame, we put no scratches on the globe, but perhaps with our gentler art we add a few little dabs of joy to life, in a nicely written praise of the Lord, written with the complete engagement of our heart.'

Hermann Zapf was born in Nuremburg in November 1918. As a youth it was his ambition to become an electrical engineer but the political situation in Germany prevented him from attending either the Technical College or the Art School, his second choice. Instead he became apprenticed as a photo-retoucher.

It was in his first years as an apprentice that he became aware of calligraphy through the work of Rudolf Koch's book *Das Schreiber als Kunstfertig Keit* and set about practising with a broad-edged pen the Fractur letter they contained, little realizing the great field of creative activity this would open up for him. Soon he discovered Edward Johnston's *Writing and Illuminating and Lettering* and it was through the influence of the latter that he began to move away from the Fractur style to a wider appreciation of letterforms.

He was further assisted in his diligent self-teaching by research in the old city library of Nuremburg with its great collection of works by the writing masters of the past, which assisted his study of historical models. The price of self-tuition is, of course, high and a price which no aspiring calligrapher today need pay.

As Hermann Zapf puts it, there was '... no friendly teacher looking over my shoulder to

Calligraphic title page
Letters built up with two different widths of broad-edged pens with double stroke stems.

correct my mistakes. With a critical comment, he could have saved me two years of going the wrong way by holding the pen incorrectly. By self-instruction, you repeat your mistakes again and again, without knowing they are mistakes.'

In 1938 he entered the printing house of Paul Koch, son of Rudolf Koch at the Werkstaff Haus Zum Furstenech, a delightful fourteenth-century building in the old part of the city in Frankfurt. Soon after moving to Frankfurt, he was befriended by Gustav Mori, the type historian, and through this friendship he was able to continue his course of self-instruction using Gustav Mori's extensive library, gaining also through Mori an introduction to the Stempel type foundry and

their punchcutter, August Rosenburger. The relationship proved extremely useful, culminating in Hermann Zapf's first typeface, Gilgenart. He was then twenty years old.

In many ways, Hermann Zapf epitomizes what is perhaps the greatest strength of German calligraphy or fine writing; that is, he uses calligraphy as a basis for all letter-crafted disciplines and divisive lines are not drawn between each activity, the practitioner moving easily between one form and another.

Hermann Zapf describes himself as a calligrapher, type designer, book designer and teacher, and although we are primarily concerned with the calligraphic aspect of his work, it is impossible to see this in isolation, each boundary being crossed and recrossed. As a type designer, he has designed a hundred and seventy-five typefaces for hand and photo composition and digital laser systems. His typefaces are among the most widely used in the latter half of the twentieth

PAPER-MAKING BY HAND

A BOOK OF SUSPICIONS BY WALTER HAMADY

THE PERISHABLE PRESS LIMITED

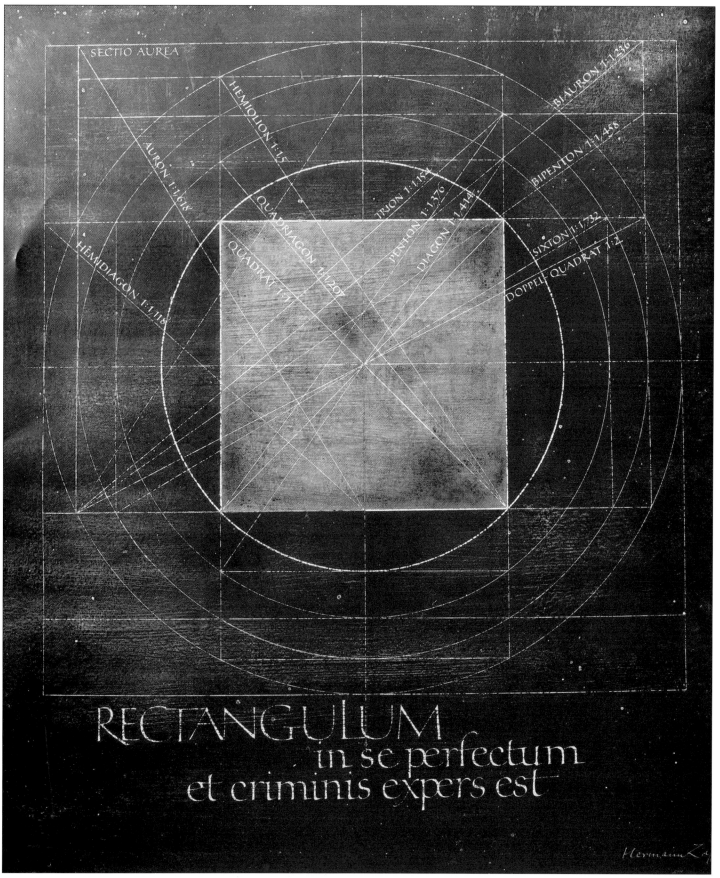

Rectangulum Hermann Zapf
epitomizes the belief that
calligraphy is a basis for all
letter-crafted disciplines; the
boundaries should be crossed
and recrossed.

A new typeface: Civilité The complete font of the alphabet.

Zapf Civilité 1971 First
sketches on Japanese paper,
using a broad-edged pen.

Civilité: the final characters
*Retouched drawings with a
broad-edged pen.*

These illustrations show
various stages and methods
of turning calligraphy into a
typeface. The complete font
(top left) was cut in 24 point
on Didcot system by Paul H.
Duensing. The first sketches
(top right) were done to test
the weight and spacing and
to compare alternate letters
(ligatures marked with
asterisks). The hand-cut
letters are shown on the left.

Pen and Graver Originally
designed as calligraphic
examples, this time the letters
were cut by hand to be used as
type by the punch cutter,
August Rosenberger.

only a ligature (or needed separate for Eng.?)

abcqukeloyirdwbln

* * * runs over the x-height

mdugszjwxtvgsII.

perhaps under the base line both very light

non-ligning figures only

spa 1234567890of?!

= 74 pt PICA

LGUTSPEEJ

* *

QWFYKXZPL

* *

MCBDOAHKI

* D = too German

NHDASPDRV

* more weight than the usual characters
 as a typical Civilité element

Hermann Zapf
1971

century, and Palatina, Melior and Optima represent his best known faces.

After the war he returned to Stempel as Art Director where he remained until 1956. In 1949 he published his first great book *Feder und Stichel* (Pen and Graver), begun before the war. The quality of the printing and the clarity of the plates have combined to produce a book described as 'unequalled in our time'. It was first begun in 1939 and the drawings completed in 1941. The plates were cut by August Rosenburg during the war. It had importance for another reason, for it marked the beginning of a personal development in writing technique, whereby a subtle shading of the letter-stroke is created by varying the pen pressure — starting a stroke with pressure, reducing it at the waist and increasing it again at the end of a stroke. This he calls 'the piano-player method' which was quite different to the method used by Edward Johnston and Rudolf Koch. His second book, *Manuale Typgraphicum*, was published in 1954.

It was during his period at Stempel that he became an instructor of lettering at the Offenbach Werkkunstschule, where one of his students was Friedrich Poppl. Since this time he has become a Visiting professor and has attended many workshops in Europe and in America.

He feels both concern and optimism about the future of calligraphy — concern that:

'At schools and universities in my country (Germany), the teaching of art history completely ignores letterforms in every aspect. Contemporary calligraphy does not exist for them. Medieval manuscripts are included for study but they teach nothing of calligraphy from our present century. Modern painting fills their lectures.

Calligraphic poster *These lines are a quotation from the Lebanese poet, Kahlil Gibran (1883-1931).*

The history of the world is none other HEGEL than the progress of the consciousness of Freedom.

WRITING IT IS THIS BOON TO MANKIND THAT ABRAHAM LINCOLN PRAISED IN THE HIGHEST OF TERMS WHEN HE SPOKE OF WRITING AS THE GREATEST E·A·LOWE INVENTION OF MAN·

Hegel quotation for the Scott Paper Company The paper had a rough surface so the letter outlines are not absolutely crisp.

Capitalis Quadrata A free version, from a collection of historical examples.

And of art schools, he says: 'There is no time left to teach calligraphy or lettering in either basic or advanced courses. They think calligraphy is outdated — not modern enough for so-called visual communication in our day of electronics and computers.'

However, on an optimistic note he sees the advent of more leisure time reflected in the growing interest in calligraphy, the increase in the number of calligraphic societies, and the growing number of workshops now available.

Zapf Chancery Hermann Zapf's words in his own calligraphic hand translated into a typeface, just as Gutenberg's type was created over four hundred years ago!

'For someone who wants to start, it is never too late. Like music, you connect this art not only with your hands, but with all your feelings — your heart and your mind. It is the perfect human experience.'

Friedrich Poppl

1923 - 1982 GERMANY

'The form will remain uncorrupted only through the contrast between black and white.'

Friedrich Poppl was born in the village of Soborten near Toplitz-Schonau in what is now Czechoslovakia. He received his early education as an artist and designer in the Technical School (Staatsfachschule). At the age of eighteen he was conscripted into the army serving on the Russian front, where he was finally taken prisoner. In 1946, whilst still a prisoner, his right leg was amputated and as a consequence he was released and returned home in 1948. These are the basic facts of Friedrich Poppl's early life.

It was typical of the man that these traumatic events imbued in him a sense of urgency and intensity of commitment to make up for the lost years. That he ultimately became one of Germany's most influential modern calligraphers is now

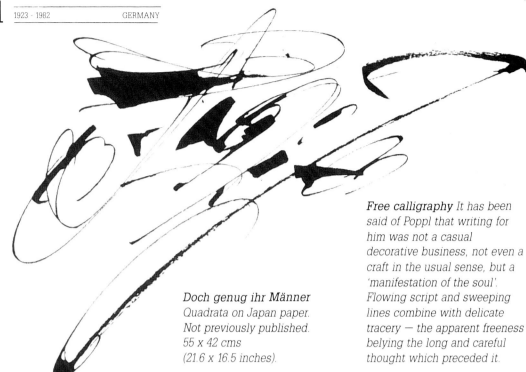

Doch genug ihr Männer
Quadrata on Japan paper.
Not previously published.
55 x 42 cms
(21.6 x 16.5 inches).

Free calligraphy It has been said of Poppl that writing for him was not a casual decorative business, not even a craft in the usual sense, but a 'manifestation of the soul'. Flowing script and sweeping lines combine with delicate tracery — the apparent freeness belying the long and careful thought which preceded it.

DOCH GENVG'IHR MÆNNER!
WAS ICH ZV MEINER VERTEIDIGVNG ZV SAGEN WÛSSTE,
IST ETWA DIES VND VIELLEICHT NOCH MEHR DERGLEICHEN.
VIELLEICHT ABER WIRD MANCHER VON EVCH VNWILLIG,
WENN ER AN SICH SELBST DENKT, WIE ER BEI DVRCHFECH-
TVNG EINES WEIT LEICHTEREN RECHTSSTREITES, ALS DIESER
MEIN PROZESS IST, DIE RICHTER GEBETEN VND ANGE-
FLEHT HAT VNTER VIELEN TRÆNEN, WIE ER KINDER VON
SICH MIT HIER HERAVFGEBRACHT HAT, VM NVR MÖGLICHST
VIEL MITLEID ZV ERREGEN, VND VIELE ANDERE VON
SEINEN VERWANDTEN VND FREVNDEN DAZV, DASS ICH
ABER VON ALLEDEM NICHTS TVE, WÆHREND ICH DOCH,
WIE ES SCHEINEN KANN, IN DER ÆVSSERSTEN GEFAHR
SCHWEBE.

Friedrich Poppl's writing instruments Apart from conventional calligraphy tools, Poppl used the ruling pen, a drawing instrument intended for very precise strokes. This came about while working in the 1950s on a commission requiring very precise lettering.

Late one night after hours of work, Poppl felt such an overwhelming aversion to this instrument that he plunged it into the ink and wrote a word right across a fresh sheet of paper. The quality of the letters unintentionally created in a fit of anger was so pleasing that Poppl continued to experiment with the ruling pen. Because he was hampered by the small amount of ink the pen could hold, his father-in-law made for him the very wide pen in the centre of the picture. Calligraphers use the ruling pen today as a matter of course, many unaware of its origin!

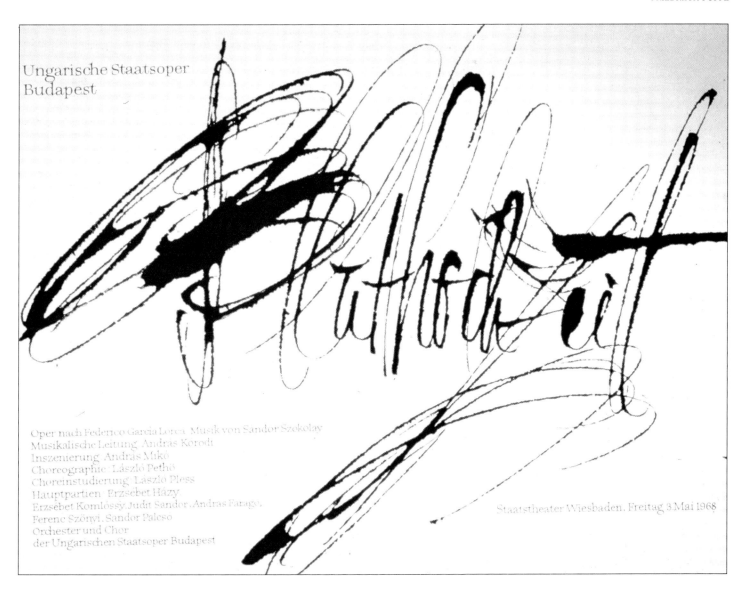

Ungarische Staatsoper
Budapest

Oper nach Federico Garcia Lorca. Musik von Sandor Szokolay
Musikalische Leitung: András Korodi
Inszenierung: András Mikó
Choreographie: László Pethö
Choreinstudierung: Laszló Pless
Hauptpartien: Erzsébet Házy,
Erzsébet Komlóssy, Judit Sander, Andras Farago,
Ferenc Szönyi, Sandor Palcso
Orchester und Chor
der Ungarischen Staatsoper Budapest

Staatstheater Wiesbaden, Freitag 3.Mai 1968

Opera Poster 1968 This demonstrates the range of Poppl's skills, the spontaneous flowing script drawn from the edge of the ruling pen combining the precision required to design a typeface (Poppl Antiqua) used as text in the poster. The contrast of scale has been exploited to the fullest extent which also demonstrates his ability to harmoniously unite text, letterform and space.

'Ich lerne immernoch' Michelangelo Not previously published. The vigorous strokes here express classical antiquity and match the meaning of the words. This script expresses all Poppl's passion at this stage of his career. Everything he learnt through writing Classical Antiqua found its ultimate expression in Poppl Nero.

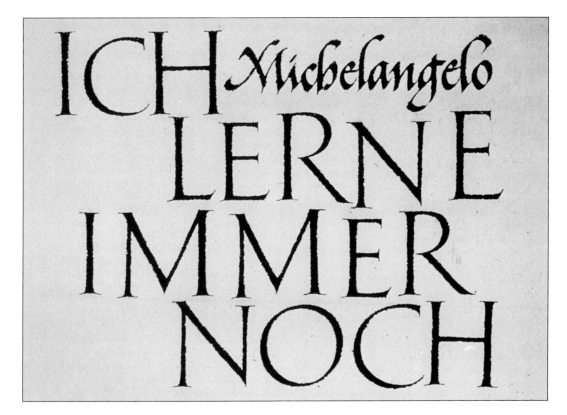

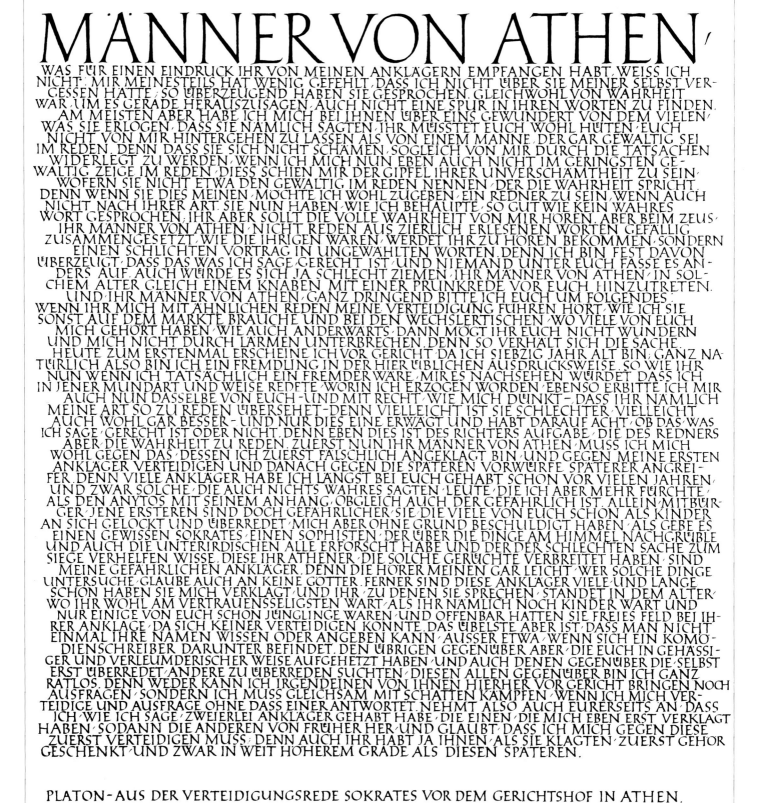

Manner von Athen 1956 Not previously published. Friedrich Poppl's message in this sheet of sixty lines is something like this:

'Look, dear friends, three years after completing my studies I have already quite clearly and definitely freed myself from my teacher's script. Now I look towards original classical sources for my forms. Look! I'm on the way to finding my own style!'

In contrast to his flowing script, here Friedrich Poppl exhibits a totally different approach to design. The classical Antiqua is written with minimal line-spacing to achieve a perfectly even tonal 'colour'. This is akin to medieval German calligraphy with the creation of a woven texture through the writing of Gothic characters. Simple historical imitation, however, it is not — although the effect is antique, the letters are Friedrich Poppl's own.

Falstaff 1968/69 Written with a large drawing pen held at an angle, this is a free interpretation of the famous character from Guiseppe Verdi's Opera, probably created in 1968 or 1969. Original size is 19 x 7cms (7.5 x 2.75 inches.)

universally accepted. In the days immediately after his release, the path was not easy. Wishing to complete his education, he applied for admission to the Offenbach Werkkunstschule. However, all his previous work had been lost during the war and he had to recommence preparing a new portfolio and contacting his old professors which took a further two years, and it was not until 1950 that he gained admission. He graduated in 1953 when he received diplomas both in Graphic Design and Lettering.

In 1955 he was appointed teacher at the Weisbaden College of Applied Arts, where he was allowed to continue with his private practice and indeed continued to combine teaching with his own work until his death in 1982. When he commenced teaching, he compiled a teaching manual which contains much of his philosophy about the role of lettering in modern society and in it he writes 'The task of the creative artist cannot and should not be to invent new and unusual letter images. Basic letterforms are fixed; to each new generation is entrusted the task of developing appropriate design reflecting the contemporary consciousness of style.'

The work of Friedrich Poppl is discernibly rooted in the Offenbach Werkkunstschule tradition and perhaps, more importantly, in its philosophy: the discipline of writing must be applied to the whole range of letter-related activities, together with a deeply rooted understanding of the letterform and, in a practical sense, of training designers to earn a living in our modern society. This is demonstrated by the apparent ease with which he moves between the constraints of type design to the near abstraction and perfectly controlled freedom of his calligraphy.

In 1967, Friedrich Poppl designed a poster for the Weisbaden International May Festival. The poster contained several lines written in his magnificent freely-drawn Roman Square Capitals. This was seen by G G Lange, the creative director for the typefounders A Berthold AG of Berlin and resulted in Poppl being offered an exclusive contract with them. These freely drawn letters became the basis for a number of his typefaces — Antiqua, Pontifex, Laudatio and Nero. In all, Poppl designed eleven separate typefaces with forty variations which appeared during his lifetime and one, Fraktur, was assembled by his widow, Gertrude, from drawings left on his workbench.

Arne Wolf, in a moving tribute to Friedrich Poppl writes that he had: 'the seemingly effortless ability to combine spontaneity with precision; to be precise without being pedantic, to work with abandon while retaining full control; to impose order without succumbing to rigidity, and to honour tradition but not to fall slave to it.'

Poppl-Antiqua
Poppl-Antiqua
Poppl-Antiqua
Poppl-Antiqua
Poppl-Antiqua
Poppl-Antiqua

Poppl-College 1
Poppl-College 2
Poppl-College 1
Poppl-College 2
Poppl-College 1
Poppl-College 2
Poppl Exquisit
Poppl Exquisit
Poppl Exquisit
Poppl Exquisit
Poppl Heavy
Poppl-Laudatio
Poppl-Laudatio
Poppl-Laudatio
Poppl-Laudatio
Poppl-Laudatio
Poppl-Laudatio
Poppl-Laudatio
Poppl-Laudatio
Poppl-Laudatio
Poppl-Laudatio
Poppl-Laudatio
Poppl Leporello
POPPL NERO

POPPL NERO
POPPL-PONTIFEX
Poppl-Pontifex
Poppl-Pontifex
Poppl-Pontifex
Poppl-Pontifex
Poppl-Pontifex
Poppl-Residenz
Poppl-Residenz
POPPL SALADIN
POPPL SALADIN
Poppl Stretto

Peter Halliday

'We must respect our roots. We must question and expand the received wisdom of our teachers.'

Peter Halliday was born in 1939 in Kent, England, and from 1956-60 studied at Medway College of Art, where he obtained his National Diploma in Design. He studied writing, illuminating and lettering with Maisie Sherley, who was herself taught by two students of Edward Johnston. He feels that this direct line of descent was a very formative but not constraining factor — rather a great and firm foundation in both training and philosophy, firmly rooted as it is in the Johnstonian tradition. However radically his concepts deviate from the 'norms' of calligraphy, this sound traditional aspect of Peter Halliday's training is reflected in his work.

After graduation, Peter Halliday became a teacher of Art and Design at the John Taylor High School in Staffordshire, where, despite many changes over the years, he remains and is now Head of Department. In 1976 he was elected a Fellow of the Society of Scribes and Illuminators, and was Chairman from 1982 to 1985. He has amassed a large body of work in addition to his writing on calligraphy. He lectures and leads workshops in Britain and America.

As a teacher and writer on calligraphy, Peter Halliday sometimes finds that his personal ideas come into conflict with the perceived ideas of others about the British lettering arts movement. Much of his calligraphic output during the last ten to fifteen years has been dominated by the need to show his personal reaction to

poetry and literature; this intellectual and analytical approach to calligraphy is evident in his work. His ability to respect his roots, while at the same time questioning and expanding upon the received wisdom of his teachers has become a

source of inspiration and development for much of his work, as shown in these examples.

One constant factor in Peter Halliday's work is his desire to maintain the highest possible standards of craftsmanship.

Days by Philip Larkin 1989

This interpretation of one of Larkin's enigmatic poems was the response to a commission. Says Peter Halliday, 'To try to explain how such a solution was arrived at is almost impossible. Somehow the idea of folding and repeating the words had the same sense of the inexplicable. The idea of folding came about in an idle, pondering moment: the only problem that remained was how to cut and fold in such a way as to make the original idea work without spoiling the purity of the original concept.'

The developing concept: a sketchbook visual followed by rough paper mockups. As the design progresses, the text is rotated to read from top to bottom. The final visual shows the text written as in the final completed version but with large spaces between each line caused by folding the paper. This problem is solved by repeating the ink writing again

in pencil. This gives better structural unity to the work and reinforces the poem's 'sense of the inexplicable'.

Pencil and ink on Roma handmade paper. 35 x 52 x 20.3 cms (14 x 20.5 x 8 inches).

1 Roma handmade paper and bone scorer prior to writing.

2 Background paper carefully cut to exactly fit creased paper with glued flaps. When assembled this will have the effect of a single sheet of paper with a raised creased section.

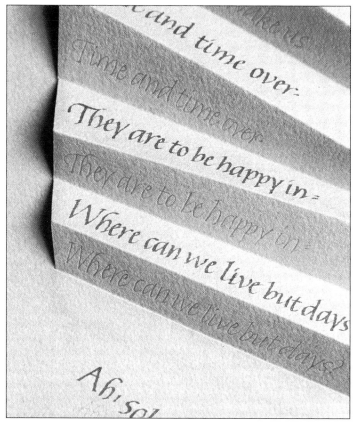

3 Detail shows contrasting writing in ink and pencil on alternate folds. Paper is cut to form an integral part of mount

Days by Philip Larkin from 'The Whitsun Weddings' published by Faber & Faber

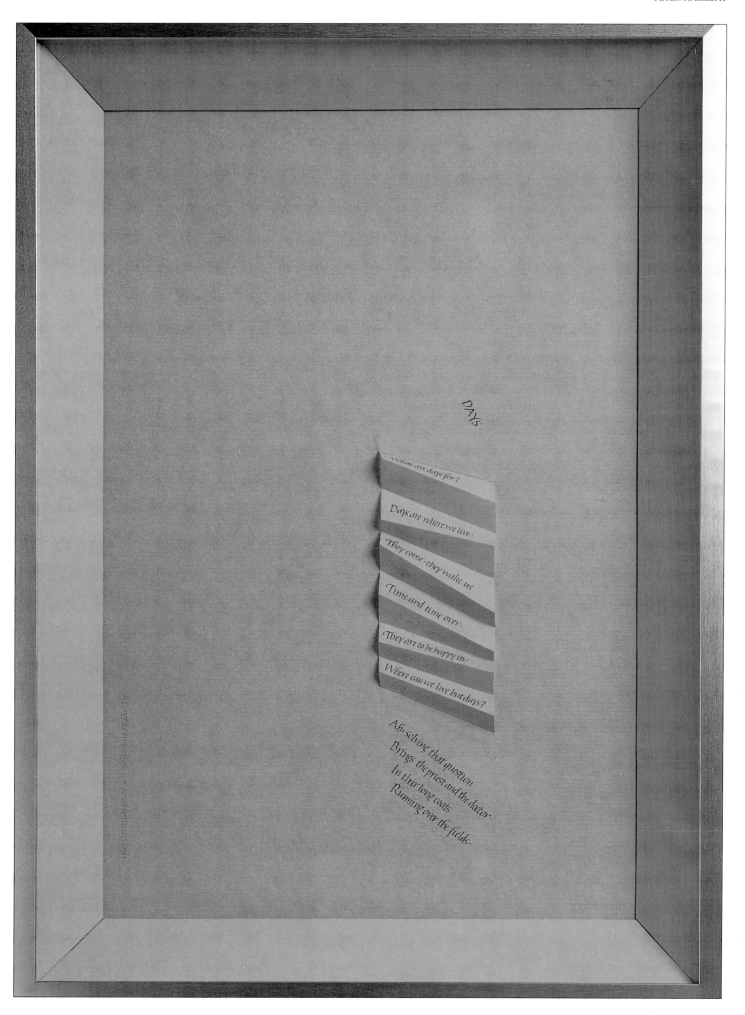

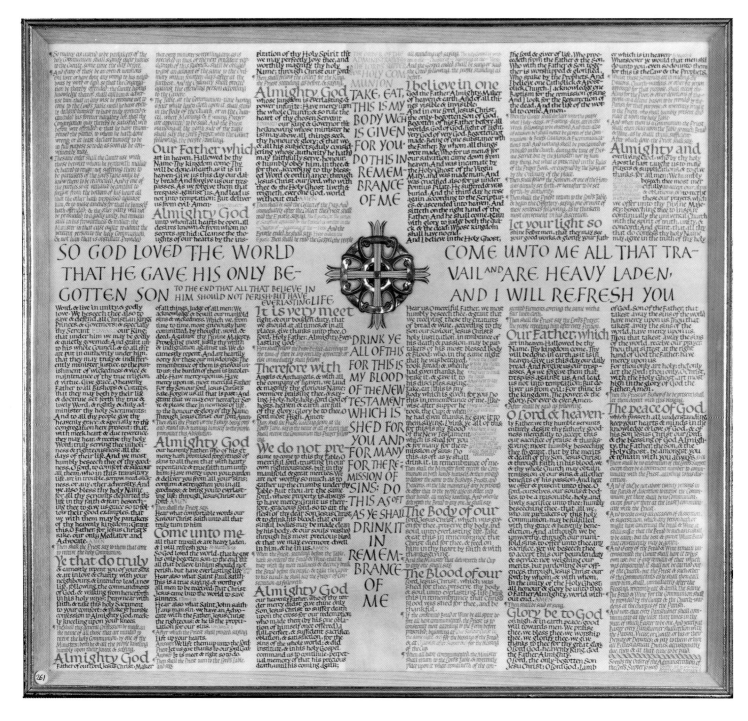

The Communion Service 1976

'Rather than writing this piece in the form of a book I felt that the appearance of a large textural mass would not only look impressive, but would do justice to the sublime English of the Book of Common Prayer. The planning of such a piece so that it can be appreciated from different distances poses interesting questions about the emphasis within the text and the visual balance of the whole. The work was planned so that the star of each section has its own emphasis by simply filling the column with large vermilion writing; the main text was written in a foundational hand which was deliberately slightly varied to maintain some variety of texture. The rubric was written in a compressed hand in vermilion and the instructions for the priest in the same hand and size but in pale blue.

The central cross motif was based on decoration contemporary with the Ramsey Psalter on which Johnston based his studies for his foundational hand. The whole piece is, in a way, a homage to Johnston.

Detail Chinese ink, raised and burnished gold vermilion and blue watercolour on unstretched vellum. Written using goose quills. 62 x 67 cms (24.5 x 26.5 inches).

Poem 13, from 'No Thanks'
by E E Cummings 1980

Says Peter Halliday, 'I have long been fascinated by the poetry of E E Cummings. He is a lyric poet who does not allow superfluous detail to intervene and, similar to Japanese haiku poems, manages to approach the essential nature of the subject. The unconvential layout which was often used by Cummings has an added fascination. In some ways, Cummings' work seems unpromising for a calligrapher; but in this piece, as in much of my work, the interpretation and presentation is very important and can sometimes be seen to be more dominating than the calligraphy. But the words remain the essential vehicle and my calligraphic response to the directing force.

In this poem, the word 'grass-hopper' is progressively re-arranged in the same way that some grasshoppers fly like a butterfly and then fold up and land looking like any other grasshopper. A condition of using Cummings' poetry is that I do not alter the layout in any way, and so although I have treated the word 'grasshopper' in a special way, I have not changed its position. The main substance of the text was written on the background paper, and 'grasshopper' is separated so that it has a layer of Perspex for each letter. This means that when the word is written at the top, it appears in an apparently haphazard way and as it is repeated, it is gradually rearranged into the correct spelling.'

The finished piece has been surrounded by a light-box which has a low-power fluorescent light hidden above, which lights it through the Perspex.

1 *Lines drawn on Xerox copy of poems to ensure the correct vertical character alignment ©1973/1978 by Nancy T Andrews.*

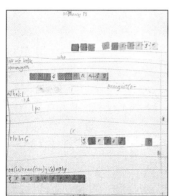

2 *First notebook ideas regarding colour and structure.*

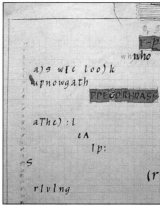

3 *The design has now been calculated on a grid, using the same format as used for the original poem.*

4 *Background writing showing main substance of text.*

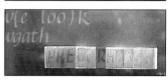

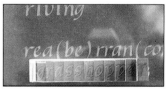

5 *The final letters written on various layers of Plexiglass.*

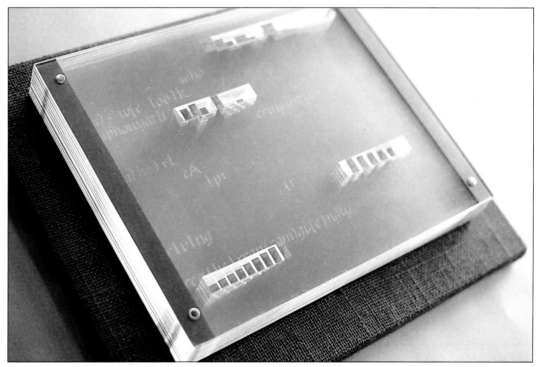

Watercolour on paper within layers of Perspex (Plexiglass), all contained in a light-box. 24 x 30 x 6.5 cms (9.5 x 12 x 2.5 inches).

The complete poem assembled: because of the scuptural quality of this piece, the letters on Plexiglass will not only have depth but also

suggest the jumping movement associated with grasshoppers; an effect created by the different layers seeming to move as you pass in front of the work.

111

Claude Dieterich

It is easier to understand
a nation
by listening to its

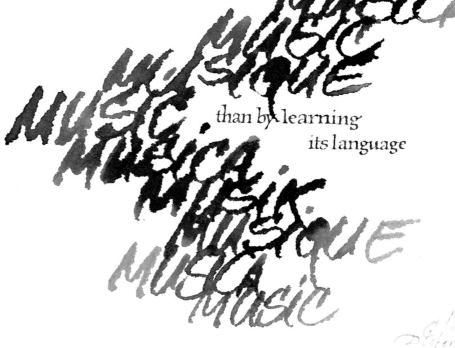

than by learning
its language

Exhibition catalogue Cover
design for the Museum of
Modern Art of Latin America

Music and Letters *Claude
Dieterich believes that calligra-
phers must serve the text, just
as musical instruments are
tuned to transmit the inspira-
tion of the composer.*

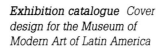

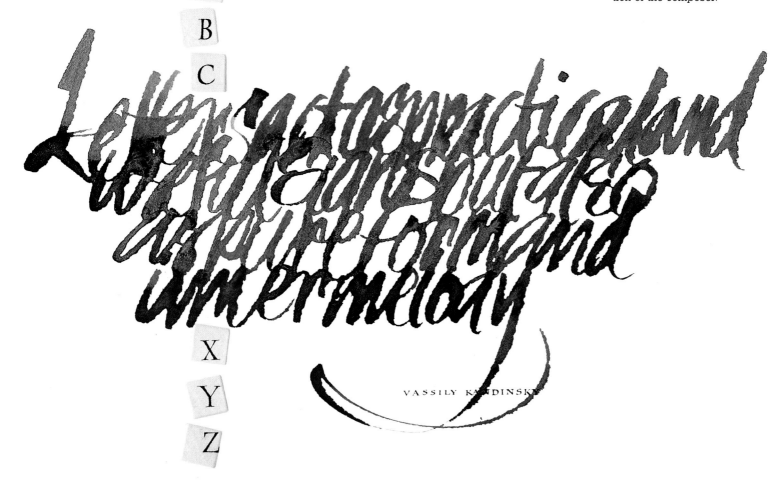

VASSILY KANDINSKY

Calligraphy *'Calligraphy helps me to find myself and wake up to another reality.'*

PAUL STANDARD

Geometry
can
produce
legible
letters
but art alone makes them beautiful.
ART
begins where
GEOMETRY
ends,
and imparts to letters a character
transcending mere measurement

A logo *Created for 'Latin America Reservation Center'.*

CLT *A logo for a sculptor.*

Geometry *1990 a quotation from Paul Standard.*

became more and more immersed in calligraphy, and for the next ten years he did three pages of practice every day. He left teaching in 1980.

After leaving college in 1953, he worked in Paris until 1961 as a designer, illustrator and letterer, working for advertising agencies, publishers and packagers, and has to his credit many posters and logotypes.

His meticulous craftsmanship and incisive quality of encapsulating logotype designs with economy of line are reflected in his calligraphy, which is often counterbalanced by finely detailed drawing. He tries to achieve the same feeling and relationship to his work as a skilled carpenter to a piece of furniture he is creating: he believes that primarily, calligraphy must serve the text but that calligraphers are instruments, like musical instruments tuned to transmit a composer's inspiration. To achieve this, the calligrapher must use mind and heart and hand. To consider calligraphy as either an art or a craft is irrelevant.

Claude now works in Florida, USA. He left France in 1961 for Peru where he had his own studio until 1983. Between 1983 and 1985 he freelanced in New York, returning again to Peru until 1986. Although he still has a home in Peru, he now freelances from Miami. In 1983 he had the opportunity to study with Hermann Zapf and later with Julian Waters, a fact which underlines the debt which many calligraphers owe to each other and their work.

The particular sources which have inspired Claude Dieterich are the Trajan capitals; the Italian lower-case letters of the Renaissance; the German medieval Textura and Fractur letters, and also the calligraphy of 16th-century Spain.

Despite, or possibly because of the strong historical background, his work remains essentially contemporary.

'I feel that calligraphy is not only a question of technique and skills but also a spiritual matter. It helps me to make up another reality.'

Claude Dieterich was born in Colmar, France in 1930 and spent his formative years during the war at school in Avignon, where his father was a papermaking engineer. In addition to his daytime studies at the Lycée Mistral, he spent many of his evenings at classes in the local École Des Beaux Arts. This part of his education was completed at the École des Arts Decoratifs in Grenoble where he studied Graphic Design with typography as his chief interest. Although instruction in calligraphy was included in the syllabus, little emphasis was placed upon it. Some fifteen years later he was asked to organize a course of typography at the Catholic University in Lima, Peru, and so he again became acquainted with the subject in order to teach his students. With the aid of some old books and the basic instruction which he received in Grenoble, he began doing exercises with broad nibs. Shortly after this, while on a trip to New York, he came across Johnston's *Writing and Illuminating and Lettering* and Ralph Douglas's *Calligraphic Lettering*. With this preparation, he was ready to commence teaching. As so often happens, he became expert in the subject by teaching it and working with his students. Claude Dieterich

Viceregal Peruvian Art
The cover for the exhibition catalogue.

VICEREGAL PERUVIAN ART
Barbosa-Stern Collection
Arte Virreynal
Peruano
Colección
Barbosa-Stern

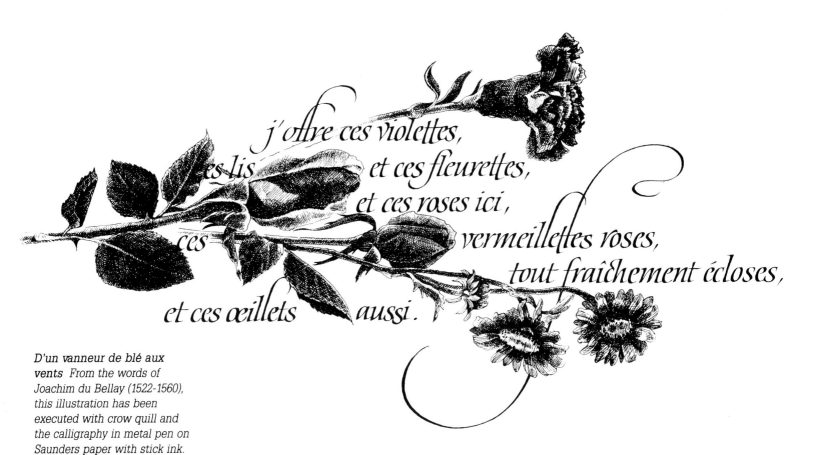

j'offre ces violettes,
ces lis et ces fleurettes,
et ces roses ici,
ces vermeillettes roses,
tout fraîchement écloses,
et ces œillets aussi.

D'un vanneur de blé aux vents *From the words of Joachim du Bellay (1522-1560), this illustration has been executed with crow quill and the calligraphy in metal pen on Saunders paper with stick ink.*

'The Ark of the Covenant' for a Bible book.

God declares that there will come a time when you return and repopulate the land. Then nobody will speak anymore about THE ARK OF THE COVENANT OF THE LORD." People won't think about it; they won't remember it; they won't need it; they won't make another.

How-to and tools

Abstract calligraphy

When creating or assessing any piece of calligraphy, there are basic principles which remain consistent whatever the other variables. According to Claude Mediavilla, these are:

1 The sophistication of form
2 The use of contrast
3 The precision of curves
4 The harmony of proportions

If these elements have been neglected or ignored the results will always be disappointing.

Claude Mediavilla says, 'This analysis is not purely theoretical; in fact, there are no steps more practical and the sketches which follow clearly show what is meant by using the wrong strokes or lack of tension.'

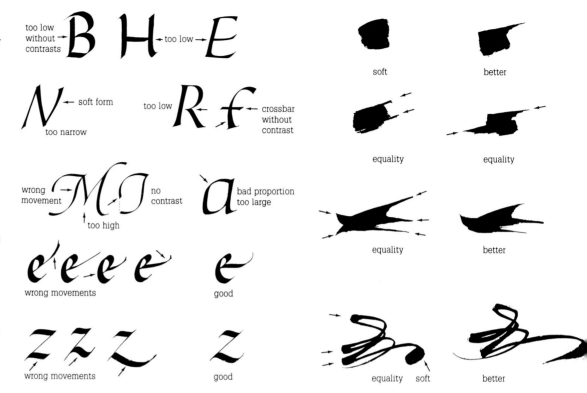

Bone scorer

A bone scorer will help create a smooth fold without creasing or damaging the paper (useful for calligraphic manuscripts) Early scribes set bone into ornamental handles and used this stylus to score the back of a page with an unobtrusive rule.

Brushes

These are usually made of sable or man-made fibre although coarser brushes may be made of other animal hair. Predominantly, of two types — pointed or square-edged.

Pointed brushes
Available in a range of sizes and bristle lengths. A reputable dealer should allow you to test the fineness of the point before purchase. If the brush is of high quality, a No 2 will give as fine a point as a No 0 and hold considerably more paint, and thus be easier to use. Generally, the pointed brush is used to create a built-up letter or for painting fine detail. The pointed brush can also be used to create spontaneous letterforms as in the work of **Karlgeorg Hoefer** (page 48-51) where the whole range of brush is used within a single letter, from the fine pointed tip to the thick body of the brush.

Bamboo brushes
Chinese fine pointed; this will make a useful addition to your pointed brushes.

Broad-edged brushes
These can be used as an alternative or complementary to the broad-edged nib, but have greater flexibility — very useful in creating Roman Capitals.

The broad-edged brush produces bold lettering and is ideal for creating spontaneous letterforms. The letterstrokes can be altered by manipulation in a way that is not possible with the pen as in the work of **John Stevens** (pages 68-73) or to create contrast when used in conjunction with an edged pen.

A broad-edged brush with extra-long bristles is used by a signwriter.

Burnishers

These are variously shaped tools with a smooth rounded end or surface, usually of agate or haematite. They are used to work in and polish up the gold used for illumination until it is brilliant, smooth and shiny. Some burnishers are specially shaped for working gold leaf into the edges and rounded areas of a letter.

Carolingian minuscule

These are rounded extended letterforms with small body height and relatively large ascenders and descenders, and good interlinear spacing. The letters have no capitals and were usually written in a small size. The 't' and 'g' vary from today's characters.

pen pushed 1 pulled 2

single stroke

or

pen angle 45°

interlinear space 2-3 x body height

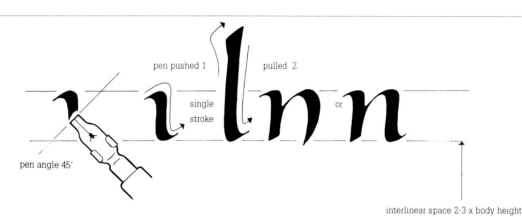

Seruat coeptam translatione apedib
usq aduertice idest abimo usq adsummu
abextremis usq adpmos toto conforsi
sunt corpore uulnus inquit et luuor et
plaga tument aut em uerberib luuent

Copperplate

A monoline cursive script drawn with a flexible pointed nib, based, as the name suggests, on the cursive script originally engraved on to copper plate. The words are written in a nearly continuous running movement. Shading is produced by varying the pressure on the nib. There is heavy emphasis on the angle of slope.

Aim at improvement in every line

Foundational hand

Fully rounded letters based on the round 'o', with each letter clearly defined. The pen is held at a constant angle and 'pulled' in a forward movement.

The point of view of the early calligrapher was most direct: in the first place his Manuscript was to be read, then, to be played with or glorified. *E.J.*

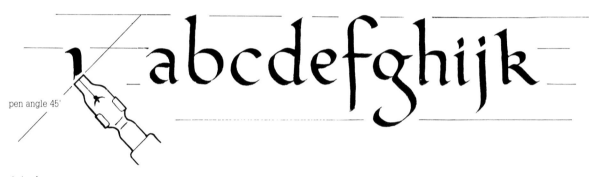

pen angle 45°

On Edward Johnston's original text shown here, there is some inconsistency in the size of his ascenders and descenders. His foundational hand was, in fact, a modification of 10th century Winchester script.

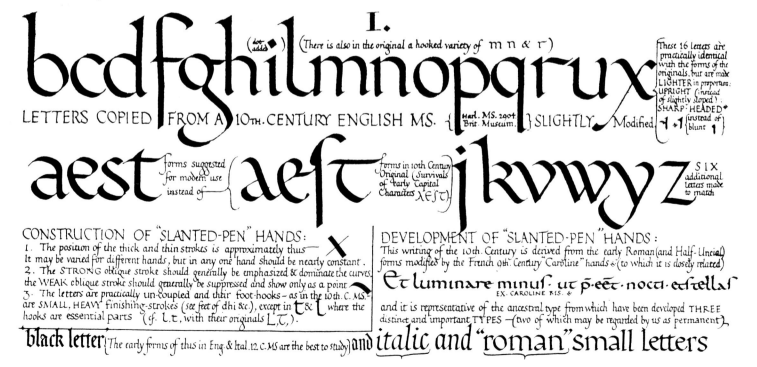

I.

bcdfghilmnopqrux

(dot adds ◆) (There is also in the original a hooked variety of m n & r)

These 16 letters are practically identical with the forms of the originals, but are made LIGHTER in proportion: UPRIGHT (instead of slightly sloped): SHARP-HEADED ◆ (instead of blunt)

LETTERS COPIED FROM A 10TH CENTURY ENGLISH MS. { Harl. MS. 2904. Brit. Museum. } SLIGHTLY Modified.

aest — forms suggested for modern use instead of — { aeft — forms in 10th Century Original (Survivals of early Capital Characters ΛΕST) } jkvwyz

SIX additional letters made to match

CONSTRUCTION OF "SLANTED-PEN" HANDS: X
1. The position of the thick and thin strokes is approximately thus — X
It may be varied for different hands, but in any one hand should be nearly constant.
2. The STRONG oblique stroke should generally be emphasized & dominate the curves: the WEAK oblique stroke should generally be suppressed and show only as a point
3. The letters are practically un-coupled and their foot-hooks - as in the 10th. C. MS. are SMALL, HEAVY finishing-strokes (see feet of dhi &c.), except in t & l where the hooks are essential parts (cf. L.t, with their originals L,τ,).

DEVELOPMENT OF "SLANTED-PEN" HANDS:
This writing of the 10th. Century is derived from the early Roman (and Half-Uncial) forms modified by the French 9th. Century "Caroline" hands & (to which it is closely related)

Et luminare minuſ· ut p̄·eēt· nocti· etſtellaſ
EX. CAROLINE MS. &

and it is representative of the ancestral type from which have been developed THREE distinct and important TYPES — (two of which may be regarded by us as permanent),

black letter (The early forms of this in Eng. & Ital. 12. C. MS are the best to study) and *italic* and "roman" small letters

118

Gilding

Burnishing, illuminating and gilding all refer to the processes whereby gold leaf can be added to decorate and illuminate lettering.

1 For raised gold, using a pen or brush, apply gesso quickly. Make a slightly raised, domed shape, like a blob of liquid.

2 When the gesso dries, scrape it smooth with a scalpel or knife, but do not flatten the domed shape.

3 Carefully cut gold leaf into convenient pieces. Gold leaf is very light: use a shield to prevent draughts blowing it about.

4 Breathe on to the gesso through a tube to increase dampness and make it tacky.

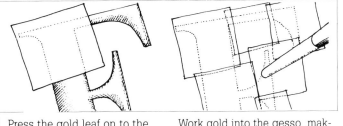

5 Press the gold leaf on to the gesso with an agate or haematite burnishing tool which has been cleaned first on silk.

Work gold into the gesso, making sure it adheres firmly to all of the design, especially the edges. Clean burnisher again.

6 Remove excess surrounding gold with a soft brush or knife.

Gothic *Littera Bastarda*

It is very difficult to define general characteristics as they differ so considerably. (This is an English version *circa* 1415 and called Bastard Secretary, meaning low born, not aspiring to greatness.) The exaggerated 'W' could be regarded as characteristic although the French did not use this extensively.

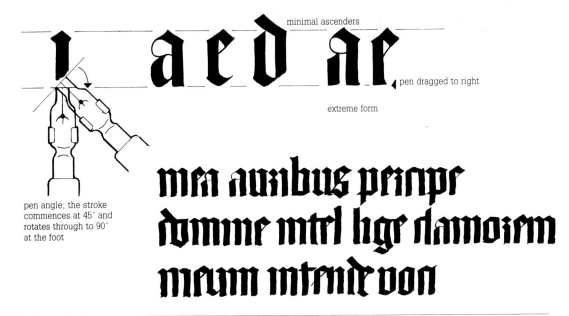

Gothic *Textura Prescisus Vel Sine Pedibus*

Gothic *Textura Quadrata* 'with their feet cut off'. An abbreviated form of *Textura Quadrata* with the bottom diamond foot removed. Strokes are made as nearly identical as possible to enhance the *textura* effect on the page.

minimal ascenders

pen dragged to right

extreme form

pen angle; the stroke commences at 45° and rotates through to 90° at the foot

Gothic *Textura Quadrata*

The most important factor is that the letters produce an even woven effect created by consistent stroke, inter-stroke and inter-word spacing.

uin gemitibus et cunctorum
medere uulneribz alienus
aicua. Perrpm.

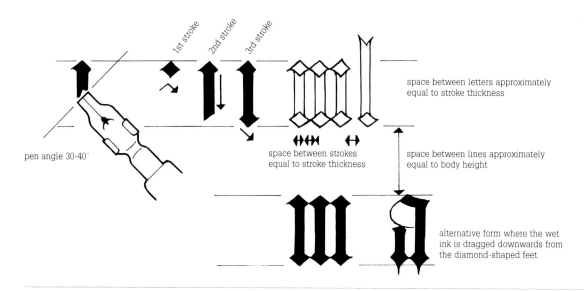

1st stroke 2nd stroke 3rd stroke

pen angle 30-40°

space between letters approximately equal to stroke thickness

space between strokes equal to stroke thickness

space between lines approximately equal to body height

alternative form where the wet ink is dragged downwards from the diamond-shaped feet

Humanist minuscule

Similar in principle to the Carolingian minuscule from which it is derived, it is rounded in form with clearly defined letters. There are wedge serifs on ascenders and on z, j, m, n, and u. Flat serifs occur on some down and trailing strokes. The capitals are based on Roman *capitalis monumentalis*. It has two-storey 'a's and 'g's. It is also known as *Roman Book Hand* or *corsiva humanista*.

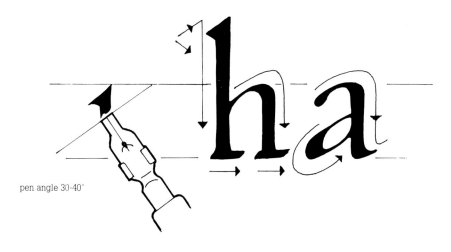

pen angle 30-40°

Vidi un uictoiofo & fommo duce
Pur come un di color chen capitoglio
Triumphal carro a gran gloria conduce

Italic

Clearly defined letters. The 'a' and 'g' are single storey and the letters are usually sloped. It is similar to Humanist minuscule but more compressed in form with eliptical 'o's and is chiefly differentiated by its hooked serif. It has generous ascenders and descenders and may be used with sloped or Roman capitals.

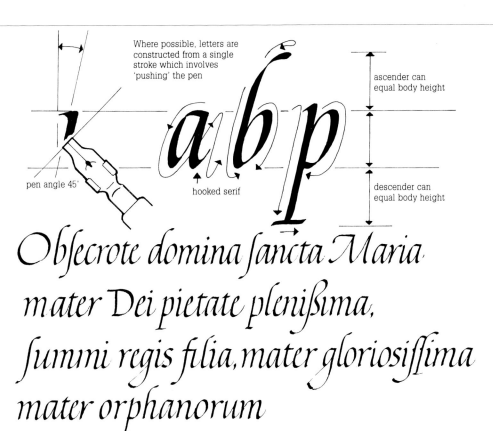

Where possible, letters are constructed from a single stroke which involves 'pushing' the pen

pen angle 45°

hooked serif

ascender can equal body height

descender can equal body height

Obsecrote domina sancta Maria mater Dei pietate plenißima, summi regis filia, mater gloriosißima mater orphanorum

Pens and nibs

Nibs are available for specific needs such as script, round hand, poster and scroll, and can be bought individually or as a set. Steel nibs are commonly used in conjunction with a reservoir which may be either detachable or an integral part of the nib. Nibs can be straight-cut (right-handed) or cut obliquely (left-handed). The pen is loaded with ink or paint, using a brush or ink-dipper.

Dip pens, which tend to be larger in size, are dipped directly into the ink bottle.

Fountain pens may be an integral complete unit or have interchangeable nib units, with squeeze or piston-type reservoirs. Broad-edged versions are popular and easy to use. If you choose a pen with a squeeze-fill reservoir, it is easier to change the colour of ink.

Quill pen The traditional form of pen, the quill is still regarded as the finest writing tool on account of its flexibility.

Primary flight feathers of swan, goose or turkey are best: left side flight feathers for right-handed and right flight feathers for left-handed people.

Reed pen The earliest form of pen, it was made by cutting the reed at an oblique angle with the end cut square. It can produce a character similar to the broad-edged letter, be chewed or hammered to make a brush and is suitable for drawing fine lines. A modern equivalent can be made from garden cane by removing its pith and replacing this with a paper-clip or sliver of plastic yoghurt pot to create a reservoir.

Ruling pens These are useful for drawing outlines for large built-up letters. Using the edge of the pen can create interesting effects (see page 105).

Fibre-tip pens are good for preparing early designs (see Julian Waters, pages 38-43) but the tips, susceptible to inconsistency due to wear and tear, do not really lend themselves to continuous use.

Cutting a quill

Preparing the quill Remove surplus barbs from feather to create a working length shaft. Soak in water overnight. Heat silver sand in a metal tray; shake off surplus water. Fill the barrel of quill with sand then plunge it into hot sand for a few minutes. This will make it firm.

2 Make a slit in the top of the barrel, cutting from underneath.

4 Make another oblique cut below the first to create a shoulder. Do this on both sides; make sure slit is in the centre.

1 Cut away tip of barrel at an oblique angle.

3 Slice the underside of the pen to about half its diameter.

5 On a hard surface cut the end square. Turn nib over; pare tip finely and obliquely to finalize shape and smooth surface.

Lombardic

These are rounded in form and are ideal for elaborate decoration. The down-strokes are slightly waisted and the serifs are fine or hairline.

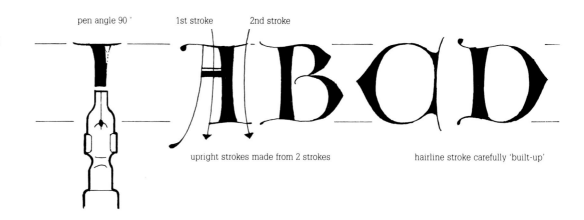

pen angle 90° 1st stroke 2nd stroke

upright strokes made from 2 strokes hairline stroke carefully 'built-up'

Rotunda

A rounder hand in form than the Gothic letters of Northern Europe. In the extreme form, the 'O' is constructed from two semi-circles.

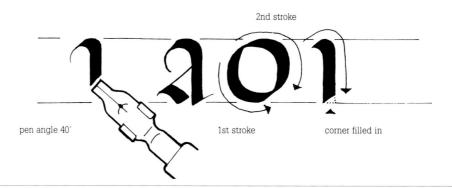

2nd stroke

pen angle 40° 1st stroke corner filled in

Washing off

This technique is based on the fact that while gouache, watercolour and watersoluble inks can be 'washed', waterproof inks and waxes are water resistant and will act as resists.

4 Build up further calligraphy in waterproof ink and gouache.

1 Paint interesting background shapes in gouache.

5 Wash off once again. Being waterproof, the ink images will remain, creating 'controlled accidentals'.

2 Wash off with shower spray, leaving little more than a stain on the paper.

6 Gradually build up calligraphy and painted areas until the final image is created to your satisfaction.

3 Add calligraphy in gouache. Wash off again to leave a faint ghost image.

Many calligraphers are using this method, including **Charles Pearce** (pages 32-35) and **Thomas Ingmire** (page 97).

Glossary

Acrylic Water-based paint which can be used in various consistencies from thick to thin. It dries waterproof.

Arch Part of a lower-case letter formed by a curve springing from the stem of the letter (see **Letter parts**).

Ascender The rising stroke of a lower-case letter (see **Letter parts**).

Base line The line on which the letter sits (see **Letter parts**).

Black letter A Gothic letter, loosely defined by its thick vertical strokes, and which is sometimes referred to as Old English.

Bleach Household bleach diluted and used as 'ink' on a coloured background to produce a lighter-coloured bleached letter.

Bone scorer A piece of bone or ivory used for forming a crease mark or burnishing.

Boustrophedon An arrangement of lines of writing, used by the Greeks, in which alternate lines are written in opposite directions.

Bowl Curved letter stroke which encloses a counter (see **Letter parts**).

Broad-edged pen Fountain pens with broad-edged nibs are easy to use but they do not offer the fine control of a 'dip' pen. An edged pen can be used to form fine **hairlines** (see also **Pen**).

Brush Usually made of sable or man-made fibre although coarser brushes may be made of other animal hair. These are predominantly of two types — pointed or square-edged (see **Brushes** in How-to and tools section).

Built-up letters Letterforms created by drawing rather than writing, or with modifications to structural pen-strokes.

Burnisher A polished stone of agate or haematite used to smooth gold after it has been laid on size to bring out its full effect. An animal's tooth set in a handle can also be used (see **Burnishers**, How-to and tools section).

Calligram Writing done in a way that creates an image.

Calligraphy From the Greek *Kalli* meaning beautiful and *Graphos* meaning to make a mark; thus, 'beautiful writing'.

Capital Also referred to as majuscule or upper case (see also **Roman capitals**).

Caroline minuscule The offical writing hand of the Franks created at the behest of Charlemagne in AD 789. The first true minuscule or lower-case alphabet. Of major importance as our modern lower-case letters indirectly derive from this hand (see **Humanist minuscule**). It is characterized by a small round body with long **ascenders** and **descenders**; the body of the letter being about three pen widths, with ascenders and descenders up to six pen widths. Good **inter-linear spacing** is required when writing this hand. Modern versions of this hand are seen in the work of **Sheila Waters** (pages 80-85).

Colours Usually ready mixed in the form of **ink**, **watercolour**, **gouache** or **acrylic**, or (used less frequently in calligraphy) pastel or wax crayon. Ink will generally be waterproof and as with watercolour, transparent. The other media will be in varying degrees more opaque. Wax crayons can be overlaid. Calligraphers find a useful technique of overlaying to be a darker colour over a lighter one and scratch-through (a broad-edged steel nib can be used) showing the lighter colours underneath. Waterproof inks or **acrylics** are essential for **resist** techniques, while water-soluble colours can be used to produce flat, even effects (**gouache**) or used for **washing off** or sponging, as in the work of **Thomas Ingmire** (pages 94-97) or **Charles Pearce** (32-37). Colour pigments are still available and can be ground or mixed in much the same way as used by medieval illustrators. These will produce permanent and intense colours as in the miniatures of **Claude Mediavilla** (pages 44-47)

Complementary colour The colour which contrasts with another most strongly, such as red and green; they are opposites on the colour wheel.

Composing room The part of a printing works where type is set and made up.

Copperplate By the end of the 16th century rolled copperplate was produced to a high quality, thus opening up possibilities for engravers to produce fine detailed illustrations and lettering. The copperplate letter derives from the fine cursive letters that the engraver could produce with his burin. (See **How-to and tools** section.)

Counter Enclosed space within a letter (see **Letter parts**).

Cross stroke A horizontal stroke essential to the skeleton form of a letter, such as in A, E, F, T (see **Letter parts**).

Descender The tail of a lower-case letter that drops below the **baseline** (see **Letter parts**).

Dragon's blood Rouge paper used for tracing (see **Paper: rouge paper**).

Ductus The direction and sequence of each stroke in which a **broad pen** is used to create a letter.

Flourishes Embellishments of letters or words. The continuance of a stroke, usually a terminal stroke; to infill a space (see **Swash**). **Jean Larcher** (pages 86-93), **Claude Mediavilla** (pages 44-47), and **John Stevens** (pages 68-73) include examples of good flourishes.

Foundational hand This is the hand devised by Edward Johnston, based on the English **Caroline minuscule**. An extremely basic hand, this is easily learned by a student and lends itself to the creation of refined **flourishes** and **hairlines**. The proportions of the letters are based on the round 'O'. The **ascender serifs** can be made up of three strokes or by simple hooks (see also the **How-to and tools** section).

Fractur A Gothic letter with broken strokes, usually written at speed. See also Gothic *littera bastarda*.

Gall (Gallic acid) Nut-like growths on oak trees used as a basis for the early manufacture of ink.

Gesso (see **Gilding**) A smooth mixture of the medium which is used to create raised forms and letters for **gilding**. It is made from slaked plaster, white lead, gum and sugar. The preparation of gesso is a lengthy process. When it is applied, it should be flexible and slightly tacky in order to receive the gold evenly.

Gilding Applying gold to an adhesive base. Three types of gilding are used in calligraphy: 1 Raised gold 2 Flat gold 3 Powdered gold (see **How-to and tools** section).

Glair Egg-white mixed with water used to bind colour pigments and to prevent powder brushing away.

Gloss In calligraphic terms a reference to inserting words between lines to interpret or explain text.

Gothic A term applied to a variety of writing hands, used generally between the 11th and 16th century which were post-Carolingian and pre-Humanist minuscule. They were characterized by the condensed letters which were replaced by angular forms. There are four classifications: 1 Early Gothic 11th to 12th century. 2 Gothic *Textura Quadrata* 13th to 15th century. 3 Gothic *Textura prescisus vel sine pedibus* (or 'Gothic *Textura* without feet') which was 13th to 16th century. 4 Gothic *littera bastarda*, from the 13th century onwards. It is also referred to as Batarde (French), **Fraktur** (German), Secretary Hand (English). (See How-to and tools section).

Gouache An opaque water-soluble paint, usually available in tubes, which can be applied in a similar way to watercolour.

Gum arabic Gum which is added to water-based paint to increase fluidity and aid adherence. It can be used for Resists.

Gum sanderac Used on parchment to inhibit the spread of ink.

Hairline Very fine line created by 'skating' the wet ink from the main stroke of the letter with the corner of the quill or nib. In type, a fine line corresponding to the Roman serif and thin strokes.

Hand Handwriting or script. Lettering written by hand.

Humanist minuscule The writing hand of the Italian Renaissance. In the quest for manuscripts of classic antiquity, the scholars mistook the classic scripts copied by the scribes of Charlemagne for original Roman manuscripts. The Humanist minuscule is closely modelled on the **Caroline minuscule**. Its chief importance for us is that it was this script which quickly succeeded the **Gothic** scripts as models for type and which are still today the principal models from which our text typefaces derive. It is characterized by rounded lower-case letters clearly separated and capital letters based on Roman stone-cut quadrata letters.

Illumination To make a page bright by the use of gold. (see Gilding, How-to and tools).

Indent To leave additional space, for example at the beginning of a paragraph.

Ink Essentially the medium for writing available in many varieties, formulations and colours. Originally produced from a mixture of oak galls and iron salts in medieval times which made a brown ink, or from soot, water and gum which produced black ink and was used as early as 2500 BC

Chinese stick ink This ink is solid and comes in block or stick form. It is a favourite of many calligraphers. A small amount of distilled water is dropped into a saucer or palette and the stick ink is rubbed into this until the right consistency is obtained. As well as being suitable for writing, stick ink possesses qualities that calligraphers may find useful in such related work as lino, relief or mono-printing. It also has possibilities in **resist** work.

Non-waterproof ink Generally preferred by calligraphers, non-waterproof ink ranges from specially formulated ink for calligraphy to ordinary fountain-pen ink. This ink allows for greater versatility when it is used with water, and some interesting effects can be obtained. Do note, however, that it is advisable to check the light-fastness of fountain-pen ink as it can prove more fugitive than waterproof ink.

Waterproof ink Because of its opacity, there is a tendency to use this for technical drawings and for **built-up lettering** for reproduction. Most waterproof inks contain shellac and the calligrapher should be aware that this will cause a permanent coating on the nib, which should therefore be thoroughly washed after and possibly during use. It may be helpful to dilute this ink with water during use.

Coloured inks These should be used with discretion as in most instances more

satisfactory results can be obtained with **gouache**, watercolour or **acrylic**. However, a number of new inks are becoming available and for practical purposes liquid watercolour seems to fulfil the requirements for most writing in colour. Coloured inks are invaluable in **resist** work but do check their light-fastness first.

Interlinear spacing Spacing between the lines. A subtle but vital element of design, good interlinear spacing is an important aid in the visual scanning of text. It is also of major importance in producing tonal 'colour' or texture.

Italic Slanted writing derived from 'Italian hand'. A cursive writing based on the **Humanist** or **Caroline** minuscule and accepted as a style in its own right and the hand of the Papal Chancery. Aldus Manutius of Venice first produced the italic as a typeface in 1500 and his designs are still in current use under the names **Bembo** and **Poliphilus**. Italic is now a term used for any sloping letter but a differentiation should be made between a true italic and an upright (or 'Roman') letter which has been slanted. (See **How-to and tools**.)

Justification Text which aligns evenly on both left and right-hand side. If text is aligned on the left this can be referred to as 'ranged left' with the right 'unjustified' or 'ragged right'. The reverse applies to text ranged from the right-hand side. Alternatives are centred text and assymetrical text.

letter they are rounded in form and are ideal for elaborate decoration. The down-strokes are slightly waisted and the **serifs** are fine or hairline.

Lower-case A small letter, not a capital letter, also termed **minuscule**. The name derives from when printers kept capital letters (**majuscule**) in the top (upper) typecase and the small **minuscule** in the lower typecase.

Majuscule A capital letter, also referred to as upper case (see **Uncial**).

Manuscript Specifically, a book or document that has been written by hand.

Masking To protect a given area of work, usually to prevent colour encroachment from surrounding areas (see **Resists**).

Masking film Low-tack transparent film usually applied to a larger area than required; the desired shape is then cut out with a sharp scalpel. Care must be exercised when cutting the mask so as to prevent damage to the underlying material. The advantage of this film is that the transparent film allows for accurate masking.

Masking fluid A liquid, usually rubber-based, which can be used with **brush, pen, nib** or **ruling pen**. After the required letter or shape has been drawn and allowed to dry, colour can be applied over it. When the colour is completely dry, the film can be removed by gentle rubbing,

Miniscule A small lower-case letter.

Nib Metal (quill) tip of a **pen**.

Nib width A conventional method of assessing the correct proportion of a letter. The body of the letter will be equivalent to a given number of pen widths; the **ascender**, **descender** and the **capitals** having another given number of pen-widths. By this method all letters written in the same hand will retain the same proportion, regardless of their individual size.

Ornament An embellishment to a piece of work in excess of any practical requirement. The particular use of ornament is associated with specific social, cultural and religious periods and place. An understanding of its use forms an essential ingredient in an appreciation of both the historic development of calligraphy and its modern application.

Paint See acrylic, watercolour, gouache.

Paleographic The study of written forms, including the general development of alphabets and particulars of handwritten **manuscripts**, such as their date, provenance and so on.

Paper Paper was invented by the Chinese and introduced into Europe by the Arabs in the Middle Ages. Manufactured from compacted interlacing fibres of rag, straw or wood, it is produced in a wide range of surface and colours. For general calligraphic work

It is generally true that all papers are good to write on: the difficulty is to find the right technique, tool and medium with which to write.

Layout paper (tracing or detail paper). Thin semi-transparent paper used for producing initial ideas. By overlaying sheets, sketches can be worked over and developed.

Rouge paper (or tracing-down paper) is used as an interleaf between the working layout and a final piece. The working drawing is drawn over with a hard pencil, transferring the red from the **rouge paper** on to the final piece. It can be made economically by painting jeweller's rouge on to layout paper. (See **Dragon's blood**.)

Papyrus The first flexible writing material invented by man with surviving examples over 4000 years old. Made from the stem of the papyrus plant growing on the banks of the Nile, it was cut into thin strips, woven into a lattice work mat and then hammered into a flat writing surface.

Parchment Made from sheepskin, this preceded the use of paper in Europe — thicker and more durable than **vellum**. In general terminology, any skin which is suitable for writing.

Pen The basic writing tool of the calligrapher and made from a range of materials. See **Reed pen** and **Quill pen**. Steel nibs and pen nibs are the most commonly used nibs by scribes, usually in conjunction with a reservoir which may be

Fountain pens Broad-edged versions are becoming increasingly popular and are convenient for easy use. It is recommended that the scribe uses a whetstone for finely honing steel nibs. This also works well for fountain pens, although it is doubtful whether the manufacturers would advise it. (See also **Broad-edged pen**.)

Ruling pens These are made for ruling straight lines in conjunction with ruler, set-square or french curves, and are useful in drawing outlines for large **built-up** letters for reproduction. However, interesting effects can be obtained by using the edge of the pen — see the work of Friedrich Poppl (pages 104-107), **Karlgeorg Hoefer** (48-51) and **Werner Schneider** (16-21).

Fibre-tips A modern version of the Egyptian **reed pen**. Can be useful in the preparation of early designs.

Pencil Made of graphite and available in various degrees of hardness. 9H (very hard) to 6B (very soft) with HB (average). Carpenters' pencils with a broad edge will be found useful in developing initial ideas. Some authorities recommend tying two pencils together to simulate a **broad-edged pen** — of doubtful value. A name also given to a signwriter's or artist's brush.

Photo-composition The setting of type by photographic means rather than by hot metal type.

Letter parts

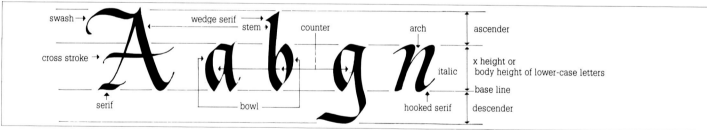

Letterforms The essential form or character of a letter or alphabet which distinguishes it from other letters or alphabets. In many instances letterforms, especially in calligraphy, are dictated by the tool and the **ductus** which created the letter.

Lombardic (or Uncial) Capital, **Gothic** letters said to have appeared originally in Lombardy, although this is disputed. Used as a **versal**

leaving the original surface underneath.

Masking tape Low-tack adhesive, particularly useful if straight lines are required.

Masthead Title, logo, or 'block' of information about a publisher or publication.

Minim The height of the body of the **miniscule** letter, excluding the **ascender** and **descender**.

non-coated and especially handmade papers, although more expensive, are most suitable. The drying methods partially determine the texture of handmade papers with three categories: Rough, semi-rough which is known as C.P. (cold press) or 'not', and the smoothest 'hot press' or H.P. Each paper has its own weight and texture and knowledge of the paper's potential can be gained only through experience and practice.

detachable or an integral part of the nib. The pen is loaded with **ink** or **paint** by the use of a **brush** or ink-dipper. Drop the ink or paint into the reservoir and let it flow down to the tip. The nibs are available as straight-cut for right-handed scribes or cut obliquely for left-handed scribes. **Dip pens** are also used, although these tend to be larger in size. As the name suggests, these are dipped directly into the ink bottle.

Pounce Fine powder used on unsized paper to prevent ink spreading and as a preparation on parchment.

Quill pen The traditional form of the **pen** and used extensively until the early 19th century when **steel nibs** and better **inks** became available. Although calligraphers will use a range of writing materials, many scribes still regard the quill as the premier writing tool because of its greater

flexibility. Primary flight feathers of swan, goose and turkeys are ideal — left-side flight feathers for right-handed people; right flight feathers for left-handed people!

Reed pen Used by the Egyptians and probably the earliest form of **pen**, it was made by cutting the reed at an oblique angle and the end cut square. Capable of producing a character similar to the broad-edged letter, the reed could also be hammered or chewed to produce a **brush** and was suitable for drawing fine lines. A modern equivalent can be made from garden cane: remove the pith in the core of the cane and it can be replaced with a paper-clip or sliver of yoghurt pot to create the reservoir.

Resists (see **masking**) The use of one substance to inhibit the effect of another on the working surface. For instance, one method would be to use white **gouache** or **gum arabic** (which are water soluble) in which to draw the letter or design. When dry, this can be over-painted with a **water-proof ink** or **acrylic** paint. When the second layer is completely dry, the work can be washed under running water or a cold shower,

dissolving and removing the water-soluble paint or gum and leaving the waterproof ink or paint on the surface. In the work of **Charles Pearce** (pages 32-37) and **Tom Ingmire** (94-97) this has been brought to a very sophisticated level. They have also utilized the slight staining effect left when colour is **washed off**, in combination with the various over-layers of resist work.

Roman capitals These fall into two distinct styles — Ladidary square capital or *capitalis monumentalis* and *Rustica*. The outstanding beauty of *capitalis monumentalis* has endured since Roman times and still forms the basis of many of our type designs. As the name suggests, this style is associated with inscriptional letters. One of the outstanding examples of this is the inscription at the base of the Trajan Column in Rome erected in 114 AD and used by many calligraphers and letterers as a model. Although the form of these letters have been described in detail since the Renaissance, it is only since the publication of the work of Father Catich in 1969 *The Origin of the Serif* that it has been shown definitively that the method by which

these letters were constructed was by painting with a broad-edged sable **brush** and then subsequently cut with a 'v' section. It is possible to construct these letters with a **broad-edged pen** and many calligraphers use this method, although ultimately only the brush can explore and bring out the full potential inherent in the letters. See the work of **John Stevens**.

Rotunda Round-hand, particularly associated with Italy and Southern France and Spain between the 13th and 15th centuries. The letters are rounder in form than the **Gothic** letters of Northern Europe. In the extreme form, the 'O' is constructed from two semi-circles.

Ruling pen Precision drawing instrument suitable for fine artwork.

Rustica This was used for inscriptions, frequently mixed with *capitalis monumentalis*. It is more practical for use as a book hand because of its greater speed of writing, and can be written equally well with **brush** and **pen**. In form it is very compressed and written with brush or pen held nearly vertical — giving fine upright strokes and heavy horizontal

strokes. It remained in use as a book hand for headings until the 11th century.

Rustic capitals See Roman capitals.

Script Cursive writing hand or writing by hand.

Semi uncial (see **uncial**) A forerunner of the **minuscule**. **Ascenders** and **descenders** are in evidence. A rounded character with the pen held at close to horizontal. The 'N' and the 'Z' retain only their uncial form.

Serif The fine strokes which terminate the main strokes of a **letterform**: for instance, pen-written letters can have hooked, wedged, **hairline**, club or slab serifs, or no serifs; drawn letters and types have even more variety.

Stem Vertical stroke of a letter (see **Letter parts**).

Swash An extension to a single letter for the purpose of ornamentation — as opposed to a **flourish** which can be applied to a word or groups of words to fill a vacant space. The swash will work best on letters which contain a stroke that can be extended, for example, an A or an R.

Typography The art and craft of setting type for printing.

Uncial (see **majuscule**) A handwritten script of essentially **capital** letters with few **ascenders** or **descenders**, such as P, L, G and D (5th to 9th century).

Upper-case Capital letter. See also **Lower case**.

Vellum See **Parchment**. Calf-skin used for writing upon.

Versal A letter with exaggerated round and vertical strokes and **serifs**, derived from **Roman square capitals**. Often used in medieval manu-scripts at the beginning of a line, chapter or verse, and incorporating within the outline, either colour, gold or illustration, or all three in combination.

Washing off A resist technique, whereby water-based colours can be washed and 'softened' while waterproof colours remain dominant (see **How-to and tools** section).

X height A term used in **typography** to describe the height of the main part (or body) of a letter, without **ascenders** and **descenders**.

Further reading

Many of the twenty calligraphers contributing to this book have had their work or articles published in both books and magazines. The following list will provide useful information for further reference material about individual calligraphers.

At the end, the author has also listed his own recommendations for further reading.

Denis Brown

Calligraphy Review Spring 1990 (Ireland)
Craft Review Winter 1989 (Ireland)
Craft Review Summer 1990 (Ireland)
The Scribe Spring 1989 (Ireland)

Claude Dieterich

Art Direction October 1973 (USA)

Arts et Métiers du Livre 130 1984 (France)
Calligraphy Review 1987, 1988, 1989 (USA)
Creativity: 2 1972, 3 1973, 6 1976 (USA)
Gebrauchsgraphik May 1968 (Germany)
Graphic Design 1983 (Japan)
Graphis Annual 1971-72, 1972-73, 1973-74 (Switzerland)
Graphis Packaging: 3 1978, 4 1984 (Switzerland)
International Calligraphy Today 1982 (USA)

Logotypes of the World 1984 (Japan)
Magenta 1983 (Mexico)
Modern Publicity 38, 1968-69, 1977 (England)
Modern Scribes and Lettering Artists Studio Vista 1980 (England & USA)
Signs and Emblems 1984 (USA)
Top Symbols and Trademarks of the World Volume 3, 1973 (Italy)
Trademarks: 7 1980 (USA)
Trademarks and Symbols: Volume 2 1973 (Japan)
Trademarks and Symbols of the World 1987 (Japan)
Typography: 3 1982 (USA)
Who's Who in Graphic Arts: Volume 2 1982 (Switzerland)
Zeichen Marken und Signets 1983 (Germany)

Peter Halliday

The Art of the Scribe Catalogue SSI 1984
The Calligrapher's Handbook 1985 (UK)

The Calligrapher's Project Book 1987 (UK)
Calligraphy '84 Exhibition catalogue 1984
Calligraphy Idea Exchange Volume 2 No 4, 1985
Calligraphy in Print Catalogue 1987
Calligraphy Masterclass 1990 (UK)
Contemporary British Lettering 1984
Creative Guide — Lettering and Calligraphy 1990
Graphics World 1990
Kalligrafi 1987 (Denmark)
Lettering Arts in the 80s Catalogue 1984 (USA)
Modern Scribes and Lettering Artists II 1980
60 Alphabets by Gunnlauger S E Briem 1986

Karlgeorg Hoefer

KGH: Kalligraphie, Gestallete Handschrift 1986 (Germany)
Schriftkünst Letter Art Karlgeorg Hoefer 1989 (Germany)

Lorenzo Homar

Calligraphy Review
Contemporary Calligraphy
Modern Scribes and Lettering Artists II 1986
Modern Calligraphy Today

David Howells

Modern Scribes and Lettering Artists II 1980 (UK)
The Rime of the Ancient Mariner Arcadia Press (Limited edition)
60 Alphabets by Gunnlauger S E Briem 1986
Tyger Tyger Taurus Press (Limited edition)

Thomas Ingmire

Alphabet (The Journal of The Friends of Calligraphy) Volume 2 No 1, 1986
Ampersand (The Journal of the Pacific Center for the Book Arts) 1984
Calligraphy Idea Exchange: Volume 2 No 3, 1885

Calligraphy Idea Exchange
Volume 3 No 4, 1986
Calligraphy Idea Exchange
Summer 1987
Calligraphy '84 Exhibition
Catalogue 1984 (UK)
Lettering Arts in the 80s
Ampersand Publications 1984
Modern Scribes and
Lettering Artists Book 2
1985 Taplinger Publishing
Company (USA)
Newsletter (Friends of
Calligraphy: San Francisco)
Volume 3 No. 2, 1978 (USA)
Newsletter (Friends of
Calligraphy: San Francisco)
Volume 8 No. 3, 1983 (USA)
Painting for Calligraphers
by Marie Angel, Pelham
Books Ltd 1984 (UK)
Words of Risk: the art of
Thomas Ingmire by Michael
Gullic, Calligraphy Review
Editions 1989

Donald Jackson

The Calligrapher's
Handbook 1985 (UK)
The Story of Writing Studio
Vista 1980 (UK, USA & several
European editions)
The Calligrapher's
Handbook

Jean Larcher

Allover Patterns with Letter
Forms Dover Publications
1985 (USA)
Arts & Métiers du Livre No.
140, 1986 (France)
Bon A Tirer Nos. 14 & 15,
1979 (France)
Cadrat D'Or Jombart, Kapp &
Lahure 1986 (France)
Calligraphies Editions
Quintette 1984 (France)
Calligraphy Review: Volume
5 No. 2, Winter 1987 (USA)
Communication et Langages
No 82, 1990 (France)
Fantastic Alphabets Dover
Publications 1976 (USA)
Jean Larcher Calligraphe
1986 (France)
La Letra Enciclopedia del
Diseno 1988 (Spain)
Pop Message Post Cards
Dover Publications 1985 (USA)
Typomondo 5 Artra
Editeur/Bussieres 1985
(France)
The 3-D Alphabet Colouring
Book Dover Publications
1978 (USA)

Claude Mediavilla

Arts Graphiques Magazine
May 1989 (France)
Artists Magazine 1988
BAT 1979 (France)
Calligraphy Review Winter
1987 (USA)
De Plomb, d'Encre et de
Lumière National Printing
Office 1982 (France)
La Calligraphie Remy
Magermans 1984 (Belgium)

Leçon de Calligraphie
Dessain & Tolra 1988 (France)
Le Figaro 27 April 1989
France)
Lettres Capitales Remy
Magermans 1982 (Belgium)
Magazine Idea 1984 (Japan)
Modern Scribes & Lettering
Artists 1980 (UK)
National Printing Office
Magazine 1985 (France)
Scriptores Magazine 1986
(Holland)
Visible Language 1983 (USA)

Charles Pearce

The Anatomy of Letters
Taplinger Publishing
Company 1987 (USA)
A Calligraphy Manual for
the Beginner Pentalic 1981
(USA)
A Little Manual of
Calligraphy Pentalic 1981
(USA) & Collins (UK)
A Young Person's Guide to
Calligraphy Pentalic 1980
(USA)
Calligraphy: The Art of Fine
Writing Cumberland
Graphics 1975 (UK)
Italic Writing Platignum 1979
(USA)
Lettering, The Art of
Calligraphy Platignum 1978
(USA)

Friedrich Poppl

Ausstellungskatalog
Typomundus ICTA 1972
(Germany)
Calligraphy Idea Exchange
Volume 3 No 1, Autumn
1985 (USA)
Calligraphy Idea Exchange 1
No 1, Autumn 1985 (USA)
Calligraphy Today by
Heather Child, Studio Vista
1976 (UK)
Deutscher Druker No 30,
1982 (Germany)
Druckwelt No 19, 1982
(Germany)
Die Urkunde by Karl Groner
Verlag Ulm/Donau 1969
(Germany)
Gebrauchsgraphik 5 1962
(Germany)
Gebrauchsgraphik 5 1965
Gebrauchsgraphik 1 1968
(Germany)
Graphik 3 1964 (Germany)
Graphik 4 1969 (Germany)
Modern Publicity 1968 &
1969 (UK)
Polygraph 21 1965
The International Journal of
Typographics 12 1980
International Calligraphy
Today ITC 1982 (USA)

Gottfried Pott

Workshop Impression 1989

Leonid Pronenko

Calligraphy by J Martin 1984
(London)

Calligraphy For All 1990
(USSR)
Calligraphy Idea Exchange
1985 (USA)
The Calligraphy Source Book
by M Stribley 1986 (UK)
Calligraphy Review Volume
6, No 12, 1988 (USA)
International Calligraphy
Today 1982 (USA)
Letter Craft by John Biggs
1982 (UK)
The Library Chronicle
University of Texas (USA)
Modern Scribes and
Lettering Artists II 1986 (UK)
60 Alphabets by Gunnlaugur
SE Briem 1986 (UK)
Youthful Artist Journal
(USSR)
World of Books (USSR)

Werner Schneider

Schrift: Analyse-Layout-
Design (Germany)
Baseline Letraset 1989 (UK)

John Stevens

Alphabet '83 1983 (USA)
Calligraphy Idea Exchange
1985 (USA)
Calligraphy in the Graphic
Arts 1988
Calligraphy Today III
Graphic Design USA 1988
(USA)
Lettering Arts in the 80s
Modern Scribes and
Lettering Artists II 1986
(UK)
Print Regional Design
Annual 1987 (USA)
Signature (MN)
Society of Scribes Journal
1983
Type Directors Annual
Volumes 6 & 10

Arie Trum

Calligraphy Idea Exchange
Oakland 1987 (USA)
Calligraphy Review 1987
(Norway)
Duisburg Session Catalogue
Wilhelm Lehmbruck Museum
1973 (Germany)
Eindhoven Artists Art
Foundation Eindhoven 1975
(Holland)
Futura Dutch Architects
Review 1976
Information Bulletin City of
Eindhoven 1973
Man and Concrete Dutch
Architect Society 1976
Modern Art Catalogue of
Eindhoven 1976 (Holland)
Waarheid Festival RAI
Amsterdam 1972 (Holland)

Julian Waters

Wildlife America US Postal
Service 1987 (USA)
Modern Scribes and
Lettering Artists 1980 (UK)
Modern Scribes and
Lettering Artists II 1986 (UK)

Sheila Waters

Modern Scribes and
Lettering Artists 1980 (UK)
Scripsit Journal of
Washington Calligraphers
Guild, Summer 1990
Modern Scribes and
Lettering Artists II 1986
(UK)

Hermann Zapf

ABC-XYZapf 1989
About Alphabets 1960
About Alphabets 1970
Creative Calligraphy
(Germany, England, France
and Spain)
Hermann Zapf and his
Design Philosophy 1987
Hermann Zapf: Hora fugit —
Carpe diem 1984
Manuale Typographicum
1954 in 16 languages, 1968 in
18 languages
Pen and Graver 1950 and
1952
Typographic Variations 1963
Germany, England and France
William Morris 1948

**The author's recommended
further reading**

The Art of Calligraphy
(Western Europe and
America) by Joyce Irene
Whalley, Bloomsbury Books
1980 (UK)
The Calligrapher's
Handbook by Heather
Child, Society of Scribes and
Illuminators, A & C Black
1985 (UK)
Creative Lettering by
Michael Harvey, The Bodley
Head 1985 (UK)
The Decorated Letter by J J
G Alexander, Thames and
Hudson 1978 (UK)
English Handwriting
540-1853 by Joyce Irene
Whalley, HMSO 1969 (UK)
Medieval Calligraphy: its
history and technique by
Marc Drogin, George Prior
1980 (UK), Allanheld &
Schram (USA)
Modern Scribes and
Lettering Artists Studio
Vista 1980 (UK)
Modern Scribes and
Lettering Artists Trefoil
1986 (UK)
The Origin of the Serif by E
M Catich, Catfish Press 1969
(USA)
Sixty Alphabets by
Gunnlauger S E Briem,
Thames and Hudson (UK)
The Story of Writing by
Donald Jackson, Studio Vista
1989 (UK)
Unterricht in Ornamentaler
Schrift by Rudolf von
Larisch 1911
Writing and Illuminating
and Lettering by Edward
Johnston, Black 1983 (UK)

Index